Works of Splendor and Imagination

Works of Splendor and Imagination: The Exhibition Watercolor, 1770–1870

By Jane Bayard

YALE CENTER FOR BRITISH ART · NEW HAVEN

Contents

This catalogue is published on the occasion of an exhibition at the Yale Center for British Art, New Haven, Connecticut, September 16–November 22, 1981.

Design: Renée Cossutta
Typesetting: Helene Wells Studio
Paper: Mohawk Superfine
Printing: Cover—Eastern Press
 Text—George E. Platt & Company, Inc.
 Plates—Rembrandt Press
Binding: Mueller Trade Bindery
at the Direction of the Yale University Printing Service

Preface

OF PARAMOUNT IMPORTANCE to the growth of English Romanticism were two concurrent developments: the technical revolution in watercolor painting that occurred at the beginning of the 19th century and the organization of watercolor painters into exhibiting societies intent on demonstrating to the broadest audience the new variety and richness of effects attainable through this medium. Watercolors had been included in the earliest exhibitions at the Royal Academy, but in competition with oil paintings, they were undervalued and generally ignored. Even the brilliant efforts of Paul Sandby and John Robert Cozens did not elevate the status of watercolor painting to the level of public approbation desired by its practitioners. With the extraordinary innovations in watercolor painting that were being made about 1800 by J. M. W. Turner, Thomas Girtin, John Sell Cotman and others, the moment was opportune for watercolorists in general to aggressively promote their medium as an alternative to oil painting for treating the most progressive aims of art. The watercolor societies that emerged in the first decades of the century provided, through annual exhibitions, a public forum for these claims, encouraging many artists, especially landscapists, to adopt watercolor as their primary means of expression.

For the next sixty years, highly finished watercolors, often grand in scale and ambitious in technique, were abundantly painted for public exhibition, and many of these individual paintings, including a number in this exhibition, rank with the most advanced works of art produced in any nation during this period.

The purpose of this exhibition is to explore the various aspects of this phenomenon from the aesthetic and social attitudes that created and sustained it to the new exhibition methods, painting techniques and patterns of patronage that it generated. We are grateful to Jane Bayard, a Doctoral candidate in the Department of the History of Art, who proposed this topic, selected the exhibits and wrote the accompanying catalogue. It is an outstanding scholarly achievement and a major contribution to the sparse literature on this neglected subject.

The exhibition makes full use of the Center's extensive holdings in this area, but a number of watercolors have been borrowed for their historical importance or their singular grandeur. Mr. Paul Mellon has once again generously made available the finest works from his own collection, and our warmest thanks are extended to him and to the public and private lenders in England who have so readily consented to participate in our venture.

Patrick Noon
Acting Curator of Prints and Drawings

Acknowledgments

THE IDEA for this exhibition originated with Andrew Wilton, to whom I owe the greatest debt of gratitude. From the outset he has been a constant supporter of my undertaking, and his wide knowledge of the field has made his advice and comments invaluable. I am also grateful to Patrick Noon, who made many useful suggestions about the catalogue. He and the print room staff, especially Angela Bailey, Dolores Gall, Randi Joseph and Lib Woodworth, have made my work easier in a number of ways: I am most appreciative of their help. Many other staff members at the Center offered their time and knowledge: in particular, I must thank the former director, Edmund Pillsbury, who encouraged the project from the beginning. In the practical matters of mounting the exhibition and producing the catalogue, my debts are many. Michael Marsland and Joseph Szaszfai were responsible for much of the photography for the catalogue. Ursula Dreibholz and Paula Jakubiak were always ready to help with matters of conservation, and Gene Healy and Rob Meyers were of great assistance in matting, framing and installing the exhibition. Greer Allen and Renée Cossutta deserve much credit for the catalogue design, and to Lawrence Kenney I extend my gratitude for his careful editing of the manuscript. Cecie Clement was a wonderful expediter in the production of the catalogue.

A most important contribution was made by the lenders to the exhibition, whose generosity in sending watercolors to Yale I acknowledge with thanks. Among the many people in English museums who assisted me in my research, I would like to thank the following: John Murdoch and Michael Kauffmann, the Victoria and Albert Museum; Malcolm Fry, Royal Society of Painters in Water-Colours; Peter Moore, formerly at the British Museum; Francis Hawcroft and Vivien Knight, Whitworth Art Gallery, Manchester; Julian Treuherz, City Art Gallery, Manchester; Duncan Robinson and David Scrase, the Fitzwilliam Museum, Cambridge; Andrew Greg, Laing Art Gallery, Newcastle upon Tyne; David Phillips, Castle Museum, Nottingham; Dr. David Brown, the Ashmolean Museum, Oxford; Richard Locket, City Art Gallery, Birmingham; Marco Livingstone, Walker Art Gallery, Liverpool; Andrew Robertson, City Art Gallery, Leeds; Francis Greenacre, City Art Gallery, Bristol; R. H. Wood, Usher Art Gallery, Lincoln; Dr. Miklos Rajnai, formerly at the Castle Museum, Norwich; Jill Knight, Victoria Art Gallery, Bath; Mary Goodchild, City Art Gallery, Sheffield; Halina Grubert, Cecil Higgins Art Gallery, Bedford; Dr. Peter Cannon-Brookes, National Gallery of Wales, Cardiff; and James Holloway, formerly at the National Gallery of Scotland, Edinburgh.

My research in England was also helped in many ways by the staff of the Paul Mellon Centre for British Studies in London, and I am most grateful to the director and librarian, Christopher White and Brian Allen. Several people have contributed valuable information on particular artists and watercolors: I would especially like to mention Beverly Carter, Duncan Bull, Dr. Michael Pidgeley, William Pressley, Bruce Robertson, and Scott Wilcox. Finally, I want to thank my husband, Patrick Curley, whose patience and steady encouragement were the greatest support of all.

Jane Bayard

Lenders

(the numbers refer to catalogue entries)

Private Collections

Dyer Collection: 20.
Mr. and Mrs. Paul Mellon: 51, 52, 61, 85.
Mrs. Basil Taylor: 36.

Public Collections

The Fitzwilliam Museum, Cambridge: 66.
Tyne and Wear County Council Museums (Laing Art Gallery, Newcastle upon Tyne): 9.
Castle Museum and Art Gallery, Nottingham: 16.
Victoria and Albert Museum, London: 19, 23, 49, 64.
Whitworth Art Gallery, Manchester: 44, 72.

Index of Artists

Abbreviations for Institutions

AA	Associated Artists in Water-Colours, also known as The Society of Painters in Miniatures and Water-Colours (1807–12).
ARA	Associate of the Royal Academy.
BFAC	Burlington Fine Arts Club
BI	British Institution (1805–67).
BM	British Museum.
MMA	Metropolitan Museum of Art, New York.
NGL	National Gallery, London.
NSPW	New Society of Painters in Water-Colours (1832–63), thereafter known as the Institute of Painters in Water-Colours, and in 1883, The Royal Institute of Painters in Water-Colours.
RA	Royal Academy (1768–) or Royal Academician.
SA	Society of Artists of Great Britain (1760–91).
SBA	Society of British Artists (1823–87), thereafter known as The Royal Society of British Artists.
SPW	Society of Painters in Water-Colours (1804–), known as The Society of Painters in Oils and Water-Colours, 1813–20, and as The Royal Society of Painters in Water-Colours in 1881. From 1832, also referred to as The Old Water-Colour Society.
VAM	Victoria and Albert Museum.
YCBA	Yale Center for British Art.

The catalogue is arranged chronologically by artist. All measurements are given in millimeters and inches: height precedes width. The support of each watercolor is white wove paper unless otherwise specified.

References cited more than once in the catalogue are abbreviated, but cited in full in the bibliography. Unless otherwise noted, London is the place of publication. For a more detailed bibliography of the subject, see the third volume of Hardie's *Water-Colour Painting in Britain* and S. T. Lucas's *Bibliography of Water Colour Painting and Painters* (1976).

Frequently used sources not cited in the catalogue are:

SPW catalogues, yearly from 1805.

AA catalogues, 1808–12.

NSPW catalogues, yearly from 1832.

A. Graves, *The Royal Academy of Arts, a Complete Dictionary of Contributors and their Work from its Foundation in 1769 to 1904,* 4 vols, 1905–06.

Bibliography

Agnew — Thomas Agnew & Sons, Exhibitions of Watercolours and Drawings, London. Annual.

Alison, *Essay* — A. Alison, *Essay on the Nature and Principles of Taste*, Edinburgh, 1790.

Barret, *Water-Colour* — G. Barret, Jr. *The Theory and Practice of Water-Colour Painting*, 1840.

Binyon — L. Binyon, *English Water-Colours*, 2nd edition, 1944.

Blake, *Poetry and Prose* — W. Blake, *The Poetry and Prose of William Blake*, edited by D. Erdmann, New York, 1970.

Burke, *Sublime and Beautiful* — E. Burke, *A Philosophical Enquiry into the Origin of our Ideas of the Sublime and the Beautiful*, edited by J. T. Boulton, 1968.

Butlin & Joll, *Turner* — M. Butlin and E. Joll, *The Paintings of J.M.W. Turner*, RA, New Haven and London, 1978.

Callow, *Autobiography* — W. Callow, *William Callow, R.W.S., an Autobiography*, edited by H. M. Cundall, 1908.

Cox, 1976 — London, Anthony Reed, and New York, Davis and Long, *David Cox, Drawings and Paintings*, 1976.

Craig, *Lectures* — W. M. Craig, *A Course of Lectures on Drawing, Painting, and Engraving*, 1821.

Eastlake, *Household Taste* — Sir C. Eastlake, *Hints on Household Taste*, 1868.

Farington, *Diary* — J. Farington, *The Farington Diary by Joseph Farington*, RA, 8 vols. edited by J. Grieg, 1922–28.

Finberg, *Turner* — A. J. Finberg, *The Life of J.M.W. Turner*, Oxford, 1939.

Fitzgerald, *Frames* — P. Fitzgerald, "Picture Frames," *Art Journal*, 1886, p. 325.

Gilchrist, *Blake* — A. Gilchrist, *The Life of William Blake*, 2 vols. 1880.

Hardie — M. Hardie, *Water-Colour Painting in Britain*, 3 vols. edited by D. Snelgrove with J. Mayne and R. Taylor, 1967–68.

Hayes, *Gainsborough* — J. Hayes, *The Drawings of Thomas Gainsborough*, 2 vols. 1970.

Howard, *Colour* — F. Howard, *Colour as a Means of Art*, 1838.

Leslie, *Constable* — Sir C. Leslie, *Memoir of the Life of John Constable*, 5th ed. 1951.

Lewis, *Lewis* — Maj. Gen. M. Lewis, C.B.E. *John Frederick Lewis*, RA, *1805–1876*, Leigh-on-Sea, 1978.

Lewis, 1971 — Newcastle upon Tyne, Laing Art Gallery, *John Frederick Lewis* RA, 1971.

NGA 1962 — National Gallery of Art, Washington, D.C. *An Exhibition of Drawings and Watercolors from the Collection of Mr. & Mrs. Paul Mellon*, 1962.

Nicholson, *Landscape from Nature* — F. Nicholson, *The Practice of Drawing and Painting Landscape from Nature*, 1820.

OWSC — *The Old Water-Colour Society's Club*, Annual vols., 1923–.

Palmer, *Letters* — S. Palmer, *The Letters of Samuel Palmer*, 2 vols. edited by R. Lister, 1974.

Palmer, *Life* — A. H. Palmer, *The Life and Letters of Samuel Palmer Painter and Etcher*, 1892.

PML-RA — The Pierpont Morgan Library, New York, *English Drawings and Watercolors 1550–1850, in the Collection of Mr. & Mrs. Paul Mellon*, 1972, and the RA, London, 1973.

Pyne, *Royal Residences* — W. H. Pyne, *The History of the Royal Residences of Windsor Castle, St. James Palace, Carlton House, Kensington Palace, Hampton Court, Buckingham Palace, and Frogmore etc.*, 3 vols. 1819.

Pyne, *Microcosm* — W. H. Pyne, *Microcosm; A Pictorial Delineation of the Arts, Manufactures, etc., of Great Britain*, Pub. by R. Ackermann, 1806, and subsequently.

Rajnai and Allthorpe-Guyton, *Cotman* — M. Rajnai and M. Allthorpe-Guyton, *John Sell Cotman, 1782–1842, Early Drawings in the Norwich Castle Museum*, Norwich Castle Museum, 1979.

Reading, *Havell* — Reading, City Museum and Art Gallery, *William Havell*, 1970.

Reynolds, *Discourses*	Sir J. Reynolds, *Discourses on Art*, edited by R. Wark, 1975.
Roget	J. L. Roget, *A History of the Old Water-Colour Society*, 2 vols. 1891.
Repository of Arts	*The Repository of Arts, Manufactures, and Literature*, Pub. by R. Ackermann, 1808–28.
Ruskin, *Works*	J. Ruskin, *The Complete Works of John Ruskin*, 39 vols. edited by E. T. Cook and A. Wedderburn, 1903–12.
Somerset House Gazette	W. H. Pyne, editor and writer, *Somerset House Gazette*, 2 vols. 1823–24.
Spink 1973	B. Taylor, *The Old Watercolour Society and its Founder Members 1804–1812*, Spink & Son, Ltd., 1973.
Tate, *Landscape*, 1973	L. Parris, *Landscape in Britain 1750–1850*, Tate Gallery, London, 1973.
Tate, *Blake*, 1978	M. Butlin, *William Blake*, Tate Gallery, London, 1978.
Uwins, *Memoir*	Mrs. Uwins, *A Memoir of Thomas Uwins* RA, 2 vols. 1858.
VAM, *British Watercolours*	L. Lambourne and J. Hamilton, *British Watercolours in the Victoria and Albert Museum, An Illustrated Summary Catalogue*, 1980.
VAM, *Forty-two Watercolours*	J. Murdoch, *Forty-two Watercolours from the Victoria and Albert Museum*, 1977.
VAM, *Cristall*	B. Taylor, *Joshua Cristall 1767–1842*, Victoria and Albert Museum, London, 1975.
VAM, *Sketching Society*	J. Hamilton, *The Sketching Society*, Victoria and Albert Museum, London, 1971.
VAM, SPW Price Books	Victoria and Albert Library, unpublished MSS, price books of SPW, 1805–1812.
Varley, *Treatise*	J. Varley, *A Treatise on the Principles of Landscape*, n.d., c. 1816.
Victoria, 1971	*British Watercolour Drawings in the Collection of Mr. & Mrs. Paul Mellon*, The Art Gallery of Greater Victoria, Canada, 1971.
VMFA Richmond 1963	*Painting in England 1700–1850: Collection of Mr. & Mrs. Paul Mellon*, Virginia Museum of Fine Arts, Richmond, 1963.
Webber, *Orrock*	B. Webber, *James Orrock, R.I.*, 2 vols. 1903.
Whitley, 1800–1820	W. Whitley, *Art in England, 1800–1820*, 1928.
Whitley, 1821–1837	W. Whitley, *Art in England, 1821–1837*, 1930.
Whitley, *Heaphy*	W. Whitley, *Thomas Heaphy*, 1933.
Williams, *Watercolours*	I. Williams, *Early English Watercolours*, 1952.
Wilton, *British Watercolours*	A. Wilton, *British Watercolours 1700–1850*, Oxford, 1977.
Wilton, *Turner*	A. Wilton, *J. M. W. Turner: His Art and Life*, New York, 1979.
YCBA, *Cozens*	A. Wilton, *The Art of Alexander and John Robert Cozens*, Yale Center for British Art, New Haven, 1980.
YCBA, *English Landscape*	C. White, *English Landscape 1630–1850*, Yale Center for British Art, New Haven, 1977.
YCBA, Fifty Drawings	*Exhibition of Fifty Beautiful Drawings*, Yale Center for British Art, New Haven, unpublished checklist, 1977.
YCBA, *Portrait Drawings*	P. J. Noon, *English Portrait Drawings and Miniatures*, Yale Center for British Art, New Haven, 1979.
YCBA, *Selections*	*Selected Drawings, Paintings, and Books*, Yale Center for British Art, New Haven, 1977.
YCBA, *Selected Watercolors*	*Selected Watercolors*, Yale Center for British Art, New Haven, 1980.

Introduction: History and Style

IT WOULD HAVE COME as a surprise to Sir Joshua Reynolds to know that within a generation of his death in 1792, the art of watercolor was so transformed that artists in the medium were able to produce works as large, as technically complex, and as ambitious as paintings in oil. The unpretentious stained or tinted drawings current in his lifetime, in which a pen or pencil sketch was washed with an ink monochrome and then heightened with touches of color, gave no hint that more elaborate works in watercolor were possible. Within the first decade of the nineteenth century, however, exhibitions devoted exclusively to watercolor were being promoted, and these shows contained some of the most advanced works to be seen in London at the time. Encouraged by the reception of their novel efforts, watercolor artists concentrated on producing large and ambitious pieces, and so established the exhibition watercolor as a legitimate and impressive art form.

The exhibition watercolor was of central importance to the development of English art, a fact which has long been overlooked or ignored. During the period when the British school of watercolor came of age and flourished, exhibition watercolors were the artists' final statements of their ambitions and abilities, the works upon which they felt their future fame would rest. They were the keystone of the artists' contemporary reputation as well. The public based their judgments upon these finished exhibition pieces, collectors bought them as important examples of British art, critics reviewed them, and fellow artists, both in watercolor and oil, were influenced by them. In the history of English landscape painting exhibition watercolors held an important place, and they had a marked impact upon contemporary oil painting technique. Not only does the form reveal much about the motivations and interests of the period in which it flourished: intrinsically it is worth examining because many exhibition watercolors are of lasting beauty and artistic value.

Covering almost a century, 1772–1868, this show attempts to follow the history of the exhibition watercolor. Most of the works come from the Center's collection, which is rich in major examples of exhibition watercolors. A few loans from English collections have filled important gaps. Not all the watercolors were exhibited: some were included because they demonstrate points of technique or style, others because they represent typical but unidentifiable exhibition pieces shown originally under titles such as 'Composition,' or 'Landscape – Sunset.' The size of the show precluded works representing the local schools exhibited at the provincial galleries of Norwich, Bristol, etc., and the choice was limited to watercolors which would have been seen at the main galleries in London. The Pre-Raphaelites were also left out, as their aims and ambitions contributed little that was new to the exhibition watercolor tradition.

The three essays that follow deal with the development of the exhibition watercolor: changes in style and subject matter, the growth of technique, and a consideration of how watercolors were displayed. The last subject is important in understanding the form, and it is unfortunate that it was not possible to hang a part of the present show as it would have been hung in the nineteenth century. None of these essays pretends to be an exhaustive discussion, but, taken together, they are intended to raise questions which may reshape attitudes about exhibition watercolors and help put them in a clearer perspective.

Watercolors had been exhibited since the 1760s, when the Society of Artists, the Free Society, and the Royal Academy opened their galleries. The shows which these associations held every spring provided artists with a forum in which they could receive criticism and recognition from their fellows. They also gave artists the chance to develop a reputation with the public, and that helped to sell their work. For artists in watercolor, the chance to exhibit publicly was a mixed blessing. In the day of tinted drawings, watercolorists worked either for engravers or antiquarians who wanted topographic records of particular places, or for clients who commissioned small-scale portraits. The exhibitions benefited watercolor artists by allowing them to create independent works of art, showpieces that were not finished under the direction of a client. However, even finished stained drawings were not considered imposing enough to warrant membership for their creators in the RA, which by 1791 was the only remaining gallery where artists could exhibit. At that point, connoisseurs and writers felt that great art, works of stature and importance, could be created only in oil or sculpture.

Watercolors were seen as a form of drawing, estimable within that limitation, but clearly in a second class. As a result, watercolors were hung badly at the Academy, tucked away in the smaller room with the engravings, miniatures, and second-rate oils, placed "between windows and under windows, sometimes in the darkened room with the sculpture, where if they had merit, it could not be seen."[1]

One of the chief grievances of watercolor artists exhibiting at the Academy was that their work was hung with oils. This was felt to be an unfair comparison: in a crowded gallery, even a bad painting in oil would catch the viewer's eye sooner than a smaller, more delicate watercolor. Hanging their works in competition with larger, more powerful oils, watercolor artists were encouraged to experiment in order to strengthen their medium. In exhibition pieces, at least, watercolorists shared the same concerns and interests as their rivals in oil. By the beginning of the century, it had become their aim to demonstrate that watercolor could be manipulated to produce works of greater size, force, and strength of coloring than had ever been considered possible.

The ambition to expand the limits of their art, to paint rather than to draw in watercolor, had several other aspects, technical, expressive, and aesthetic. The development of technique will be discussed later, but it can be pointed out here that there were two paths open to watercolor artists in search of increased depth and power. Paul Sandby's career as an exhibitor demonstrates one direction which artists could take to strengthen their exhibition pieces. Sandby's delicate topographic drawings, finished with simple washes of color, were intended mostly for engraving or the collector's portfolio. However, his larger, more forceful works in bodycolor, often of generalized classical subjects in the tradition of Marco Ricci and Gaspar Dughet, were framed like oils and meant for exhibition.[2] Contemporary opinion held that bodycolor, an opaque technique closer to oil than watercolor in its application, was strong enough to base one's reputation upon as an exhibitor, while watercolor was not. From the beginning of the eighteenth century, continental artists like Ricci, Jean Pillement, and Charles Clerriseau, by visiting and working in England, established a high reputation for works in bodycolor. At the formation of the RA,

Francesco Zuccarelli, George Barret, Sr., and Mary Moser, all of whom worked extensively in the medium, were founding members along with Sandby. By the beginning of the nineteenth century, though, with the rise of stronger works in pure watercolor, bodycolor went out of fashion. It did not regain its popularity until the late 1820s, when watercolorists again realized its potential for giving solidity and denseness to their work.

Transparency was watercolor's great strength, and there were many artists who rejected the aid of bodycolor, hoping to discover other expedients by which they could strengthen the medium without losing its primary quality. The road taken by these artists was to concentrate on color and tone. Color washes, instead of serving as the final touch on a monochrome drawing, became the chief vehicle through which an image was created. Drawing became secondary to color, and increasingly complex methods evolved to reinforce the new tonal approach to the medium.

Developments in the field of aesthetics also contributed to the changes taking place in the art of watercolor. During the second half of the eighteenth century, attitudes toward nature underwent revisions which opened new possibilities to landscape artists. The watercolor tradition was linked indissolubly with topography, where careful observation and exact rendering formed the basis for antiquarian and scientific study. It was for this purpose that Sandby traveled with Sir Charles Greville to Wales in 1771, and that Thomas Girtin worked for James Moore in the Midlands in 1794. By that time, however, other considerations were modifying and expanding this fact-recording tradition.

In the first half of the eighteenth century, during Jonathan Richardson's day, landscape was considered an unimportant branch of art because it did not "improve the mind" or could "excite no noble sentiments."[3] When it was not factual or scientific, it was merely decorative, as in the classical pastiches made for overmantels or chimneypieces by John Wootton and George Lambert. But paintings by Salvator Rosa, Claude, Poussin, and the Dutch Italianates upon which these English works were based had a profound shaping influence on the growing taste for landscape. "The great masters of this art

have been principally Italians," wrote Archibald Alison,

> men who were born among scenes of distinguished beauty, . . . and whose works have disseminated . . . the admiration of the scenes which they copied. From both these causes, . . . the Imagery of Italian Scenery had got strongly the possession of our imagination. Our first impressions of the Beauty of Nature had been gained from the compositions which delineated such scenery: and we were gradually accustomed to consider them as the standard of Natural Beauty.[4]

Inspired by the great Italian tradition, a steadily increasing stream of British artists crossed the Alps from *c.* 1750 in search of the scenes and culture which had had such a formative influence upon them at home in the shape of paintings and engravings. Firsthand experience of the mountains of Switzerland and of the atmosphere and light of the Mediterranean called forth a strong imaginative response. Italian scenery became an object of study in itself: it was no longer a backdrop for groups of Virgilian shepherds. Associations with antiquity and the more recent artistic past led artists like Richard Wilson, William Pars, Francis Towne, and John Robert Cozens to evoke the inherent poetry of a landscape without the mediating power of historical figures.

Watercolor artists were in the vanguard of the new response to nature. Pars, beginning his career as a topographer in the employ of the Society of Dilettanti, was the first artist to exhibit views of the Alps at the RA, and later, his expressive response to Italian light and color set a precedent that was built upon by J. R. Cozens. The latter's contribution lay in his ability to evoke the immense scale, solitude, and melancholy of the mountains and plains, using minimal means. His palette was deliberately limited, and his technique eccentric by the standards of the day, but his success within the boundaries which he imposed upon himself was to influence many artists in the next generation, including the two key figures for watercolor, Turner and Girtin.

Even before Cozens had gone to Italy, Thomas Gainsborough was composing and drawing landscapes inspired by the Dutch tradition of Wynants and Ruisdael, but he protested that to paint a landscape of any merit, it "must be of his own brain," that is, one in which his imagination was paramount.[5] Gainsborough's works exercised an important influence, not only on other artists, but on connoisseurs like William Gilpin, Uvedale Price, and Richard Payne Knight. Well before they had begun to write about the Picturesque, Gainsborough was exploring its pictorial possibilities. One of his landscape drawings, composed in the studio from an arrangement of sticks and bits of rock and glass, would have illustrated Gilpin's essays perfectly. Gilpin was one of the first to write about the force of imagination in landscape, and to advocate

> such imaginary views as give *a general idea of a country,* spread themselves more diffusely, and are carried, in the . . . imagination, through the *whole description.* . . . he who works from imagination — that is, he who culls from nature the most beautiful of her productions — a *distance* here; and there a *foreground* — combines them artificially; and removing everything offensive, admits only such parts, as are *congruous*; and *beautiful*; will in all probability, make a much better landscape than he who takes it all as it comes.[6]

Gilpin's theories and the entire cult of the Picturesque were also indebted to Edmund Burke's *A Philosophical Enquiry into the Origin of our Ideas of the Sublime and Beautiful* (1757), in which Burke examined the causes of different aesthetic sensations. For Burke, Sublimity was the strongest, most direct emotion, encompassing ideas of terror, pain, awe, vastness, and obscurity, while Beauty involved the qualities of smallness, delicacy, smoothness, and soft, gradual variations. Both Burke and Gilpin, along with many of their contemporaries, were convinced that it was possible to discover the fixed laws which they believed must govern life and art. Burke wanted to ascertain the rules of Taste: amplifying upon this, Gilpin attempted to formulate the underlying order of the natural scene. Both were concerned with categories — one of direct aesthetic experiences, the other, of types in landscape. Gilpin's form of the Picturesque was the artist's selection and combination of

elements to form a balanced and pleasing whole. This was strengthened by the removal of any accidents or particulars which detracted from the general effect. Gilpin's emphasis was on the artful composition of landscape, and thus was more closely related to the seventeenth-century Italian tradition than to simple topography. He was read widely by artists and amateurs alike, and his theories and vocabulary formed a link between the most forward-looking artists and the enlightened general public. For watercolor artists, his writings were influential not only in teaching them how to compose landscape that could evoke aesthetic responses, but in making landscape a subject worthy of consideration for the connoisseur and patron.

Two others who had influence on the development of the Picturesque were Uvedale Price and Richard Payne Knight. Knight's theories were the simplest: for him, the Picturesque was merely that which was paintable. He had no pretension to define aesthetic categories, as did Gilpin and Price. Price's contribution was to speak up for the historical significance of the Picturesque. He contended that "broken tints" and "rugged outlines" were visual evidence of the passing of time, capable of igniting the viewer's historical imagination. Watercolor artists like Thomas Hearne, Michael "Angelo" Rooker, and Julius Caesar Ibbetson anticipated and upheld Price's ideas, drawing a picturesque in their works that was concerned with real places, where the process of decay and organic growth inspired a nostalgia or appreciation for the past.

This sort of reverie was further refined by Archibald Alison in his *Essays upon the Nature and Principles of Taste* (1790), where he argued for the power of Association.

> Whatever increases this exercise or employment of Imagination, increases also the emotion of Beauty and Sublimity. This is very obviously the effect of all Associations. There is no man, who has not some interesting associations with particular scenes . . . who does not feel their beauty and sublimity enhanced to him, by such connections. The view of the house where one was born, the school where one was educated, . . . is indifferent to no man. They recall so many images of past happiness and past affections, . . . and lead altogether to so

long a train of feelings and recollections, that there is hardly any scene, which one beholds with such rapture. The scenes which have been distinguished by the residence of any person, whose memory we admire, produce a similar effect. . . . The scenes themselves may be little beautiful, but the delight with which we recollect . . . their lives, blends itself indefinitely with the emotions which the scenery itself, excites; . . . and converts everything to beauty which appears to have been connected with them.[7]

Alison distinguished between "simple emotions," such as joy, pity, or benevolence, and the more complex "emotions of Taste," such as tranquility, melancholy, or awe, because the latter were dependent on a certain state of mind in which "the imagination is free and unembarrassed, or in which the attention is so little occupied . . . as to leave us open to all the impressions, which the objects that are before us, can create."[8] He was describing a state of intense mental and emotional activity combined with physical passivity: this was the sort of aesthetic sensation that J. R. Cozens was trying to spark in his watercolors. Association was best suited to landscape of historical or architectural scenes, and it was the Alisonian aesthetic that gave the topographical–antiquarian tradition new life and vigor. In such works, for example, John Varley's *Dolbadern Castle* (no. 35), the view was supposed to "lead the mind to indulge in pleasing association of ideas, and bring before it the romantic knights, and fair dames, whose deeds stand in the faithful page of history."[9]

The growing acceptance of landscape as a major concern of both artists and connoisseurs continued, and watercolor artists were in the forefront of the movement. In another way, however, they still followed the lead of painters in oil, who from the beginning of the eighteenth century felt that the greatest artistic honors could be won only by painting moral or elevated subjects. To combine high art and the heroic mode with landscape became an object of desire for watercolor artists as well. They felt that this would reinforce the new expressive range of landscape and increase their artistic reputation. In 1799 several watercolorists, including Girtin, Louis Francia, and Robert Ker Porter, established a club known as The Brothers, or Girtin's Sketching Society. They met weekly "for

the purpose of establishing by practice a school of historic landscape, the subjects being original designs from poetick passages."[10] After Girtin's departure from Paris in 1801, John Sell Cotman became the nominal head of a similar group, whose members included John Varley, William Havell, Joshua Cristall, and Paul Sandby Munn. Examples of early subjects, in which the landscape plays a major role in expressing poetic mood, are Havell and Munn's versions of *Pale Melancholy* (nos. 42 and 25), taken from William Collins's *Ode to the Passions* (1747).

In 1808 a further association succeeded this last one, founded by the Chalon brothers and Francis Stevens and known as The Society for the Study of Epic and Pastoral Design. Every Wednesday evening from November to May the eight members and two visitors met to sketch a poetic subject, have supper, and discuss their work. Robert Hills, William Turner of Oxford, William Henry Pyne, and Cristall attended many meetings over the next ten years. An occasional painter or architect came, but significantly, the sketching societies were dominated by watercolor artists. These groups were both preamble and parallel to the exhibition watercolor societies in their desire to expand the limits of watercolor and to compete on a higher level than ever before.

The first decade of the nineteenth century was a transition period between the eighteenth-century traditions of high art and the new era in which landscape flourished. Reynolds, Gainsborough, and Wilson were dead, and except for the precocious Turner and Sir Thomas Lawrence, no really forceful painters were on the scene. David Wilkie and Constable would not emerge fully for another ten years. During this time, watercolor artists formed the avant garde. They were the first organized group to champion landscape and to mount shows devoted almost exclusively to it. Looking to the past as well as to the future, they maintained their own topographic tradition, renewing it with recent aesthetic theories, and challenged their old limits by painting more ambitious themes and subjects. Further, they fulfilled an important role as technical innovators, borrowing from, and even influencing procedures in oil. They were producing some of the most advanced, novel, and interesting work to be seen in England at the time.

In spite of the fact that at the beginning of the nineteenth century some of the most powerful works exhibited were the watercolors of Girtin and Turner, the Academy still treated watercolor artists as if they were incapable of producing more than the outmoded stained drawings. If an artist wanted official recognition, he still had to pursue painting, as Turner did, or as Girtin might have had he lived. In the short span of his career, Girtin exhibited works which surpassed J. R. Cozens's in intensity. Like Cozens's, Girtin's views were always of actual places, yet the ostensible subjects were made subordinate to the mood or emotion of the composition. Even in the *Ouse Bridge* (no. 26), which falls completely within both the topographic and picturesque traditions, Girtin conveys a melancholy sense of the passage of time and the insignificance of individual humanity. His poetic painterly style was the foundation for much of the best work in watercolor over the next fifty years.

During the same period, Turner was producing even more ambitious works for exhibition, watercolors which in size and technique were the equals of his oil paintings. In the *Glacier and Source of the Arveiron, Chamonix* (no. 30), it was as if Turner had set out to prove that a complex composition of Burkeian Sublimity could be made successfully in watercolor. Technically it was much more complex than Girtin's work, and it was not as restrained: Turner did not hesitate to use emblems, for example the snake in the foreground, to reinforce the sense of terror and desolation he conjured up in this landscape. In another instance, still working in a Burkeian mode, he executed the *Lake Geneva* (no. 31). The Beautiful was his theme here, and he interpreted it according to the smooth and silvery formula of paintings by Claude. Better than anyone else, Turner was able to scale the reaches of high art, to paint in the grand manner as prescribed by Reynolds, and he did it not only in landscape but in watercolor.

Close upon the heels of Girtin and Turner came a group of watercolor artists who, although in no way as original or profound, were ready to make the most of the recent advances in the medium. Knowing that little recognition was to be expected from the RA, they began to plan a separate exhibition devoted to watercolor alone. On November 30, 1804, William Wells, Samuel Shelley, William H. Pyne,

Robert Hills, Nicholas Pocock, John and Cornelius Varley, John Claude Nattes, and William Sawrey Gilpin founded the Society of Painters in Water-Colours. George Barret, Jr., Joshua Cristall, John Glover, William Havell, James Holworthy, and Stephen Francis Rigaud all joined before the first exhibition, which opened April 22, 1805. At the first meeting, the members elected a committee, with Gilpin as president, and wrote the Society's rules, which were very similar to those of the RA.[11] The Society's intentions were stated in the introduction to their first catalogue:

> The utility of an Exhibition in forwarding the Fine Arts arises, not only from the advantage of public criticisms, but also from the opportunity it gives to the Artist of comparing his own works with those of his contemporaries in the same walk. To embrace both these points to their fullest extent is the object of the Present Exhibition, which consisting of water-colour pictures only, must from that circumstance give them a better arrangement, and a fairer ground of appreciation than when mixed with Pictures in Oil.[12]

By founding what was in effect a watercolor academy, the originators of the SPW were looking to gain exactly what the RA had achieved for its members in 1768: public recognition, a place to show and sell their work, and, as they all taught, a kind of school for watercolor. The first exhibition was a rousing success. During its six-week run just under 12,000 people paid the admission price of a shilling. For the second exhibition, the catalogue was sold separately for sixpence, and still admission rose by 500. Proving themselves good businessmen, members of the Society introduced the custom of making sales in the gallery. A room attendant held a book with all the prices, in which a would-be purchaser could enter his name, put down 10 per cent of the price, and then pay the remainder upon delivery of the watercolor.[13]

Only seven of these price books — those from the years 1805–12 — survive, but even this limited number enables us to form a picture of the early patrons of the SPW.[14] During that time, the fashionable world, connoisseurs, and artists made a point of visiting the new exhibitions, and the recorded purchasers were a distinguished mix of all three groups. The ongoing war with France prevented English travelers from visiting Europe, where they could see and purchase continental works. As a result, there was a turn to British art, and in particular to watercolors, which were the newest, most original facet of the native tradition. At the first exhibition, John Glover sold works to Dr. Thomas Monro and Walter Fawkes, both important patrons of watercolor artists. He also sold works to Lord Stafford, Lord Carlisle, and the Duchess of Rutland. In 1808, Sir Thomas Lawrence bought a Heaphy for £105, a Havell landscape for £42, and a sketch by Cristall for three guineas. Aside from patrons like Monro and Fawkes, connoisseurs such as Thomas Hope, Lord Kinnaird, Lord Ossulston, and Sir Henry Englefield were constant purchasers at the early exhibitions. The members supported each other as well: Ramsay Reinagle bought a landscape by Varley for five guineas in 1810, and at the same time, a view by Barret for three guineas.

Contemporary reaction was not all favorable, however. Joseph Farington recorded a conversation between Benjamin West and Sir George Beaumont, Turner's enemy and a champion of the mellow tones of old master painting:

> He remarked on West so strongly speaking of the merit of the water-colour drawings now exhibiting by that Society, and said he wondered at it. For his part when he went into the room there was such a want of harmony, such *chattering display*, that it afforded him little pleasure. There were some effects of *rays, etc.*, that were ingenious, but no breadth or solidity.[15]

The next year, Farington made note of a "wager of 20 guineas that in *three years* there will be no water-colour exhibition."[16] As it turned out, this was not far from the truth. But in the first years, a combination of novelty and genuine merit in the exhibition watercolor made the SPW prosper.

The success of the Society made competition inevitable. Since only members and fellow exhibitors (equivalent to the associates of the RA) could exhibit their work on the Society's walls, a number of highly talented artists were left out. In 1807 several of these formed the New

Society of Painters in Miniature and Water-Colours, or the Associated Artists, as they became known the next year. Among the exhibitors were J. S. Cotman, David Cox, Peter De Wint, Frederick Nash, Samuel Prout, and William Westall, all of whom later joined the SPW. Even William Blake exhibited with the AA in 1812. "This company of artists," wrote a critic in 1809, "may be regarded as a slip or scion of the association in Spring-gardens [where the SPW exhibited that year], bearing fruits of a similar quality to those of the parent stock, but some summers behind it in culture and maturity."[17]

Unfortunately, what began as fair rivalry between the two groups ended in disaster for them both. The exhibitions were too similar, each with a preponderance of landscapes, and they inevitably detracted from each other. Critics began to complain of "the endless round of lakes, mountains, and clouds, clouds, mountains and lakes," and "repetitions of Tintern Abbey from within, and Tintern Abbey from without, and the same by moonlight, and twilight, and every other light."[18] From 1809 there was a dwindling in the receipts of both societies. As a result of the war with France, even the wealthy were under financial strain, and patronage declined. In 1812, in a last effort to rally, the AA included oil painting in their exhibition. It was futile, and an ignominious end came when the landlord seized the entire contents of the gallery in lieu of the unpaid rent. The SPW was in no better straits. They held a meeting to discuss the future; one group, headed by Glover (who was a successful painter in oil as well as in watercolor), suggested that they too should include oils in their next exhibition. The idea was received dubiously, as the same measure had not saved the AA. Unable to come to an agreement, they were forced to dissolve the SPW on the eighth anniversary of its founding.

The members who wanted to include oils refused to accept defeat. They decided to carry on under the amended title of the Society of Painters in Oil and Water-Colours. The Varleys, Barret, Cristall, Copley Fielding, Glover, Havell, Holworthy, "Warwick" Smith, and Thomas Uwins, plus several new members, John Linnell, David Cox, and George Fennel Robson among them, constituted the new group. Jane Austen, visiting their 1813 exhibition, "was very well pleased," but it was "not thought a good

collection."[19] The watercolor societies had not lived up to their early promise: exhibitions of watercolors alone were not yet strong enough to survive the reaction which followed their initial vogue. They needed the temporary support of oil paintings, an expedient that gave watercolor artists time to solidify their popularity as exhibitors. By 1821 the SPW moved to a smaller gallery in Piccadilly, and resolved that they should "henceforth be a Society of Painters in Water-Colours only, and that no Oil Paintings shall be exhibited with their works."[20] The following paragraph comes from the introduction to the SPW catalogue of 1821:

> Painting in Water Colours may justly be regarded as a new art, and, in its present application, the invention of British Artists; consideration which ought to have some influence on its public estimation and encouragement. Within a few years the materials employed in this species of painting, and the manner of using them, have been equally improved, by new chemical discoveries, and successful innovations, on the old methods of practice. The feeble tinted drawings formerly supposed to be the utmost efforts of this art, have been succeeded by pictures not inferior in power to oil-paintings, and equal in delicacy of tint, and purity and airiness of tone. Those who are acquainted with the splendid Collection of Walter Fawkes, Esq., that liberal and judicious patron of the Fine Arts, and of this art in particular, must be sensible of these modern improvements; which must also be well known to all who have compared the neat but inefficient drawings of Sandby, Hearne, and others of their day, with the works which have been introduced to public notice in the exhibitions of the Royal Academy and of this Society.

Allowing for a little exaggeration and a bit of patriotic boasting, we may assume the members of the SPW were stating the case as they saw it. Watercolor had indeed come a long way, even since the first exhibition, when they wondered "whether the novel term *Painters* in Water-Colours might not be considered by the world of taste to savour of assumption."[21]

In spite of the setback of 1813–21, watercolor artists could still make one claim

which oil painters could not. As Sir Martin Archer Shee wrote in 1805, "Britain has displayed a power, a vigour, a spirit, a richness of effect in water-coloured drawings, which rival the productions of the easel, and surpass the efforts of every other age, and nation."[22] This was the first original contribution which English artists had made to the centuries old continental tradition, and they were understandably proud of it. Watercolor had been used before, but even allowing, as they did, fresco and distemper to be forms of watercolor, their use of the medium was a departure.[23] The rapid advances in technique and the possibility of further innovation made watercolor seem more modern and forward-looking than oil. Many artists felt that painting in oil had reached its peak a century earlier and was in decline. Reynolds, Gainsborough, and Wilson were seen as the end of a tradition stretching back to the Renaissance, whose day was not over for any lack of talent, but because of the lack of great patronage. Large commissions were things of the past — the careers of Barry and Haydon were grim reminders of this. Compared to their paintings, the work of watercolor artists better suited the modest pretensions of a modern patron. Also, artists were not slow to capitalize on the Britishness of the medium. This factor certainly contributed to the sudden fashion sparked by the earliest watercolor shows. Not only had the current war with France cut off the supply of contemporary continental paintings, it had also encouraged a sense of nationalism that found an outlet in "buying British."

Politics and the tide of taste nearly undid watercolorists a few years after their initial success, but watercolor survived as an exhibition medium because it had a broad-based appeal that even oil lacked. In spite of the fact that watercolors occasionally commanded higher prices than oils — Thomas Heaphy sold his *Fishmarket* for a record-breaking 400 guineas in 1809, though ten years later Constable was asking 100 guineas for his large canvas, *The White Horse* — they were by and large less expensive, and thus more readily available to the public.[24] In 1802, Sir George Beaumont wrote to William Gilpin that watercolor "is more easily acquired and the artists can afford to work for a lower price," and "all the rising and promising young men give themselves up to it."[25] Watercolor was cheaper for the artist as

well. Materials did not cost much, and an artist could produce several finished watercolors in the time it took to complete a large oil.

Another important aspect of watercolor's success was its attraction for amateurs. Oil had little appeal for the dilettante: it was too time-consuming, cumbersome, and messy. Watercolor artists, aside from what they could sell at exhibitions or to engravers and printsellers, could command a steady source of income from teaching. It was a neat, portable, quick method, and techniques were easily systematized for the benefit of students. Artists also published teaching manuals, and these reached an even wider audience, educating them in the beauties of the medium. Amateurs thus taught how to appreciate the watercolor process came to the exhibitions already prepared to admire and buy the finished works of the professionals in the field.

In the early years of the watercolor exhibitions, Sir George Beaumont made one comment about them that had more than a grain of truth in it. "He complained much," according to Farington, "of the *manner* which prevails among the *water-colour* painters."[26] From the very first show, a coherent exhibition style began to evolve, which was to last until the re-formation of the SPW in 1821. The old tinted manner, still seen in some of the less important members' work — that of Pocock, Nattes, Gilpin, and Wells — was quickly superceded by the Society style. It was compounded of several elements found in the work of the stronger artists: Varley, Havell, Barret, Glover, and Cristall. Varley's "systematic execution" especially, his simplification of Girtin's low-toned washes, was pervasive.[27] His influence can be seen in the early work of his numerous pupils, for example, Fielding's *Landscape with Limekiln* (no. 56) or Cox's *Millbank* (no. 47).

Aside from a strong flavor of Girtinesque generalizing, the corporate style had a distinctly old master mellowness of tone. This had been a concern of painters long before watercolorists took it up, but the golden transparency of old varnish was easily imitated by the latter. Barret, "wild in his pursuit of warm colour,"[28] and Glover, "the successful translator of Claude,"[29] helped to demonstrate that "the transparent depth and lustre so much admired in the paintings of the old masters, can be produced

by these materials."[30] The same writer also pointed out that "In certain drawings of Varley and Havell, much of the richness and depth of the Venetian style is obvious."[31] Ramsay Reinagle preferred "old master tone" to the extent that he put off a sketching tour until the autumn, "the country being before that time *too green* for colouring."[32] The avoidance of green seems strange for a landscape painter, but it was a general prejudice which lasted until the middle of the century. As one writer put it,

> a green picture, however true to nature, instantly excites an universal outcry as being disagreeable . . . and if any of the modern school . . . have been for a moment tolerated [in using green], it has arisen from the previous great reputation of the artist, or for other merits in the work, and in *spite* of its being a green picture.[33]

The fact that the SPW's artists were primarily landscape painters contributed to the group style as well. By far the greatest number of works in the early shows of both watercolor societies were topographic views of the sort developed by Girtin, "representations of interesting scenery, and not . . . mere delineations of individual character, or of local and unattractive objects."[34] Other directions in landscape were being explored at the same time, though. The historic landscape was always a rarity in the exhibitions, but the pastoral form was popular and appeared in several guises. The classic pastoral, based upon the writings of Ovid, Theocritus, or Virgil, was the specialty of Cristall, whose most ambitious work in this mode was the *Arcadian Shepherds* (no. 20). Cristall was a leader in the field of modern pastorals as well, and many of his exhibition pieces depicted peasant figures of picturesque simplicity, like his *Young Woodcutter* (no. 21). Equally popular was the pastoral based upon the compositions of Claude and Poussin. The serene landscapes of Varley, Glover, and Barret were often executed on this model. Varley's *Suburbs of an Ancient City* (no. 36) was an attempt to capture the structure and balance of a Poussin in watercolor, while Barret's *Classical Landscape* (no. 16) was a large-scale interpretation of a Claudian sunset. The picturesque tradition and the pastoral met in the "compositions" of Varley, Nicholson, Barret, and Glover. An

exhibition watercolor of Glover's was described by a critic in 1817 as exactly "what a good composition ought to be — a finely selected combination of views taken from some of the fairest specimens of Nature's scenery,"[35] which sounds almost like a quotation from Gilpin.

Most of the artists in both societies worked in a variety of styles, epic, rustic, sublime, pastoral, and topographic, according to their talents and in order to please the varied taste of the public. The most ambitious ones, and Glover is a good example, chose to work mainly in the elevated realm of the epic and pastoral, knowing that the high repute in which these modes were held would enhance their own artistic reputation.

For the first twenty-five years of the SPW exhibitions, figure painting played a small but important role. The fancy pictures and biblical subjects of Shelley and Rigaud gave viewers a welcome change and punctuated a gallery full of landscapes. Shelley's earlier exhibition works were mostly portrait miniatures and drawings, but the exhibitions of the SPW inspired him to create larger, more elaborate works like *Rasselas* (no. 6), which hung in the first show. Rigaud was the only member of either watercolor society who worked entirely in the historical mode. His exhibition subjects ranged from Ossian and Milton to the Bible and scenes from Roman history, but his talents were so slight that his work was given little recognition even in his own lifetime. A much stronger figure artist was Robert Hills, whose works fell more within the Society style. His color studies and animal sketches are popular today, but in his own lifetime he was best known for his exhibition watercolors, large, carefully worked rustic scenes with deer and cattle, which were praised in the journals of his day for their finish and accuracy. Much of his labor went into the exact rendering of textures of fur, foliage, and wood, yet he could capture an atmospheric effect, such as the snow falling in his *Village Snow Scene* (no. 24), with assurance and total originality. Hills drew and colored with Linnean precision, but the exhibition pieces he created were more than just accurate records. They were pastoral images of direct and unsentimental beauty, the products of a lifetime spent in the close study of nature.

Joshua Cristall was the leader of the early figure painters, and the most varied in his

exhibition work. He sought the poise and simplicity of the antique in his figure style and achieved it with a technique of broad, clear washes combined with assured draughtsmanship. Even his modern figures have a classic monumentality, as in the ambitious *Fishmarket on the Beach at Hastings* (no. 19). If Cristall was the finest of the figure painters in the SPW's first years, Thomas Heaphy was by far the most successful with the public. Although he was criticized for painting low subjects instead of elevated ones, his anecdotal scenes, descended from the works of Jan Steen and Adriaen Van Ostade, were enormously popular and fetched record prices. Just as Sir George Beaumont admired David Wilkie's Dutch inspired genre paintings like *The Blind Fiddler* (RA 1807), a connoisseur like Thomas Hope, who owned a collection of Dutch paintings that had been praised by Reynolds, was full of praise for the "high finishing and minute detail" which Heaphy lavished on his "squinting blackguards and fighting fishwomen."[36] In general, figure painters charged more for their work than landscape painters at this time, but while Shelley asked only 10 guineas for *Rasselas* (no. 6) in 1805, Heaphy got 73 guineas for *Inattention* (no. 28) in 1808, and the following year asked £210 for *The Wounded Leg* (VAM).[37]

The re-formation of the SPW in 1821 heralded a new era in the creative and stylistic interests of watercolor artists. The corporate style lingered on in the works of some of the older members, but it was gradually replaced by something quite different in intent and execution. In the field of landscape, the restraint of the Girtin and Varley school gave way to more brightly colored scenes. After the peace of 1815, artists traveled on the Continent in search of picturesque architecture and costume, and the SPW's shows during the next twenty-five years were full of views of Venice and the cathedral towns of Germany and France. Two artists were of central importance in this change: Turner and Bonington. During the 1820s Turner was the acknowledged head of the "bianchi," or white painters, who used a light, transparent scale of coloring to capture atmospheric effects.[38] His trip to Italy in 1819 added impetus to his growing preference for pure, brilliant color, and his watercolors and oils of the next ten years, for example, his *Whiting Fishing off Margate* (no. 32) of 1822, had a profound effect upon his

contemporaries. "Sunny effects, à la Turner" were noted as a prominent feature at the SPW exhibition of 1829.[39] Turner's concentration on color suffused with light was an issue that remained central in the development of landscape painting in watercolor.

The other artist who exerted strong influence on style was Bonington, both in figure subjects and in landscape. In the latter, his deft views of French and Italian scenes were to inspire a number of imitators and followers. William Callow's *Pont Neuf* (no. 84), Thomas Boys's scene in *Prague* (no. 75), Samuel Prout's *Cathedral at Rheims* (no. 50), and J. D. Harding's *Grand Canal, Venice* (no. 71), with their bright colors and sparkling surface quality, all derive more or less from Bonington's work. Even more influential were Bonington's historical costume pieces, which had a vogue that was greatly increased by his early death in 1828. The interest shown by collectors and artists alike in these works was symptomatic of recent developments in English art as a whole.

The grand manner, old master mellowness and the predominance of landscape were waning. In their place, artists exhibited works in which the figures were more important, the colors brighter, and the emphasis upon charm and sentiment instead of melancholy or moral grandeur. The change was most visible in figure work: it was championed by Wilkie, C. R. Leslie, and William Mulready in oils, and by Bonington, the Chalons, and the Stephanoffs in watercolor. The simplicity and idealization of the antique was replaced by a fashion for the fanciful and frivolous, and the style of Watteau underwent a revival. Turner exhibited a painting in 1822, *What You Will*, described as "a whimsical attempt at a Watteau," and Thomas Stothard, with his illustrations to Boccaccio's *Decameron* (no. 10), did even more to popularize the silvery palette and the doll-like figure style of the French rococo.[40] James Stephanoff's *Lalla Rookh* (no. 60) and Bonington's *Figures in an Interior* (no. 73) both demonstrate the gemlike quality that was seen more and more in the exhibition works of watercolor artists. The change was visible at the Sketching Society as well. Epic or poetic landscape was replaced by romantic figure pieces from popular literature, for example Cristall's and A. E. Chalon's drawings of *Gil Blas* (nos. 22 and 40). James Chalon's *Music:*

Composition (no. 33) is a further example of Watteau's powerful influence.

The shift in predominance from pure landscape to the continental picturesque and figure painting was shaped in great part by the poems and novels of Sir Walter Scott. He combined in his writings an antiquarian's concern for details of costume and architecture with all the pageantry and romance of medieval chivalry. His work caught the imagination of his contemporaries, and the exhibitions of his day were full of illustrations from *Marmion, Lord of the Isles, Ivanhoe,* and *Waverley.* As early as 1811 critics complained that the SPW's gallery was "overcharged with the trash from Sir Walter Scott's last poem," while in the 1820s and 30s the Scott craze reached epidemic proportions.[41] In 1828, Cotman summed up the art of the day:

> *This* is an age for works of splendour and immagination [*sic*], but these must be *bottomed* on truth however fictitious they may be in reality and I beg to illustrate this position by referring to the works of Sir Walter Scott, and other authors of the same class. — which are in literature what the pictures of Danby, Turner, Martin & Prout are in painting, — City and Town scenery & Splendid Architecture mixed up with Elegant Landscape make up the compositions of the day — [42]

Even landscape painters were touched by Scott's all-pervasive influence. The quality of association came into play, and every bit of scenery described in his writings took on heightened artistic interest. Robson's *Loch Coruisk* (no. 62) and his *Highland Landscape* (no. 61) both reflect the poetry of Scott, whose descriptions of desolate Scottish scenes fit in with the still current idea of the Sublime.

Scott's fascination with architecture and costume helped change the emphasis in history painting from the action itself to the setting. Grand events of the past were swallowed up by the romance of the scenes in which they took place. Watercolor artists had rarely attempted the old manner of history painting, but they were in the forefront of the taste for historical romance. Before the Continent was open to English artists, watercolorists like Augustus Pugin, Frederick Nash, and Frederick Mackenzie specialized in views of ancient British

buildings, full of association with the great figures of the past. Later, views of Italy and the Gothic monuments of Europe overshadowed the native tradition, but in the 1830s a resurgence of interest in English architecture took place. The publication of antiquarian books by John Britton, Sir Samuel Meyrick, C. J. Richardson, and others provided much of the raw material in terms of architecture and costume for artists who wanted to be historically correct in their exhibition pieces. Joseph Nash's *Long Gallery at Haddon Hall* (no. 83) is an example of this kind of watercolor; Thackeray described it as being "as accurate as a catalogue, and as poetical as a court guide."[43]

More romance was to be found in the works of George Cattermole, who started as an architectural draughtsman, but under the influence of Bonington's costume pictures became the head of the "Historico-Romantic School of Water Colour Art."[44] A star exhibitor at the SPW, his style and range was described in 1850:

> A few glittering dashes of the brush, and wonderful cups and salvers, and shining suits of armour, are represented by this marvellously facile pencil. Monks, cavaliers, battles, banditti, knightly halls and awful enchanted forests in which knights and distressed damsels wander, the pomp and circumstance of feudal war, are the subjects in which Mr. Cattermole chiefly delights.[45]

Cattermole's work not only represented the current taste in subject matter: it also indicated a trend in style and technique which began to make itself felt at the end of the 1820s. It was at that time that bodycolor began to reappear in the exhibition works of SPW members, not as it had been used by Sandby and his contemporaries, but mixed into parts of a transparent watercolor to give local texture and highlights. Cattermole's *Salvator Rosa* (no. 72) and J. F. Lewis's *Highland Hospitality* (no. 79) both demonstrate that with the aid of bodycolor, watercolor artists were capable of producing works of increased density and power.

Landscapists used bodycolor occasionally, but in general their palette was light and most of their work transparent. David Cox, although his late finished watercolors were often heavily worked, as in his *On the Moors near*

Bettws-y-Coed (no. 49), still relied on the white of the paper to reflect light. The same is true of the work of Callow, Fielding, and Edward Duncan: all of them used pure and delicate colors to achieve different effects of atmosphere and light. In the SPW exhibitions, Fielding was a prolific contributor of coastal and mountain scenes like *Snowdon* (no. 57) and *Loch Fyne* (no. 59), which display a great deal of technical dexterity and breadth, but rely on manipulative tricks to achieve an effect. In contrast to Fielding's work, Edward Lear's watercolors were an anomaly. His strong insistence on line, pale washes of color, and his habit of leaving his notes visible, even in finished works like his *Abou Simbel* (no. 87), all hark back to the eighteenth-century tradition of tinted drawings. Another landscapist whose work deserves mention is William Turner of Oxford. His early exhibition watercolors were in the transparent school of his teacher Varley, but from the 1830s on, he varied his masterful flat wash technique with works like *Donati's Comet* (no. 65), in which he used bodycolor to give density to an already intense color scheme.

Inevitably, the continued popularity of the SPW's exhibitions resulted in competition again. In 1832, another group, the New Society of Painters in Water-Colours, opened its doors. Like the AA, its object was to provide exhibition space for the many competent artists who were not members of the SPW. The constantly growing number of artists who wished to exhibit led also to the opening of many provincial galleries, to which London artists often sent their unsold and smaller works. The NSPW founding members were an undistinguished group, but they were successful nonetheless, and were later joined by Thomas Boys, Duncan, James Holland, and William Leighton Leitch. In 1883 it became the Royal Institute of Painters in Water-Colours, incorporating the Dudley Gallery, another watercolor exhibition founded in 1865. A few years after its establishment, a critic wrote of the NSPW:

> It is certainly the gayest exhibition room we ever looked into, and the ultramarine, and carmine, and golden yellow tints of nature have been borrowed prodigally for its walls, but the air, and mist, and shade, with which she tempers these brave colours, have been less liberally caught.[46]

Complaints of overly bright watercolors were more common than ever before during the 1830s and 40s. Painters of the continental picturesque were warned of this tendency:

> Our artists must be at the *Rhone or the Rhine* for views, fortunate if they can outface the sun flaring in the middle of the picture, and build up the dilapidated ramparts of town and castle on each side, according to the most approved academical receipt. Vistas of towns and towers, and eternal Venice, in more than Venetian glory, of old carpets and turbaned Turks, are far more favorable objects for the *raw* materials, gambouge, cobalt, and vermillion, than such sombre scenes or quiet shades as "Savage Rosa dash'd, or learned Poussin drew!"[47]

Much of the blame for extremes in coloring has always been put on the exhibitions, which forced artists to key up their colors in order to compete and be visible. But there were other contributing factors, affecting English art as a whole, that are not pointed out as often. Thomas Uwins argued that "the small dark rooms in which pictures in England are hung call for brilliancy and whiteness," and he also referred to the changes in English painting most clearly seen in the works of Turner and Constable: "Freshness seems to be the great aim of the English painters, and those who can accomplish it without losing the higher quality of harmony, certainly do produce extraordinary things."[48] He also blamed the taste of the public, who liked pictures in which "a dash of colour is made to stand for everything, on a sort of hit or miss principle, that looks flashy or captivating."[49]

The taste of the public affected more than the coloring of exhibition watercolors. During the 1840s, even the subject matter and size of a watercolor was predetermined by what visitors to the exhibition would buy. Thackeray parodied the uninformed taste of the amateurs who shopped for "tea-table tragedies" and "bread and butter idylls" at the watercolor shows: "We want pleasant pictures, that we can live with — something that shall be lively, pleasing, or tender, or sublime, if you will, but only of a moderate-sized sublimity."[50] The flower and fruit pieces of William Hunt and the illustrations of Sir John Gilbert were what the public wanted. In 1850 Uwins summed up the change in taste and patronage:

Poetry is too slow a thing for a fast generation and [one] can only hope for a hearing in anti-corn law rhymes and railroad rhapsodies. The pleasures of imagination are at an end! [only] dealers . . . can make a man's fortune. The dealers can no longer get a market for their Raphaels, Correggios, and stuff, . . . to do any business at all, they must go to living painters, and the man they take up becomes popular. The old nobility and land proprietors are gone out. Their place is supplied by railroad speculators, iron mine men, and grinders from Sheffield etc. . . . This class of men are now as much in the hands of the dealers as the old black collectors [of old master paintings] were formerly.[51]

These new patrons wanted polished, showy works with a lot of gilt around them to ornament their homes, and artists had to please them to succeed. They turned out works of solid technical artistry and disarming prettiness but lacking in imagination and power. There were exceptions to the rule, of course: J. F. Lewis, on his return from the Mideast in 1851, exhibited a powerful series of works, culminating in the *Frank Encampment* (no. 80), a painting that was, and still is, a landmark in British art. David Cox continued to exhibit his wet and windy views of Wales, and Samuel Palmer managed to combine the early intensity of his Shoreham watercolors with a mixed technique in late exhibited works like *The Lonely Tower* (no. 82).

The range of techniques available to watercolor artists, their creative limits, were as wide as they could be. No further innovations seemed possible. Watercolor artists could equal oil paintings in tone and denseness, but it became a pointless exercise. Oil was still the more prestigious medium in the eyes of the public. It was for artists like Lewis and Cattermole as well, who like many others before them, quit the SPW to try for membership in the RA. They had stretched the limits of the medium as far as they could go, and with their defection, the exhibition watercolor went into what Ruskin termed a "steady descent." He summed up the history of watercolors:

They were founded first on a true and simple school of broad light and shade, — grey touched with golden colour on the lights. This, with clear and delicate washes for its

transparent tones, was the method of all the earlier men; and the sincere love of nature which existed in the hearts of the first water colour masters — Girtin, Cousens [*sic*], Robson, Copley Fielding, Cox, Prout, and De Wint — formed a true and progressive school, till Hunt, the greatest of all, perfected his art. Hunt and Cox alone are left of all that group, and their works in the OWC [SPW] are the only ones which are now seriously worth looking at; for in the endeavour to employ new resources, to rival oil colour, and to display facility, mere method has superceded all feeling and all wholesome aim, and has itself become finally degraded. The sponge and the handkerchief have destroyed water colour painting.[52]

The empty "picture postcards" of Leitch, T. M. Richardson, Jr., and G. A. Fripp are typical of what Ruskin deplored, and they were a sign that the form was passing its prime. A reverse in taste away from the solid but uninspired work of the 1850s and 60s was inevitable. The fact that from 1862 onward, the SPW thought it worthwhile to hang a yearly winter exhibition of members' sketches was indicative of the direction in which watercolor was heading. Transparency grew more important over the next decades, and the values of suggestiveness and mood were increasingly appreciated. By the beginning of this century, Roger Fry could write scathingly that he "had no interest in water-colour 'painting' — the attempt to reproduce in the medium of water-colour something of the solid relief and actuality which are natural to oil painting."[53]

It was a sign of the revolution of taste: for our era, preliminary drawings and sketches are often more admired than a finished watercolor. We put a higher value on the creative process than on the final result. This attitude would have been incomprehensible to the majority of nineteenth-century artists, who believed that only in the finished work could their talents and creative genius be judged fairly. The importance of their exhibition watercolors cannot be ignored. They had a marked impact on the development of landscape painting, and they formed an influential part of the artistic setting in which artists as varied as Turner, Blake, and Constable worked. The style of artists such as Cotman, De Wint, and Cox was shaped by the idea of

exhibition work, while the watercolors of Fielding and Robson were created mostly for that end. Exhibition watercolors such as Adam Buck's *Portrait* (no. 12), Robson's *St. Paul's* (no. 63), Cox's *On the Moors* (no. 49), and Turner of Oxford's *Donati's Comet* (no. 65) are all different, highly original, and memorable images which demonstrate the consistently high level of quality which the form encouraged. The exhibition watercolor must be understood technically and artistically, and appreciated as a vital document in the history of English painting.

Notes

1. Roget, I, p. 130. Quoting Robert Hills.
2. In early RA catalogues, Sandby's works are marked either "stained drawing," i.e., watercolor, or "watercolour," which meant bodycolor. The distinction was dropped after 1787, the inference being that after that date, Sandby's exhibits were almost all in bodycolor or oil.
3. J. Richardson, *The Connoisseur*, 1719, p. 45.
4. Alison, *Essay*, p. 327.
5. M. Woodall, ed., *The Letters of Thomas Gainsborough*, 1963, p. 91.
6. Rev. W. Gilpin, *Tour of the Lakes*, 3rd ed., 1808, pp. XXIV–XXVI.
7. Alison, *Essay*, pp. 15–16.
8. Ibid., p. 6.
9. *Ackermann's New Drawing Book of Light and Shadow*, 1809, n.p., opp. engraving of Conway Castle.
10. Inscription by Louis Francia on verso of VAM drawing 477–1883.
11. Compare SPW's "professional reputation" and "moral character" with the RA's "men of fair moral character" and "high reputation in their several professions." Roget, I, p. 175.
12. SPW catalogue of 1805, repr. in *OWSC*, 23, 1945, pp. 42–52.
13. This practice was copied by the BI in 1806 and by the RA in 1811.
14. VAM Library, 86.BB.41.
15. Farington *Diary*, 4, p. 134. May 8, 1807.
16. Ibid., 5, p. 71. June 1, 1808.
17. *Repository of Arts*, June 1810, p. 432.
18. *Annals of Art*, 1820, quoted by A. P. Oppé in *Early Victorian England*, edited by G. M. Young, 1934, p. 166; and *Somerset House Gazette*, II, 1824, p. 48.
19. J. Austen, *Letters, 1796–1817*, ed. R. W. Chapman, 1955, p. 139. May 24, 1813.
20. Quoted in Hardie, II, p. 118.
21. *Somerset House Gazette*, II, p. 45.
22. M. A. Shee, RA, *Rhymes on Art*, 1805, pp. 43–44n.
23. Craig, *Lectures*, pp. 424–25.
24. VAM Price Book, 1809, and Leslie, *Constable*, p. 74.
25. Bodleian Library, Oxford, Ms. Eng. misc., c. 389, folio 40–1.
26. Farington *Diary*, 3, p. 205. Apr. 26, 1806.
27. *Repository of Arts*, June 1809, p. 402.
28. Ibid.
29. *Repository of Arts*, June 1810, p. 431.
30. *Repository of Arts*, May 1815, p. 293.
31. Ibid.
32. Farington *Diary*, 7, p. 7. June 23, 1811.
33. Howard, *Colour*, p. 65.
34. *Repository of Arts*, May 1817, p. 351.
35. *Repository of Arts*, May 1817, p. 352.
36. *Repository of Arts*, June 1809, p. 492.
37. SPW Price Books, 1805, 1808, and 1809.
38. Howard, *Colour*, p. 90.
39. *Athenaeum*, May 6, 1829, p. 283.
40. *Repository of Arts*, June 1822, p. 353.
41. *Repository of Arts*, June 1811, p. 344.
42. Cotman to Dawson Turner, Nov. 25, 1828. I am indebted to Michael Pidgeley of the University of Essex for this quotation.
43. W. M. Thackeray, *Contributions to the Morning Chronicle*, ed. G. Ray, Urbana, 1955, p. 136.
44. *Art Journal*, 1870, p. 92.
45. W. M. Thackeray, short notices in L. Marvy, *Sketches after the English Landscape Painters*, 1850, n.p.
46. *Athenaeum*, Apr. 18, 1835, p. 303.
47. *Blackwood's Magazine*, Oct. 1836, p. 555.
48. Uwins, *Memoir*, II, p. 256.
49. Ibid., p. 264.
50. W. M. Thackeray, *Critical Papers in Art*, 1904, pp. 196, 176.
51. Uwins, *Memoir*, I, p. 125.
52. J. Ruskin, *Academy Notes 1859*, in *Works*, XIV, p. 45.
53. R. Fry, "A Note on Water-Colour Technique," *Burlington Magazine*, 7, 1907, pp. 161–62.

Technique

EXHIBITIONS had a profound impact upon watercolor technique. Watercolor might never have evolved beyond the tinted drawings of the eighteenth century had they not been set beside oils at the RA and the Free Society. They looked very good when taken out of a collector's portfolio and held in the hand for inspection, but when seen on a gallery wall with larger, stronger oils, watercolors became negligible. It was because of the exhibitions that watercolor artists strengthened their technique. They wanted to compete for public attention and praise, and in order to do so, they had to invent methods in watercolor that approximated the power and richness of oils. Of course, watercolorists could have given up the medium and exhibited only in bodycolor and oils. Many felt that this was the only route to success and academic honors, but even more artists were unwilling to surrender watercolor's great advantage, its transparency.

At the exhbitions, artists were given the opportunity to compare and measure the different strengths of watercolor and oil. Each had desirable qualities that the other did not possess. As John Varley put it,

> Painting in oil and watercolour have each their peculiar advantages, in those qualities that are difficult to each other; and while locality and texture is one of the great excellencies of oil painting, — clear skies, distances, and water, in which there is a flatness and absence of texture, are the beauties most sought after in the art of water colours.[1]

Watercolor was best employed where transparency and a reflected brilliance from the white ground of the paper was desired. The paper surface was never entirely smooth: tiny bumps and hollows reflected different amounts of light even when layers of wash were passed over them. It was this alternation of light and shadow that gave watercolor its luminous quality. It was considered especially good for the distances in landscape — watercolor gave a subtlety to aerial tints that oil could not. This was one of the reasons that watercolor was vital to the development of landscape painting. The growing interest in rendering atmosphere and the changing qualities of light was more readily explored in watercolor than in oil, which was opaque.

The advantage of oil lay in the depth and force of tone which it was capable of giving. An oil painter's process was more versatile than a watercolorist's: the latter was limited by the medium's transparency to working from the lightest tones to the darkest. Because oil was opaque, there was no such constraint upon painters, who could put light colors over dark, or deep tones over pale. Another of the benefits of oil was its thickness, which allowed an artist to exploit the expressive qualities of brushwork to achieve texture and surface incident. In Reynolds's opinion, a highly finished painting in which all the brushwork was invisible was "narrow, vulgar, and untaught or rather ill-taught," while a looser style in which the handling of the brush showed was more striking.[2] In this area, watercolor artists were hard put to invent parallels.

Because of the increased awareness of the strengths of each technique, it became the goal of a number of artists to combine the best of both. Nicholson summed up this attitude when he wrote:

> The methods and expedients employed in painting are so numerous, that the possibility of discovering any one system, in which every advantage may be gained, and every inconvenience and defect avoided, may be doubted: every method possessing its peculiar advantages, it becomes a subject of considerable interest to discover whether, and how far, the perfection of each may be united. The imitation of nature being the object of the artist, that ought to be preferred by which it can best be attained.[3]

As early as 1772, Gainsborough tried to combine the two in a couple of his exhibits at the RA. These were varnished drawings done in a mix of watercolor, chalks, and oil and described in the catalogue as "Two landscapes, drawings, in imitation of oil painting." Sandby's *Shrewsbury Bridge* (no. 1) is another early example of a mixed technique: he used oil over bodycolor to give density to his figures and architecture. Another artist suggested the following method:

> Having drawn your subject correctly on a white paper, properly stretched, you will execute the sky and distances in transparent

water-colours, finishing, as highly as possible, and then varnish the whole with isinglass varnish. Upon this you will paint the middle parts and the foregrounds with oil colours, observing to paint the extreme lights, in such parts, of a very high tone, perhaps a little above the truth, as compared to the sky and distance, because oil colours will become darker, while those parts of the picture which have been executed in water, will remain the same. In this practice you will unite the acknowledged advantages of both kinds of painting.[4]

Such hybrid work was not the only road open to watercolor artists who wanted to strengthen their medium, however. Others concentrated on deepening tone and color without loss of transparency. In order to achieve this, they took over a technique from oil practice, glazing, where successive layers of transparent color were applied over a dry underpainting to modulate bright tones and give a soft atmospheric quality. This was to become one of the central methods of watercolor painting.

It was first used in the watercolors of English artists working in Italy around 1780. In order to capture the intense light and color of the Mediterranean landscape, they dropped the monochrome underdrawing and applied pure washes directly to the paper, using darker tints of the same color to shade and intensify tone. Although Francis Towne, William Pars, and J. R. Cozens were perhaps the first to do so, it was John "Warwick" Smith who was named unanimously by his contemporaries for coloring "with a degree of force that had never been attempted before."[5] Under the influence of his fellow artists, Smith's Italian work was stronger in color and tone than the majority of his contemporaries' watercolors at home, but back in England, he soon reverted to the old stained drawing method, seen in his *Coliseum* (no. 5). Smith was given credit for the advance from tinting to direct coloring simply because he was the only one of the group to exhibit his drawings in London after his return in 1781.[6]

Although Smith received public acclaim, discerning connoisseurs and artists saw a more profound advance in technique in the watercolors of J. R. Cozens. Cozens's method consisted in broad washes for distances and a painstaking elaboration of small brushstrokes of direct color for details, evident in the foreground of the *Lake Albano and Castel Gandolfo* (no. 7). Cozens's innovation was modeling with color rather than with line. It allowed him to reproduce the atmosphere and forms in a landscape in an entirely original way. This advance in technique from a linear style to a tonal one eventually led, by way of the Monro school, to painting in watercolor as opposed to mere drawing.

At Dr. Monro's house, the two key figures of nineteenth-century watercolor, Girtin and Turner, copied Cozens's drawings. A writer for the *Library of Fine Arts* remarked,

> It is no mean compliment to the talent of Cozens to know that Turner and Girtin have admitted that the contemplation, and the copying of ... his best works, opened to their minds, that intelligence of effect in representing distant scenery which they subsequently excelled in to so much greater a degree than their ingenious prototype.[7]

Both artists received a thorough grounding in the topographic tradition, and both were influenced as well by the works of Canaletto and Piranesi. Together with Cozens's tonal approach to landscape, these helped to form their artistic methods. Just as important as all of these was their ambition to succeed in the exhibitions at the Academy. Girtin's sketching club, with its pretensions to poetry and high art, his effort at twenty-six to produce a one-man show, the Eidometropolis, Turner's meteoric rise to full academic honors by 1802: this need to make a public name, just as much as their training, gave them the impetus to strengthen their technique, to outdo their predecessors and to compete with the painters of the day.

Girtin, wrote a contemporary,

> prepared his drawings on the same principle which had hitherto been confined to oil, namely, laying the object upon his paper, with the local colour, and shadowing the same with the individual tint of its own shadow. Previous to the practice of Turner and Girtin, drawings were first shadowed entirely through ... with black or grey, and these objects were afterwards stained, or tinted. ... It was this new practice, introduced by these distinguished artists, that acquired for designs in water-colours upon paper, the title of paintings.[8]

Girtin's style was notable for the independent use of line and penwork. Like Cozens, he manipulated color to model his forms, but he used his pen to give texture or accents. His color, as critics noted, was "autumnal," leaning strongly to warm reds, grays, browns, and deep blues for his skies.[9] The choice of palette was as deliberate as Cozens's had been: these colors were not only found in nature, but they also approximated the mellow tones of old master painting. This dark color choice was also characteristic of Turner's watercolors during the first decade of the nineteenth century. Both he and Girtin chose "sad and fuscous colours, as black or brown, or deep purple," which gave their works a feeling of the Sublime.[10] A watercolor like the *Ouse Bridge* (no. 26) demonstrated the medium's new capacity for deep tonality, force of coloring, and texture.

One of the elements that contributed to the expressiveness of Girtin's drawings was the paper he used. With the advances in technique, the stopping out, the sponging, scraping, rubbing, wiping, and cutting that were to become common in watercolor over the next few years, the paper had to be stronger, more varied in surface, and larger. In 1808, Ackermann advertised eight types of paper.[11] These included vellum and hot pressed, which were both smooth, and wove and cartridge, rough surfaced papers whose irregularities and occasional flecks gave subtle texture and variety to a design. This last sort of paper was what Girtin preferred, and it was later adopted by David Cox. Turner used colored papers to great effect in drawings and studies, as they gave an immediate depth and power to his rapid sketches, but he generally chose a smooth white wove for finished watercolors. John Sell Cotman's choice of fairly thin sheets of wove or laid paper in the earlier years of his career gave way to the use of thicker, more textured papers as his style grew more heavy. John Varley wrote, "With regard to the painter in water-colour, a very great portion of his time is employed in overcoming the peculiarities and defects of his paper."[12] In the case of exhibition watercolors, the support was of particular importance. For a large work, paper was laid down on canvas or a wood panel to give it strength, as was the case with Sandby's *Shrewsbury Bridge* (no. 1) and Harding's *Grand Canal* (no. 71). Samuel Palmer preferred stiff Bristol-board, which had a glossy surface "intermediate between paper and ivory."[13] The largest paper manufactured was a sheet well over five feet by four, but artists could also glue two or more pieces of paper together to create a larger surface, as Cristall did for his *Young Woodcutter* (no. 21).[14]

Girtin's practices were relatively simple and direct, and soon after his death they were systematized and taught by John Varley and his pupils. Girtin's innovations became the basis for an entire school of watercolor in which depth was achieved through the repetition of color washes. Edward Dayes described the value of glazing in watercolor:

> If a richness of colour is wanted, it will be necessary to repeat it two or three times. . . . This will give a depth and richness, that can never be obtained by a single colour. . . . Thus a green of blue and yellow would be raw, but burnt Terra di Sienna, or lake, glazed over it, will beautify it.[15]

William Havell's *Carew Castle* (no. 44) and John Varley's *Harlech Castle and Tegwyn Ferry* (no. 34) both demonstrate the richness of tone possible with glazing, and both also demonstrate the powerful influence of Girtin's style.

Another artist who worked in the Girtin method was De Wint. His *Landscape with Harvesters* (no. 53) shows his indebtedness to his teacher Varley in its rich blocks of color, and to Cotman in the use of reserved highlights for the distant figures. Typical of De Wint's finished watercolors is the scraped foreground detail. Like Girtin, De Wint thought and worked in terms of tone and mass, gradually building his washes to the desired strength. He then picked out highlights and put in bright accents of color, methods which came from the other great innovator in watercolor, Turner. Two later sketches of 1828 show how De Wint began an exhibition watercolor (nos. 54 and 55). The subject was Elijah, and it is notable that for such an ambitious piece of history painting, De Wint began by drawing in a manner reminiscent of the seventeenth-century Italian masters, using coarse line and hatching rather than tone to try out different compositional arrangements.

The widespread influence of Varley's teaching can also be seen in two pages from a notebook belonging to Thomas Sully, the American painter (nos. 51 and 52). On them,

Sully has given color samples from Varley's palette and annotated them with Varley's advice as to how each color was to be used. Because these pages were never exposed to prolonged sunlight, they also illustrate an unfaded early nineteenth-century palette. At that time, many artists who worked in watercolor argued in its favor because they believed it was a more permanent medium than oil.

Nicholson noted that most oils darkened with age, and that "such parts of a picture as were originally dark thus become still more so, until at last they acquire the degree of blackness and obscurity observed in many old pictures."[16] To some connoisseurs, "the changing of oil colours in a certain degree is considered advantageous, so far as they become what is called 'mellowed by time.' "[17] Sir George Beaumont, with his fondness for paintings "the colour of an old Cremona fiddle," was a case in point.[18] His desire to tone all landscapes to resemble old master paintings was not unique: it was the aim of many watercolor artists as well. Glover and Barret, to name only two, deliberately chose a range of colors which made their works resemble not only "a Claude, but the golden varnish that covers a Claude."[19]

But if the darkening of an oil was indisputable, so too was the fading of a watercolor when exposed to light. Some watercolorists argued that since their vehicle was water, which was not liable to darken or change, as oil was, watercolor must be the more permanent medium.[20] But others admitted that light had a deleterious effect. Even the first propagandist for watercolor, W. H. Pyne, deplored the fact that

> this really enchanting process is, in its own nature, too evanescent to endure exposure either to a bright light, or the least humidity of atmosphere, which is a fatal circumstance to the professors of water-colour painting, as it must of course militate against the forming of galleries of such works, however transcendent their merit.[21]

Impermanent colors—gamboge, indigo, carmine, yellow-lake and brown-pink (a misnamed yellow)—were singled out by Pyne, but they continued to be used, because without them, "in spite of all that is said to the contrary, those brilliant and richly harmonious combinations cannot be produced."[22] Artists who were unwilling "to forego the temptation of present applause, for a more lasting, though less brilliant fame, by confining themselves to pigments less liable to change,"[23] tried other experiments to make their works more permanent. Barret was of the opinion that if *enough* pigment was applied, watercolor would not fade.[24] Many artists believed that varnish would protect their work from light and moisture, besides adding the depth and sparkle of an oil painting. Carpenter's glue, isinglass, gum arabic, copal, and white wax were some of the coatings put over watercolors, but however brilliant the initial effect, the long-term result was dismally ineffective.

Despite the claims of the color-makers, the art dealers, and even the artists themselves, all of whom had a stake in the defense of watercolor, it had to be admitted that watercolor was a more fragile medium than oil. The final proof of this came in 1888, when the Department of Arts and Science published a "Report . . . of the Action of Light on Water-Colours." Until then, the topic was debatable. It was even argued by Ruskin, who had admitted that his Turner watercolors of the 1830s were badly faded by 1878, that they were "even in their partial ruin marvellous," and that their colors had "changed so harmoniously that I find in their faintness more to discover through mystery than to surrender as lost."[25]

Although Turner lived to see his technical innovations become common practice, it was a generation at least before anyone produced watercolors as rich or complex as those he exhibited in the first few years of the nineteenth century. The extraordinary range of his technical power is demonstrated in two works, the *Glacier and Source of the Arveiron* (no. 30) and the *Lake of Geneva* (no. 31). In both, he began by preparing the main areas of each composition with pale color washes. Glover's unfinished *Thames at Isleworth* (no. 17) was left at this preliminary stage: the general tones have been blocked out with delicate touches of pink, blue, and ochre. Turner went on to elaborate his sky and distances with deeper washes, which were later sponged off or wiped away in part to reveal white paper for clouds or snow, or underlayers of previous wash for sunny mountainsides. Hatching with a dry brush gave texture and definition to the mountains and trees in the background. The depth of color in the water of

the *Lake Geneva,* achieved through superimposed washes, sponging, and the soft merging of tints of gray, blue, and green, contrasted with the scraping and cutting of the paper in order to achieve highlighting and rippling effects. The foregrounds show Turner's mastery of detail: crisp linear touches defined trees and rocks, scraping gave highlights, and deep tones of local color created shadows. Here especially these watercolors have all the density of oil. Turner was known to add body to his watercolors by mixing white pigment into the water with which he worked, and also to mix gum arabic with his pigments to give them a viscous flow.[26]

Despite the fact that these two works have a strength comparable to his oils of the same period, they are executed by means which are totally suited to the medium of watercolor. This was a significant achievement. Turner could have given up watercolor in favor of the stronger medium, oil, but he did not. Instead, he chose to expand watercolor technique until he was capable of producing works which were the equals of his paintings. He proved that the medium was as versatile as oil and could be used convincingly to deal with the elevated themes and subject matter which were traditionally the province of oil painters alone.

During this period, other artists were experimenting with and expanding watercolor methods as well. Richard Westall was singled out by James Northcote, who insisted that "Westall is as much intitled to share in the honour of being one of the founders of the school of water-colours, as his highly gifted contemporaries, Girtin and Turner."[27] Westall's work, however, hardly lives up to Northcote's praise. Even in his finished exhibition pieces like *The Rosebud* (no. 14), he demonstrates little more than a pleasant mix of stipple in the faces and tinted manner elsewhere, combined with a keyed up color scheme. In later works he used gum arabic to darken his shadows, also appropriating the shine of a varnished oil for watercolor. The use of gum or varnish was disqualified in 1809 by the SPW, but artists continued the practice in spite of the injunction.[28] Northcote's praise cannot be taken at face value: he classed Westall with Girtin and Turner in order to gain some of the credit they had won in landscape for a member of his own field, figure painting. In fixing on

Westall, he chose a fellow RA and an artist whose works, if not technically advanced, were very popular at the time.

The stipple method, originating in miniature technique, continued to be popular with figure painters in watercolor. Thomas Heaphy and Adam Buck both used it to gain precision in the details of their finished works. Heaphy's rendering of fur and feathers in the various still lifes of *Inattention*(no. 28), his careful elaboration of each texture, looks forward to Lewis's even more minutely accurate display of game in the *Frank Encampment* (no. 80). James Stephanoff's technique, which was considered novel when seen in the exhibitions of the SPW during the 1820s was in fact directly descended from the tradition of Westall and Buck. Stipple was put to a new use in the work of Robert Hills, who employed a loose system of flecks and dots for landscape. The touch by touch elaboration was well suited to his exact renderings of cows, sheep, and deer, as seen in his *Landscape with Cattle* (no.23). In studies and sketches, Hills showed his mastery of wash and pencil work in the Varley tradition, but he developed the enlarged stipple procedure for finished exhibition pieces — it gave his work a textural density that approximated that of oil.

Turner was an innovator in this method as well. His technique was described by a fellow artist:

> [Turner] stretched the paper on boards and, after plunging them into water, he dropped the colour onto the paper whilst it was wet, making *marblings* and gradations throughout the work. His completing process was marvellously rapid, for he indicated his masses and incidents, took out half lights, scraped out highlights, and dragged, hatched, and stippled until the design was finished.[29]

All this can be seen in his *Whiting Fishing off Margate* (no. 32), where pale preliminary tones have been gone over with minute touches of yellow, pink, and blue, which catch the shimmering quality of the sunlit atmosphere better than any repeated washes. Early in his career, W. H. Hunt applied a similar technique of transparent touches to his genre pieces and still lifes.

In figure painting in watercolor, William Blake could lay better claim to technical

innovation than most. Growing out of his experiments with color printing in the 1790s, Blake's essays in tempera were also spurred by his failure to master oil painting, that "fetter to genius, and a dungeon to art."[30] A friend described his unorthodox technique:

> His ground was a mixture of whiting [chalk] and carpenter's glue, which he passed over several times in thin coatings: his colours he ground himself, and also united them with the same kind of glue, but in a much weaker state. He would, in the course of painting a picture, pass a very thin transparent wash of glue over the whole of the parts he had worked upon, and then proceed with his finishing.[31]

Christ Healing the Blind Man, one of a series of temperas executed around 1799–1800, demonstrates Blake's method and its drawbacks: it is cracked and the glue has yellowed somewhat, but it has all the density and power of a cabinet work in oil. In some parts, Blake may have mixed flake white or whiting with his pigments. This is perhaps what gives the solid impasto to Christ's halo, while the use of glue mixed with his pigments gives a thick, oily quality to the brushwork in the blue hills in the background.

Since watercolor had become stronger in tone and deeper in color, the white of the paper no longer reflected light as well. Methods of bringing back the white, or reserving it from successive washes of color had to be invented. One of the first to interest himself in this was Nicholson, who was awarded twenty guineas in 1799 by the Society of Arts for his "Process for producing the lights in stained Drawings."[32] His method was to melt wax, turpentine, and flake white together, and then to apply the mixture to the areas where highlights were to appear. After that, the whole design could be washed over and finished, and then the stop-out was removed with turpentine and spirits of wine.[33] As a first attempt, it gained Nicholson a degree of fame that made him a valuable asset in the early days of the SPW. John Sell Cotman, influenced by Girtin's technique as well as by Turner's dramatic use of light and shadow, developed a carefully planned procedure using superimposed washes in which the lights were reserved from the outset. So highly controlled were Cotman's constructions of color and tone

that no stop-out or sponge was necessary. However, few of his contemporaries copied his procedures.

Within a few years, the simpler methods developed by Turner were in general use: wiping wet color away with a sponge, blotting paper, a piece of cloth, the wooden tip of a brush, or simply cutting or scraping away the color with a knife or fingernail to reveal the white paper underneath. The exposed part could be left as it was or glazed with a light color to harmonize. A virtuoso depiction of falling snow by Hills is an example of the former technique (no. 24). The artist cut out each flake with the point of a knife, subtly combining these touches with the large areas of paper which he left white to represent the snow-covered roofs or ground. Scraping and glazing was the specialty of Cristall, Havell, Barret, and F. O. Finch, all of whom employed it for flowers and leaves. The foreground of Finch's *Religious Ceremony in Ancient Greece* (no. 74) illustrates this technique. Barret and Finch were also known to use wax as a stopping-out agent: it could be scraped off easily, and its use probably contributed to their markedly similar treatment of the lights in foliage.

Similar methods were soon published by other artists. In *Hints to Young Practitioners* (1805), J. W. Allston's formula for stop-out was raw egg yolk, applied before any washes and taken off at the end by rubbing with bread crumbs. If one wanted to take out the lights in a drawing already well advanced, he advised marking the areas to be lit — for smoke or waterspray — with a brush dipped in pure water, letting it sit for a moment, and then rubbing it off with a handkerchief. Fielding's *Landscape with Limekiln* (no. 56) is an example of this technique. Later artists added sugar to the water: it hastened the lifting action and made the removal of color easier. Allston was an early advocate of the sponge: "The office of the sponge is not limited to the aerial depth alone; from its general utility it may justly claim the appellation of cure for all defects in a water-colour drawing."[34] The sponge was not simply a corrective — it became one of the artist's chief tools in giving depth and texture to his work. It was particularly good for distant landscape and skies, as can be seen in the dense, velvety tones in G. F. Robson's *Loch Coruisk* (no. 62), which were achieved through this successive wash and sponge method. It was a stock device of Copley Fielding's later exhibition

style, demonstrated convincingly in his cool and misty rendering of mountain atmosphere in the *View of Snowdon* (no. 57). Sponging reached a peak in the work of Alfred William Hunt. By heavily sponging and repeatedly scrubbing the paper, Hunt achieved in *The Blue Light* (no. 91) a complete subordination of detail to the overriding atmospheric effect.

Since the last quarter of the eighteenth century, rough surfaces and broken tints had been desirable qualities in landscape. Watercolor artists achieved his sort of texture by using a relatively dry brush loaded with pigment and dragging it across the surface of the paper; the color adhered only to the points, not the hollows of the sheet. Besides giving the work a sparkle of alternate light and dark, dry brushwork also gave a degree of surface grain and texture. It was analogous to impasto work in oil, where a painter applied thick brushstrokes to attain a varied surface quality. Bonington manipulated a dry brush in his *Figures in an Interior* (no. 73) to give mass and sparkle to the costumes. Too often, Copley Fielding used a dry brush as an easy expedient to give texture to his foregrounds. Ruskin pointed out the weakness in his repeated use of this method: "broad sweeps of the brush, sparkling, careless, and as accidental as nature herself, always truthful as far as they went, implying knowledge, though not expressing it, suggesting everything, while they represented nothing."[35]

At the re-formation of the SPW in 1820, and the consequent affirmation by that institution of watercolor's ability to stand alone, there arose an increased desire to strengthen the medium to the power of oil. In spite of all the declarations against the use of bodycolor, it again began to be seen in the exhibition watercolors of several artists. One of the first to combine it with watercolor was John Varley, who in 1824 exhibited some small watercolors heightened with white and varnished with copal. A critic wrote of these that "the style is so effective, that they approximate the richness and depth of oil."[36] Not everyone approved of the mix, however. In 1827, William Havell exhibited watercolors which, according to a fellow artist, were "not popular with the members, owing to the free use of bodycolour."[37]

At about the same time, Bonington was employing bodycolor and gum to give added strength to his watercolors. Hardie called such works "hybrid and meretricious," and attributed the departure from his earlier transparent method to his growing involvement with oil painting.[38] A more straightforward explanation was that Bonington, when visiting London, saw the richly keyed up works of Varley, Robson, and Stephanoff and was inspired to emulate and borrow from their methods. James Stephanoff's *Lalla Rookh* (no. 60), with its elaborate mix of bodycolor and watercolor, is an example of the highly polished exhibition piece that Bonington would have seen. In turn, Bonington's looser and more painterly technique influenced the work of many others, especially after his early death in 1828. J. D. Harding's *French Fisherboy* (no. 70) is indebted not only to Bonington's bravura methods but also to his color range and general figure style. Harding's use of bodycolor in his large exhibition works, the *Grand Canal* for example (no. 72), helped to popularize the use of bodycolor, and he was credited by a critic in the *Art Union* as "the first to appreciate and use the opaque white; he did it in the teeth of opposition from many quarters, and doubts from all."[39] During the 1830s, both Ackermann's and Winsor & Newton introduced new white pigments, Permanent White in 1831 and Chinese White in 1834.

Blake's disciple Samuel Palmer also experimented with bodycolor and watercolor mixed. The intensity of his Shoreham pictures was largely due to the unprecedented piling up of heavy blobs of bodycolor, and the coarse but expressive brushstrokes of rich, transparent color. When two of these works were exhibited at the RA, critical reaction was so hostile that Palmer, at least for exhibition purposes, had to modify and refine his technique.[40] By the mid 1830s he had developed a meticulous method that satisfied the public's love of high finishing, and at the same time, allowed him to study nature in minute detail. *Pistil Mawddach* (no. 81) illustrates his working process: beginning with a pencil sketch, he then started to lay in washes, adding darker tones and occasionally mixing a bit of white into his water, like Turner, to get solidity. His preliminary strokes of color, ranging from wet to textured dry strokes, are still unobscured by finishing at the lower left. Heavier touches of bodycolor are used for the highlights, for example in the waterfall or the sun-tipped leaves.

Influenced by Turner's stipple and hatch

technique of the 1820s, Palmer's later exhibition style was notable for the elaboration of small, separate brushstrokes of color. In a letter to his patron, Palmer reported on his progress with a series of drawings illustrating Milton's *L'Allegro* and *Il Penseroso,* and described how he had "improved one of them essentially with just a few touches of delicate grey."[41] One of this group, *The Lonely Tower* (no. 82), shows how highly wrought Palmer's exhibition works had become by 1868. His heavy handling of the medium here is not simply a sign of Palmer's declining power: on the contrary, it is a return to the technical eloquence of his Shoreham days. Palmer used what his son described as an "egg-mixture" (recalling Blake's experiments) as a binder for his pigments to achieve the rich oily texture in his foreground, while his sky shows a full range of more orthodox watercolor techniques.[42] There, like Hunt and Lewis, he began with "a very thin wash of zinc white" upon which he rubbed transparent color, laid in thick stripes around the moon, and, finally, scraped away to reveal the white paper for stars, which he then touched with brilliant dots of red to make them sparkle.[43]

Cotman, elected an associate of the SPW in 1825, was also inspired by the current exhibitions to strengthen his watercolors. He experimented with such additions to his pigments as flour, Chinese White, and egg white. Because the combinations dried more slowly than pure watercolor, it was possible to manipulate the wet color with a hog's hair brush like oils on canvas. These works did have a richness of color somewhere between watercolor and oil. Cotman had discovered the happy medium between the two and combined in his exhibition pictures the transparency of watercolor with the solidity of oil. But his rich juxtapositions of color, as in the *Bridge in a Continental Town* (no. 41), met with immediate critical abuse. The *Examiner* wrote of his "sudden oppositions of reds, blues, and yellows" and warned other artists "to guard against an intemperance of bright colour, and to look at the *nature-taught* practice of Messers. [sic] Barret and De Wint."[44] In 1831 another critic of Cotman's exhibition work compared his coloring to musicians who tuned their instruments above concert pitch:

So it is with graphic art; every year screws colouring up to a higher scale according to Exhibition pitch, until the very shadow of a cloud is rendered more intensely blue than Byron's classic sea, . . . Yet as the ear of Fashion accommodates itself to notes sharper and sharper still, so does the prejudiced eye see harmony in this graphic hyperbole — for all is compatible with the Exhibition key.[45]

By the 1830s younger artists were following the lead set by Cotman and Turner in coloring. Cotman wrote excitedly to his friend Dawson Turner in 1834 of having seen J. F. Lewis's drawings from his Spanish tour: "words cannot convey to you their splendour, *My* poor *Red Blues* & Yellows for which I have been so much abused and broken hearted about, are faded fades, to what I there saw, Yes and aye, *Faded Jades* & trash. . . ."[46] After all the criticism he had received on this score, it must have been a welcome surprise to find others attempting to rival him. By the end of his life, Cotman's dense colors and bold designs no longer stood out on the walls of the SPW. In this respect, his contemporaries had caught up with him.

Technical exploration in the combination of watercolor and bodycolor was also furthered by William Henry Hunt. Hunt was trained in the Varley studio, and his early works show a mastery of clear washes and pen accents after the manner of Canaletto. In the later 1820s, though, his work was undergoing a major transition. Instead of flat washes, he began to use small strokes of color, and in the 1830s he added bodycolor in parts. *The Outhouse* (no. 66) demonstrates this change: over preliminary flat washes, Hunt applied loose strokes of color and gave texture and solidity with scratchy touches of dark pigment applied with a dry brush. In 1827 he began to exhibit fruit and flower pieces that had the warm tone and simple approach of De Wint's still lifes, combined with an increasingly elaborate technique of wash, dry brushwork, and stipple. The absorbent surface of watercolor paper allowed only a certain degree of tightness in his stippling, however. Miniature work, because it was done on ivory or card, allowed close touches of color to remain discrete: this was a quality that Hunt sought for his watercolors. He developed a means of overcoming the absorbency of the paper, and at the same time of retaining a white ground. He would "pencil out a group of flowers or grapes, and thickly coat each one with Chinese-white, which he would leave to harden.

On this brilliant china-like ground he would put his colours, not in washes, but solid and sure, so as not to disturb the ground which he had prepared."[47] Hardie points out that he probably mixed gum into the white ground, giving it an enamellike quality that could bear repeated touches and glazing better than simple Chinese White.[48]

Hunt's original method was to inspire a number of imitators and followers. Two of the artists who were influenced by his procedures were Birket Foster and J. F. Lewis, both of whom produced exhibition watercolors that were the centers of attraction at the SPW shows. Foster applied Hunt's stipple technique to figures and landscape as well as still life. An unusually large example of his work, *The Hayrick* (no. 90), demonstrates that this precise method was appropriate for monumental work as well as for small subjects.

Like Hunt, Lewis began his career working in a loose wash style which quickly grew more dense, richly colored, and elaborate as he began to exhibit at the SPW. His early technique is illustrated in the *Scene in a Vineyard* (no. 78), where although bodycolor and gum both are used in details, the overall effect is light and transparent. Preliminary washes were overlaid with wet touches of darker colors, as in the dappled vine leaves, but also with a dry brush used like a pen to draw details such as the weave of the baskets or the peacock feather in the woman's hat. This early delicacy gave way to the strength of bodycolor soon after. In *Highland Hospitality* (no. 79), painted only four years later, Lewis demonstrated the density and power of his developing technique. The work is reminiscent of Wilkie's paintings in terms of tone and subject matter, but the sponging, scraping, and wholesale use of gum are methods learned from the watercolors of Bonington, Cotman, and other watercolorists who expanded their technical range in order to create impressive exhibition pieces. Lewis's propensity to use watercolor like oil is particularly noticeable in the impasto of gray, pink, and white bodycolor, which gives texture to the wall of the cottage, and in the boldly applied white highlights in the faces of the two visitors.

In 1856, Lewis exhibited his masterwork, the *Frank Encampment* (no. 80), which Ruskin ranked "among the most wonderful pictures in the world."[49] The *Frank Encampment* was a tour de force of Lewis's mature technique. Using varied means, he combined great accuracy of detail with a broad rendering of intense light, space, and distance. The amount of labor it represents is staggering: the sky, as Ruskin pointed out, was put in with touches "no larger than the filament of a feather."[50] The mountains and the foreground are also made up of tiny strokes of pink, orange, and tan, modified by deeper shadows of purple and gray. Dense bodycolor gives solidity to the tent top, the tablecloth, and the costumes of the main figures, while thinner washes of white are scumbled over bright colors, as in the red pillow. Touches of color applied with the tip of a fine brush create highlights, contours, and details. A French critic of Lewis's work wrote that it would be difficult to push the watercolor fetish much further.[51] Certainly it is difficult to imagine that watercolor could ever look more like oil that it does here.

Since the beginning of the century, the range of watercolor technique had grown from simple line and wash drawings to methods as complex as Hunt's or Lewis's, equalling oil in density and power. Watercolor artists had a varied spectrum of choices: they could draw or paint, suggest or render exact detail with equal assurance. But watercolors that *did* rival oil in force and finish brought up the inevitable question which Ruskin posed to Lewis after seeing the *Frank Encampment*. He wrote, "Your picture is one of the wonders of the world . . . are you sure of your material — If one of those bits of white hairstroke fade — where are you? — *Why* don't you paint in oil only, now?"[52] Ten years before this, Thackeray had commented upon this dilemma in watercolor.

It is a pity that artists, if bent on painting with opaque colors, should not use them with varnish and oil in place of water. A few weeks in a damp room would be fatal to all these noble drawings, the colours of which are only held on the paper by a feeble binding of gum. . . . A number of watercolorists are now dipping into this dangerous white-pot, and the peculiar charm of their branch of art is ruined by the use of it. It is as if a guitar player persisted in performing an oratorio: they are always taxing their powers beyond their strength, and endeavoring to carry their art further than it will go.[53]

If it was the ambition to "perform an oratorio" that made watercolorists paint solidly, then it was an ambition that led many artists to give up watercolor and to paint in oil instead. Upon his resignation from the SPW, Lewis himself wrote of the futility of doing in watercolor what was done more simply in oil:

I work from before 9 in the morning till dusk, from half past 6 to 11 at night always, . . . and yet I swear that I am £250 a year poorer for the last seven years. . . . I felt that work was destroying me. And for what? To get by water-colour art £500 a year, when I know that as an oil painter I could with less labour get my thousand.[54]

Notes

1. Varley, *Treatise*, opp. pl. 1.
2. Reynolds, *Discourses*, p. 237.
3. Nicholson, *Landscape from Nature*, pp. 105–06.
4. Craig, *Lectures*, pp. 276–77.
5. Barret, *Water-Colour*, partially reprinted in *OWSC* 26, 1948, p. 41.
6. Pars died in Rome in 1782; Towne exhibited his drawings only once in London in 1805; and Cozens showed a drawing publicly for the last time in 1771.
7. *Library of Fine Arts*, 3, Jan. 1832, p. 12.
8. *Somerset House Gazette*, I, 1824, pp. 66–67.
9. Ibid., p. 84.
10. Burke, *Sublime and Beautiful*, p. 82.
11. Advertisement bound in back of *Microcosm of London*, 1808.
12. Varley, *Treatise*, 1816, Intro., p. 1.
13. Palmer, *Letters*, 2, p. 736.
14. T. H. Fielding, *On Painting in Oil and Water-Colours for Landscape and Portraits*, 1839, p. 92.
15. Edward Dayes, *The Works of the Late Edward Dayes*, 1805, pp. 309–10.
16. Nicholson, *Landscape from Nature*, pp. 108–09.
17. Ibid.
18. Leslie, *Constable*, p. 114.
19. Hardie, II, p. 129.
20. Nicholson, *Landscape from Nature*, p. 109; Craig, *Lectures*, p. 131.
21. *Somerset House Gazette*, II, 1824, p. 45.
22. Ibid.
23. Ibid.
24. Barret, *Water-Colour*, pp. 117–18; Nicholson, *Landscape from Nature*, p. 109.
25. J. Ruskin, *Notes by Mr. Ruskin on his drawings by the late J.M.W. Turner, R.A.*, Fine Arts Society, 1878, pp. 9, 29.
26. Hardie, I, p. 14; G. Wilkinson, *Turner Sketches 1800–1820*, 1974, p. 80.
27. Hardie, I, p. 150.
28. Roget, I, p. 445.
29. Webber, *Orrock*, I, pp. 60–61.
30. Blake, *Poetry and Prose*, p. 522.
31. J. T. Smith, *Nollekens and his Times*, 1828, p. 472.
32. Hardie, III, p. 236.
33. Nicholson, *Landscape from Nature*, pp. 84–86.
34. J. W. Allston, *Hints to Young Practitioners*, 1805, p. 44.
35. J. Ruskin, *Modern Painters*, in *Works*, III, pp. 323–24.
36. *Somerset House Gazette*, II, 1824, p. 381.
37. Uwins, *Memoir*, I, p. 184.
38. Hardie, II, p. 182.
39. *Art Union*, "Progress of Painting in Water-Colours," Oct. 1839, p. 145.
40. Whitley, 1821–37, pp. 90–91.
41. Palmer, *Letters*, 2, pp. 777–78.
42. A. H. Palmer, *Life*, p. 145.
43. Palmer, *Letters*, 2, p. 736.
44. Hardie, II, p. 89.
45. *Library of Fine Arts*, I, 1831, p. 515.
46. S. Kitson, *Life of John Sell Cotman*, 1937, p. 304. I am indebted to Michael Pidgeley of the University of Essex for the unabridged text of this quotation.
47. Webber, *Orrock*, I, p. 149.
48. Hardie, III, p. 108.
49. J. Ruskin, *Academy Notes*, 1856, in *Works*, XIV, p. 73.
50. Ibid., p. 74.
51. E. About, *Voyage à Travers l'Exposition des Beaux Arts*, Paris, 1855, p. 32.
52. J. Ruskin, letter to J. F. Lewis, transcribed in *Lewis*, 1971, p. 29.
53. W. M. Thackeray, *Contributions to the Morning Chronicle*, ed. G. Ray, Urbana, 1955, pp. 135, 137.
54. Roget, II, p. 147.

Framing and Galleries

THE PURPOSE OF A FRAME or mount is to protect a watercolor from rough handling, moisture, and dust. Aesthetically, it has other functions: it serves to focus the viewer's eye upon the composition, it increases the size and importance of the work, and it makes a transition between the picture and its surroundings. Style in frames varied with the tide of taste. From the middle of the eighteenth century, Thomas Chippendale, Sr., William Ince, and Matthew Lock, rococo designers, published pattern books which illustrated fantastically carved gilt frames, characterized by undulating outlines, openwork carving, with corners and tops embellished with arms, trophies of the chase, musical instruments, etc.[1] By around 1775, the style in frames was chastened to suit the neoclassical fashion, sparked by the publications of, among others, Piranesi and Winckelmann. Urns, medallions, laurel leaf bands, and anthemions on straight edged molding became popular ornaments.

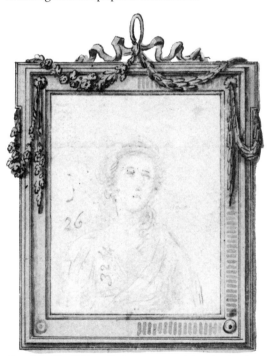

Fig. 1. John Linnell, *Frame Design, c.* 1770, pen, ink, and watercolor. The Victoria and Albert Museum.

The transition is illustrated in the frame designs of John Linnell (d. 1796), which, before 1770, exhibited all the characteristics of the French rococo.[2] By 1775, however, the outlines of his frames had become simple rectangles, the festoons and projecting moldings were restricted to the upper half and soon were done away with altogether (fig. 1). They were replaced by simple fluting, beading, and foliage bands, as shown in his designs for the Duke of Chandos (fig. 2). Linnell's drawings are in pen and watercolor, and the bright color schemes on some demonstrate that at this time frames were not always polished wood or gilt, but were occasionally painted to match the decoration of a room.

Fig. 2. John Linnell, *Moldings for Picture Frames, c.* 1775, pen, ink, and watercolor. The Victoria and Albert Museum.

Influenced by the classicizing decorative schemes of architects such as Henry Holland, James Wyatt, and Sir John Soane, the taste for antique decoration in frames continued, reaching a peak of archaeological correctness in the designs of Thomas Hope, a self-appointed arbiter of taste whom Sydney Smith dubbed "the man of chairs and tables, the gentleman of sofas."[3] In his *Household Furniture and Interior Decoration* (1807), Hope began with a picture frame as a border for the frontispiece, decorated according to "the invention of the Grecian Architects of the Lower Empire."[4] This, like his other frames, is simple in outline but dense with bands of anthemions, stars, beading, and gadrooning (fig. 3). According to Hope, these antique patterns gave "that breadth of repose and surface, that distinctness and contrast of outline, that opposition of plain and enriched parts, that harmony and significance of accessories, that afford the eye and mind the most lively enjoyment."[5]

George Smith's frame designs, published a year after Hope's, are less academically correct but more decorative.[6] In 1827 Smith published a new book, the *Cabinet Maker's and Upholsterer's Guide*, because his previous book had

become wholly obsolete and inapplicable . . . by the change of taste and rapid improvements which a period of twenty years have introduced. The travels of

Fig. 3. *Frontispiece* from *Household Furniture and Interior Decoration*, by Thomas Hope, 1807, engraving. Yale Center for British Art.

scientific men — the publications within the last twenty years — the Elgin Marbles, all alike detailing the perfection of Grecian architecture and ornament; the beautiful specimens contained in Sir William Gell's book on the remains of Pompeii — the inexhaustible resources for beautiful outline in the vases of Sir William Hamilton, if no other causes had existed, would surely have been sufficient to account for the present elegant and refined taste.[7]

The book included plates for decoration ranging in style from Egyptian through Etruscan, Gothic, and Louis XIV, and signalled the arrival of full-blown eclecticism in frames and furniture alike throughout the rest of the century (fig. 4).

During the eighteenth century, a connoisseur's general practice was to keep watercolors unframed and in portfolios, which protected them from dust and the damaging effects of light. Mounts were of paper, white or colored, and they were often ornamented with pen lines and wash borders which picked up a color within the drawing. Such a border softened the starkness of a plain white mat, and in effect served as a frame for the watercolor. An instance of this sort of margin can be seen around Edward Dayes's *Queen Square* (no. 13) of 1786. A connected series of drawings were usually matted alike: for example, Richard Wilson's views around Rome, executed for the Earl of Dartmouth about 1754, were all matted on now faded lilac paper, each with a white label on which the subject was inscribed.[8]

Finished watercolors and drawings were framed and hung during this period, both for household decoration and for public exhibition. Writing to Sir Horace Mann from Strawberry Hill in 1753, Horace Walpole described "the charming closet where I am now sitting. . . . It is hung with green paper and water-coloured pictures."[9] Another room there was known as the Beauclerk closet and contained seven of Lady Diana Beauclerk's drawings "in sut-water," framed in ebony and gold, seen against Indian blue damask walls.[10] Watercolors were not always treated so lavishly or well, however. Even as serious a collector as Dr. Thomas Monro was known to paste drawings on the walls of a room and then nail strips of gilt wood beading around them as frames.[11] Gainsborough once made the mistake of giving "twenty drawings to a lady who pasted them to the wainscot of her dressing-room," an extravagant version of the current fashion for covering the walls of a room with decorative prints.[12] Portrait drawings were also framed and hung. W. H. Pyne described the Queen's closet at Kensington Palace, with portrait drawings by Holbein on the walls, and he noted a series of small whole length pencil and watercolor portraits of the royal family by Henry Edridge which hung in one of the bedrooms at Frogmore.[13] Watercolor portraits were evidently appreciated as private domestic decorations, while oil paintings were considered appropriate for formal public rooms.

Hardie was of the opinion that "To Cozens or Sandby or Girtin the thought of a gilt mount or a gold frame closing in their drawing would have been impossible."[14] I think Hardie overstated the case, and he did not consider the impact of the exhibitions, which demanded a new and stronger format for the display of watercolors and drawings. Portfolios and paper mats were inadequate: it was the simplest thing to take the lead from painters in oil, and to frame watercolors close in wood or gilt. For safety, watercolors were glazed, but continual experimenting with varnish to protect their delicate surface implied that this was not always the case. Gainsborough exhibited varnished drawings which were meant to imitate oil paintings, and they were probably framed like oils to further the resemblance.[15] A watercolor manual of 1807 recommended varnishing

watercolors with copal, exactly like oil, and seventeen years later, John Varley exhibited several landscapes varnished this way.[16] For a slight sketch, such framing and glazing was inappropriate, but for a finished exhibition piece, a gold frame or close wood mount was accepted and even desirable, as it increased the size and importance of the watercolor. Sandby's bodycolor drawings were exhibited in the same sort of frames as oil paintings, without any mat. In 1785, when William Blake exhibited four watercolors at the RA they were hung in "close rose-wood frames."[17]

Fig. 4. *Moldings for Glass Frames and Pictures*, pl. 154 from *A Collection of Designs for Household Furniture*, by George Smith, 1808, hand-colored engraving. Yale Center for British Art.

The simplicity of Blake's choice demonstrated an important fact about exhibition frames: since it was up to the buyer to provide a frame to suit his own taste, it was the artists' practice to reuse frames of their own which they kept for the purpose of exhibition. When Lord Hardwicke bought Wright of Derby's painting *The Earth Stopper*, exhibited in 1774 at the Incorporated Society of Artists, Wright wrote to the secretary of the Society, saying

> The shabby price his Lordship is to pay for it will leave no room for his Lordship to expect the frame with it; but if he should say anything about it pray inform his Lordship

that the Earth Stopper was exhibited in an old Italian Molding frame which I have had by me for many years and keep for the use of the exhibition, and on no account let him have it.[18]

Wright's "old Italian Molding" was probably the so-called "Carlo Maratti," one of the more popular exhibition frames of the last quarter of the eighteenth and the first quarter of the nineteenth centuries. It was of wood, and had a straight gilt molding with a running leaf or sprig motif, often with beading at the inner or outer edge made of papier-mâché. This was the type of frame ordered by George III for the Raphael cartoons, over life size designs for tapestries executed in bodycolor, which were then at Hampton Court.[19] In 1826 Thomas Uwins wrote to his brother for the dimensions of "one or two rich frames" which he had left in London.[20] They had first served for exhibition watercolors at the SPW in 1810 and 1818, and he wanted to reuse them for a couple of oils he had in preparation for the RA that year.[21]

As early as 1781 it was noted that some members of the Academy, "with the idea of making their works more assertive," were sending in their exhibition pictures in larger gilt frames.[22] At the outset of the nineteenth century, James Northcote was engaged in a dispute with Sir Thomas Lawrence over the size and gaudiness of the latter's exhibition frames. Using his own master as an example, he wrote:

> Sir Joshua had nothing of this, for the frames in which he sent his fancy pictures were not above 2 in. in depth, and his portraits were sent in such frames as his sitters provided for them. One frame, in particular, I remember, had gone so often that it might have almost have found its way to the exhibition alone, and it had become so black that you could scarcely have known it was gilt.[23]

Reynold's use of a small frame for his fancy pictures was simply a matter of economy. This type of picture was done on speculation, for his own pleasure and reputation rather than for a specific client, and the artist did not want to invest in an expensive frame that might not be to the buyer's taste. Reynolds did believe, though, that "a striking frame improved a picture" and that broad gilt frames "gave a picture a more consequential air."[24]

For the exhibition works of Girtin, Turner, and the founding members of the spw, "a heavy environment of gold" became a matter of course.[25] Pyne wrote about these works,

It is only of late that such cabinet productions in this material can be rendered sufficiently rich and deep in tone, to bear out against those broad and superb frames, which seemed alone fitted to the power of oil painting of the same size; but experience has proved that water-colours, by the present improved process, have an intensity of depth, and a splendour of effect, which almost raises them to rivalry with cabinet pictures.[26]

A colored acquaint by Rowlandson and Pugin from the *Microcosm of London* (fig. 5) shows the Bond St. gallery of the spw in 1808 and bears out Pyne's statement: all the watercolors are in heavy gilt frames without any mats, in spite of the fact that there are no competing oils.[27] A scoop molding, generally with some flat decoration, is visible on many of the frames: at the same period in France, this was the type of frame chosen by Napoleon for his additions to the Louvre.[28]

Aside from showing the frames, the aquatint also provides a picture of one of the spw's early exhibitions. It was held in a large gallery, with a second room opening off it. The main room was top lit, with a coved ceiling which allowed light to wash down the walls. A thin white cloth suspended from the coving diffused the light further, protected the watercolors from direct sun, and prevented glare or reflections from the glass or the frames. Hung frame to frame, the watercolors extended from knee level to well over ten feet high, and the tops of the uppermost pictures tilted well out so that they could be seen from below. There were no identifying labels: only a number was attached to each frame. To find out the artist or the subject of any watercolor,

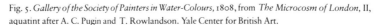

Fig. 5. *Gallery of the Society of Painters in Water-Colours, 1808*, from *The Microcosm of London*, II, aquatint after A. C. Pugin and T. Rowlandson. Yale Center for British Art.

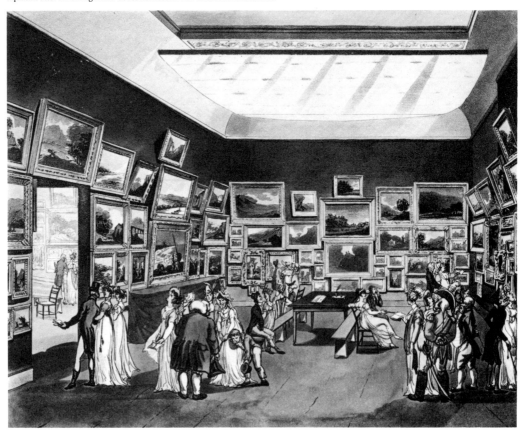

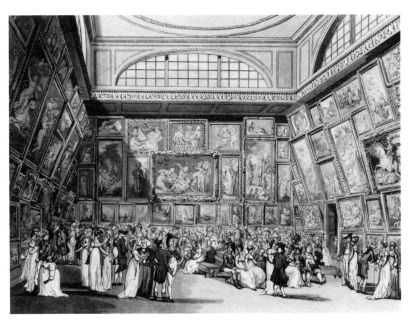

Fig. 6. *The Main Gallery of the* RA, 1807, from *The Microcosm of London*, I, aquatint after A. C. Pugin and T. Rowlandson. Yale Center for British Art.

a visitor had to buy the catalogue. Plain benches and chairs were provided, as well as a baize-covered table with the price book, pen, and inkstand. A comparison with another Rowlandson and Pugin aquatint of the RA's main gallery (fig. 6) is illuminating: except for the light screen, and allowing for the smaller quarters, the SPW hung its exhibition in exactly the same way, even to letting the frame of one picture overlap into the space of another.

In his autobiography, William Callow pointed out that, like the RA, "it was a rule of the Society at this time that the price of the drawings should not include frames, which were much more expensive than they are now, and purchasers had the option of buying the drawings framed or unframed."[29] He also noted the fact that "in the earlier days, prior to my election [1838], the Society, in order to induce members to make large and important drawings, provided frames and plate glass complete in which members might place their work."[30] First choice of these frames went to those artists who had been voted one of the yearly premiums, and as there was a limited supply, there was active competition for the frames, especially for the largest ones. In 1839 Robert Hills wrote to one of the premium winners, Samuel Prout, that "The largest frames of all 39½ × 29½ were all snapped up as I supposed they would be — so I had nothing for it

but to secure you one of the next largest — I have put your name against one 33 × 26 *sight* measure."[31] In a further letter, Hills proposed two smaller frames that were still available and informed Prout that "The members who took the large ones 39½ × 29½ were Messrs. Cattermole — Cox & Tayler."[32] Frederick Mackenzie added a postscript to this letter, informing the clearly irate Prout that "the members have the choice of frames in the order in which their names stand in the list for premiums, and your name being eighth was unfortunate with regard to your chance of getting one of the size you wished."[33]

Thomas Uwins attributed the use of large frames with showy moldings to the artist's genuine need to make his work stand out at an exhibition. "I know the importance of first impressions," he wrote, "I believe frames pay more than pictures."[34] A critic of 1820 noted that "The crowded state of the annual Exhibitions, on the first entrance of the spectator, flings upon his eye, before his attention is riveted upon some particular object, a chaotic mass of colouring."[35] Aside from its eye-catching qualities, a large frame also provided a neutral barrier which kept the contrasting color schemes of other works from clashing unpleasantly.

The notion of creating a picture to fit an existing frame was still current with oil painters

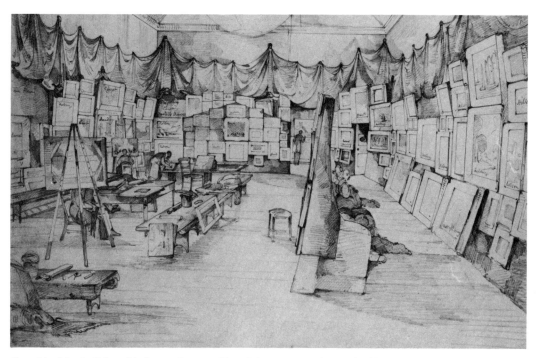

Fig. 7. John F. Lewis, *Gallery of the Society of Painters in Water-Colours*, 1830, pencil. Reproduced by permission of the Trustees of the Royal Society of Painters in Water-Colours.

as well. In 1834 Constable wrote of his determination "to attack another canal for my large frame."[36] On the subject of large and "shameful, or rather shameless frames," he spoke disparagingly to Charles Leslie of a painter who was asked by the Academy's hanging committee "to change a monstrous piece of gilded wood, as it ruined the hopes of at least five others, who only look for crumbs that fall from the Academic table, while at the same time it spoiled his own picture."[37] While on the hanging committee himself, Constable

> found much trouble from the excessive size of the frames; and on remonstrating with an exhibitor on this point, who defended himself by saying that his frames were made exactly on the pattern of those of Sir Thomas Lawrence, he could not help replying, "It was very easy to imitate Lawrence in his *frames*."[38]

Spurred on by what was current at the Academy, the taste for large and embellished frames grew during the 1820s at the SPW as well. In 1827, according to A. E. Chalon, the Society "sported a new feature, a screen covered with leaves, out of Mrs. G. Haldiman's album, all framed alike in rich frost-work, and offering in

profile the appearance of an immense mass of gilt ginger bread."[39] It was the fashion during the 1820s and 1830s to collect and put into albums representative drawings and watercolors by all the popular artists of the day. Mrs. Haldimand's was an unusually good one, and worthy of exhibition because it had been selected for her by G. F. Robson. An idea of what Chalon described can be had by looking at two drawings made in 1830 by J. F. Lewis (figs. 7 and 8). Drawn as a record of where his own watercolors were placed in the SPW gallery that year, the sketches also show the position of a number of identifiable works by Lewis's fellow exhibitors. Two screens parallel the south and west walls of the gallery: on one side of each is a bench facing the wall, while the other is hung with watercolors. One of the sketches shows an artist putting the finishing touches on a large exhibition piece: exactly like varnishing days at the RA, during which artists were allowed to touch up their work in accordance with its position and lighting in the gallery. In the background a man is framing a watercolor, perhaps in one of the SPW's premium frames.[40]

A few years before these drawings were made, a critic of the new National Gallery wrote, "The proper ground for showing pictures to advantage is red; deep crimson hangings would

harmonize and enrich the *ensemble*."[41] Used at the British Institution and at Turner's private gallery, this color was considered a fitting background for exhibition watercolors as well.[42] Visible in both the Lewis drawings is a looped drapery, anchored high on the walls and descending behind the topmost pictures. These hangings were removable: when their exhibitions closed, the SPW rented the gallery for other functions and shows.[43] George Scharf's watercolor of the NSPW in 1834 shows a similar hanging scheme (fig. 9). The same sort of looped red drapery is employed, and the richness of the closely hung frames gives a substantial boost to the watercolors they contain. The Scharf watercolor also makes evident the taste for heavy re-creations of baroque motifs molded in gesso, "graceful scrollwork and volutes swelling out at the corners," which had by this time replaced the neoclassic decoration of earlier frames.[44]

Although gesso patterns were simple and cheap to reproduce, they had drawbacks. Frames decorated with such ornaments "are so brittle that, instead of protecting the picture, they have to be handled more carefully than the picture itself, and are liable to chip at the slightest blow."[45] Mass production also resulted in a loss of quality: a mechanical mold could never reproduce the delicate work achieved in handcarving. Sir Charles Eastlake ridiculed "the monstrosities which are daily offered to the public in the name of taste — the fat cupids, the sprawling, half-dressed nymphs, the heavy plaster cornices, and the lifeless types of leaves and flowers which pass for ornament."[46] A fashion for frames within frames, where three or four distinct layers of decoration can be counted in one frame, appeared on the walls of the watercolor societies at the begining of the 1830s. Such excesses in gilt were dismissed as "merely being an excuse to put gold on the walls."[47] During the 1870s, frames with plush or velvet bands and strip cork decorations became popular.[48] These were not allowed by either Society, however.

By the middle of the 1830s another trend had begun in which frames got no lighter but were a bit more simplified. The exaggerated coquillage and deeply molded floral patterns were reduced to an outside border, while a plain gilt slip surrounded the watercolor. An early example of this sort is the frame on G. F. Robson's *St. Paul's* (no. 63). Over the next fifty years, this type of frame dominated the watercolor exhibitions, the gold slip growing gradually broader and more matlike. Soon painters in oil began to use a similar surround for their works, particularly the landscapists, who in this instance were "largely indebted to the example and influence of painters in water-colours."[49] The Pre-Raphaelites adopted the plain gold slip for their carefully designed frames: they used a flat molding made of oak, and, by not covering it with gesso, they allowed the grain of the wood to show through the gilding.[50] Eastlake wrote, "The effect of oak-grain seen through gold-leaf is exceedingly good, and the sense of texture thus produced is infinitely more interesting than the smooth monotony of gilt 'compo.'"[51] Whistler also designed his own frames, once writing that they were as carefully thought out "as my pictures, . . . carrying on the particular harmony throughout."[52] But he and the Pre-Raphaelites were the exceptions rather than the rule, and only a few watercolor artists took the trouble to design and make their own frames.

During the 1850s a controversy arose over the use of a gilt mat versus a white one. Some artists, George Cattermole among the foremost, were "opposed to the heavy gold frames then *de rigueur* in the gallery. He considered that his own drawings were seen to better advantage in white mounts."[53] Prince Albert, visiting the SPW's show in 1852, asked William Callow whether white mounts might not improve some

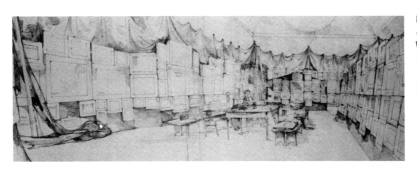

Fig. 8. John F. Lewis, *Gallery of the Society of Painters in Water-Colours*, 1830, pencil. Reproduced by permission of the Trustees of the Royal Society of Painters in Water-Colours.

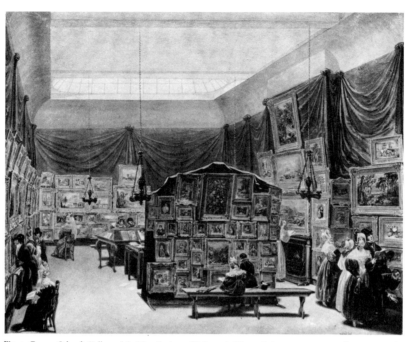

Fig. 9. George Scharf, *Gallery of the New Society of Painters in Water-Colours*, 1834, watercolor over pencil. The Victoria and Albert Museum.

rule was that all watercolors must be framed close "to prove that they could stand gilt as well as oil paintings" — the old comparison again.[54] J. F. Lewis, who was producing his most oillike exhibition watercolors at this juncture, wrote, "I shall send my picture framed because I hate and detest those horrid white mounts which in my humble opinion reduce all finished drawings to the level of sketches."[55] By 1851, however, the advocates of the white mount were beginning to carry their point, at least for a winter exhibition of sketches, as a letter from Samuel Palmer reveals. He wrote to John Linnell that the drawings "are all framed and glazed at the gallery. The only thing necessary is to mount anything which is sent upon a white or nearly white mounting. I use Bristol Board. Two sizes are prescribed for the mounts 28½ inches by 21 in or 21 by 15."[56] Gold frames were still the rule for the main spring shows until 1915. Well before that time, during the 1880s, a reverse in style and taste was championed by the members of the New English Art Club. Founded in 1886, the group "re-instated the water-colour drawing (as opposed to would-be painting) with corresponding changes in mount and frame."[57]

The overall impression we get from nineteenth century galleries is one of crowded brilliance and color. The glitter and texture of gilt moldings on closely hung frames, set against heavy crimson draperies and seen in diffused light, had a layered richness of effect independent from the merit of individual watercolors. The gallery hanging was meant to have a powerful impact upon visitors, but the components of the effect were sensibly suited to the single works as well. The gilt frames provided a neutral ground separating each watercolor from the others, and the red drapery gave them an importance they never would have had if hung on a plain wall. The fact that some watercolors were badly hung because of the range in height was a simple necessity: there were so many artists and so few exhibitions that crowding was inevitable. If an artist felt that his works were important enough to stand alone, he could either have his own show or, as many artists did, preview them in the studio prior to the exhibition. But for the exhibitions at the RA and the watercolor Societies, the aesthetic was one of crowding and color, suitable to the fact that they were festive yearly events which were of great interest and importance in the London social season. The exhibitions were meant to impress visitors first with the entire effect, and then upon closer view to let them enjoy individual works. A gallery hung with exhibition watercolors, "bearing out in effect against a mass of glittering gold, as powerfully as pictures in oils," must have been splendid indeed.[58]

Notes

1. Thomas Chippendale Sr., *The Gentleman's and Cabinet Maker's Director*, 1762. Ince and Mayhew, *The Universal System of Household Furniture*, c. 1762. Matthew Lock, *New Book of Pier Frames, Ovals, Girandoles*, etc. . . . , 1769.

2. VAM Album numbers E 59–414, 1929 and E 3466–3679, 1911, catalogued and reproduced in Helena Hayward, "The Designs of John Linnell," in *Furniture History*, v. 5, 1969, pp. 1–116.

3. Quoted in Geoffrey Wills, *English Furniture 1760–1900*, 1971, p. 172.

4. Thomas Hope, *Household Furniture and Interior Decoration*, 1807, p. 19.

5. Ibid., p. 2.

6. George Smith, *A Collection of Designs for Household Furniture and Interior Decoration*, 1808.

7. George Smith, *Cabinet Maker's and Upholsterer's Guide*, 1827, p. VI.

8. Two examples in this series are YCBA's *Temple of Minerva Medica*, B1977.14.4654, and the *Via Nomentana*, B1977.14.4656.

9. Horace Walpole, *Selected Letters of Horace Walpole*, ed. W. S. Lewis, 1973, p. 44.

10. Hardie, I, p. 151.

11. VAM, *Forty-two Watercolors*, p. 3.

12. William Jackson, *Character of Gainsborough*, 1798, p. 159n.

13. Pyne, *Royal Residences*, I, p. 20.

14. Hardie, I, p. 41.

15. However, Hayes quotes a letter from Gainsborough to Jackson of Jan. 29, 1773, in which he discloses his varnishing process for drawings. His final instruction was: "stick them upon a white paper leaving a Margin of an Inch & a half round." (Hayes, *Gainsborough*, I, p. 23.) This might do for an amateur like Jackson, who kept his drawings in a portfolio, but it seems likely that with Gainsborough's exhibited drawings done in imitation of oil, the mount was either cut off or folded round the canvas which backed it. An example of such a work is YCBA's *Romantic Landscape* (no. 413).

16. John H. Clark, *A Practical Essay on the Art of Colouring and Painting Landscapes in Water Colours*, 1807, p. 24.

17. Gilchrist, *Blake*, I, p. 57.

18. Quoted in Jack Lindsay, *Turner, his Life and Work*, New York, 1966, p. 230, n. 5.

19. The frames were made by Kingham of Longacre for £500. They can be seen in an aquatint in Pyne's *Royal Residences*, 2, opp. p. 77.

20. Uwins, *Memoir*, I, p. 389.

21. The frames were used for SPW 1810, no. 310, *A Lacemaker's School*, and SPW 1818, no. 213, *Puck, a water-colour copy of Reynolds' Painting*.

22. Quoted in Margaret Jourdain, "Some Late Georgian Picture Frames," in *Country Life*, Oct. 6, 1950, p. 1091.

23. *Conversations of James Northcote, RA, with James Ward*, ed. J. Fletcher, 1903, pp. 163–64.

24. Quoted in Jourdain, 1950, p. 1091.

25. Roget, I, p. 108.

26. *Somerset House Gazette*, II, p. 46.

27. Pyne, *Microcosm*, pp. 29–35, plate and description.

28. Henry Heydenryk, *The Art and History of Frames*, New York, 1963, pp. 83–84.

29. Callow, *Autobiography*, p. 104.

30. Ibid.

31. YCBA, Bicknell corr., p. 88. Letter from Hills to Prout, July 15, 1839.

32. YCBA, Bicknell corr., p. 89, Hills and Mackenzie to Prout, Aug. 10, 1839.

33. Ibid.

34. Uwins, *Memoir*, II, p. 131.

35. *Repository of Arts*, June 1820, p. 357.

36. Leslie, *Constable*, p. 235.

37. Ibid, p. 221.

38. Ibid, pp. 185–186.

39. Uwins, *Memoir*, I, p. 184. Screens were not new: they had been used since 1824.

40. The Society's frame-maker during this period, c. 1830–50, seems to have been George Foord of 52 Wardour St., Soho. His name recurs frequently in members' correspondence. See YCBA, Bicknell corr., pp. 88–89.

41. Whitley, 1821–37, p. 347.

42. *The Repository of Arts* commented favorably upon the "plain and simple drapery" at the SPW gallery in 1823, p. 360.

43. For instance, the SPW gallery was let to Sir Thomas Lawrence in 1823–25, and to William Daniell for his panorama in 1836.

44. Fitzgerald, *Frames*, p. 325.

45. Eastlake, *Household Taste*, p. 172.

46. Eastlake, *Household Taste*, p. 173.

47. Fitzgerald, *Frames*, p. 325.

48. M. Hardie, "Picture and Frame," in the *London Times*, June 10, 1935, p. 11.

49. Roget, II, p. 108.

50. For a Pre-Raphaelite frame, see YCBA's Burne-Jones, *Fair Rosamund*, B.1980.24.

51. Eastlake, *Household Taste*, p. 172.

52. John Mahey, "The Letters of James McNeill Whistler to George A. Lucas," in *Art Bulletin*, XLIX, 1967, p. 253.

53. Roget, II, p. 68.

54. W. Callow, "Notes on the Old Water-Colour Society," in *OWSC*, 22, p. 26, letter quoted by M. Hardie in appendix to article.

55. Quoted in Hardie, I, p. 42.

56. Palmer, *Letters*, v. I, p. 486. Palmer's talk of a winter exhibition is somewhat mysterious: Roget states that they were first thought of in 1862. (Roget, II, p. 107.) In 1851 Frederick Mackenzie made the suggestion that the summer show be continued by removing the sold pictures and replacing them with fresh contributions (Roget, II, p. 107 n. 3). This is perhaps what Palmer was referring to.

57. Duncan Mac Coll, Letter to *London Times*, June 13, 1935, p. 8.

58. *Somerset House Gazette*, I, p. 67.

The Catalogue

Paul Sandby, 1726–1809

Sandby was born in Nottingham. He was hired in 1747 by the Military Drawing Office in the Tower of London and from 1747 to 1751 worked on the survey of Scotland undertaken after Culloden. With his brother Thomas at Windsor in 1751, he helped to design the grounds. In 1760 he moved to London and was appointed Drawing Master at the Royal Military College, Woolwich, in 1768. He was active in the formation of the Society of Artists in 1760 and was a founding member of the RA in 1768. The drawings and paintings he showed there, in bodycolor and watercolor, contributed to the rising importance of both media for exhibition work. In 1775 he introduced aquatint to the British public with his *Twelve Views in Aquatinta from Drawings Taken on the Spot in South Wales.*

1. *Old Welsh Bridge at Shrewsbury* 1772

Bodycolor, gum, and oil on canvas
724 x 929 28½ x 37⅜
Insc.: Signed and dated, scraping out, on boat keel,
 LL: *PS 1772.*
Coll.: Mrs. L. B. Hann; P. & D. Colnaghi, 1965.
 B1976.7.143

Sandby executed at least twelve views of the old bridge at Shrewsbury, all based on drawings made before 1782, when the Mardol gate was taken down.[1] This particular version relates directly to the low perspective compositions of London bridges painted during the earlier part of Sandby's career by Samuel Scott and Canaletto.[2] Although the painting was probably not exhibited at the RA, Sandby showed two views of the Welsh Bridge there in 1801 (nos. 622 and 629), and another at the BI in 1806 (no. 90).

This work is experimental in technique: the artist began with bodycolor but worked on a coarse piece of canvas and finished with oil, using the latter to give the architecture and clouds solidity and crispness.[3] Like many of his contemporaries, Sandby felt that the distinctions between the various media were lessening. As artists in watercolor tried to give their work the strength and body of oils, painters experimented with watercolor grounds to give their oils transparency and aerial depth. it is not surprising, then, to find Sandby trying a mixed method which aimed at combining the best of both. To the end of his life he contributed to the effort to raise the status of watercolor and bodycolor as media worthy of exhibition.

1. See Witt photo archive 3053/E10–F6; A. Ward, *The Bridges of Shrewsbury,* 1935, p. 134.
2. For instance, Scott's *Westminster Bridge* (YCBA) or Canaletto's *London seen through an Arch of Westminster Bridge* (Duke of Northumberland).

3. In 1801 Sandby exhibited a similar oil and bodycolor combination entitled *Carrick Ferry near Wexford* which is now in the BM (L.B. 128).

2. *Distant View of Maidstone from Near the Foot of Boxley Hill* 1802

Bodycolor and gum on white laid, laid down on card
559 x 780 22 x 30¾
Insc.: Signed and dated in pen and brown ink, LL:
 P. Sandby / 1802.
Exh.: RA, 1802, no. 600.
Coll.: John Mitchell & Son, 1966. B1977.14.6272

Sandby's view of the Lower Bell Inn near Maidstone is an example of the simple topographic side of his exhibition work. The composition is neither a classical pastiche nor an experimental picture like his *Shrewsbury Bridge.* Instead, it is a late instance of a house portrait, a form popularized a century before by Peter Tillemans, John Wootton, and George Lambert. Compositional devices such as the central placement of the inn, the high view point, and the string of figures and cattle which enliven the foreground stem from paintings such as Lambert's *View of Westcombe House* (Earl of Pembroke) and Tillemans's *Mr. Jemmet Browne at a Meet of Foxhounds* (YCBA).[1] In spite of the fact that Sandby's view is a large and impressive exhibition work, it demonstrates that at the end of his career, he was unwilling to break away from the old-fashioned traditions of his youth.

1. Repr. in E. Waterhouse, *Painting in Britain,* Baltimore, 1969, pl. 96, and L. Hermann, *British Landscape Painting of the Eighteenth Century,* New York, 1974, pl. 5.

Francis Wheatley, 1747–1801

Son of a tailor in Covent Garden, Wheatley attended Shipley's School and, in 1769, the newly founded RA schools. He worked on the decorations at Vauxhall and contributed to both Boydell's Shakespeare Gallery and Macklin's Poets Gallery. He exhibited at the SA from 1765 to 1783 and at the RA from 1771. In 1779 he fled from London because of debts, returning in 1783. He was made ARA in 1790 and RA in 1791. Declared a bankrupt in 1794, he appealed for financial aid to the Academy and died a pensioner of the institution.

3. *Rustic Courtship* 1786

Watercolor, pen and black ink, over pencil, on white laid, laid down on card, and slightly enlarged all around (oval)

428 × 329 16⅞ × 13¾
Insc.: Signed and dated in pen and black ink, LR: *Fr. Wheatley delt. 1786.*
Engr.: Anonymous, published March 31, 1787.
Exh.: NGA, 1962, no. 97, repr.
Coll.: J. P. Morgan; Agnew, 1961. B1977.14.6315

One genre in which Wheatley specialized was the fancy picture, an eighteenth-century form developed by Philippe Mercier, Francis Hayman, Gainsborough, and Reynolds. Fancy pictures were pastorals of Greuzian sentiment, in which elegant peasants were shown performing everyday actions in much the same spirit that Marie Antoinette played at being a dairymaid. Prints after such pictures were popular with a wide urban audience who were nostalgic about the simplicity of rural life. This watercolor was engraved in 1787, probably as one of a pair or series. Another drawing of the same size and content was Wheatley's *Love in a Mill* (Captain Fletcher of Saltoun), which was engraved by Delatre in the same year.[1]

George Crabbe's poem *The Village*, published three years before this watercolor was executed, forms an apposite poetic parallel:

No Shepherds now in smooth alternate verse,
Their country's beauty or their nymphs rehearse:
Yet still for these we frame the tender strain,
Still in our lays fond Corydons complain
And shepherd's boys their amorous pains reveal
The only pains, alas, they never feel.[2]

In terms of technique and figure style, watercolor artists of the next generation seem to have taken more from his versatile contemporaries, Stothard and Westall, but Wheatley's contribution to the fancy picture is nonetheless an important precedent for the nineteenth-century pastorals of Cristall, Uwins, and the Chalons.

1. Repr. in M. Webster, *Francis Wheatley* RA *1747–1801*, 1965, no. 42, p. 30.
2. G. Crabbe, *The Village*, Book i, 9–14.

Thomas Malton, Jr., 1748–1804

The son of an architectural draughtsman, Malton was born in 1748. Taught by his father and at the RA schools, he specialized in architectural subjects, which he exhibited at the RA from 1773. He published *A Picturesque Tour through the Cities of London and Westminster* in 1792 and worked as a drawing master: Turner studied with him for a brief period in 1789.

4. *The North Front of St. Paul's* 1785

Watercolor, pen and black ink, on white laid, laid down on card
690 × 970 27³/₁₆ × 38¼
Exh.: RA, 1785, no. 589.
Engr.: *A Picturesque Tour Through the Cities of London and Westminster . . .*, 1792, pl. 53.
Coll.: The Architectural Association; charity sale at Sotheby's no. 414; bt. John Baskett, 1976. B1977.14.144

Although Malton's view of St. Paul's was included in his *Picturesque Tour Through . . . London and Westminster,* this watercolor cannot be considered a preparatory study for the engraving. Not only do the perimeters of the two works differ, but the ambitious scale of the watercolor makes it evident that it was an independent work meant for exhibition. It demonstrates the impact that the exhibitions had upon eighteenth-century topographic draughtsmen. The technique is still the stained method, and the view is factual, but the composition is complex and carefully elaborated. Malton enlivened the work with varied figure groups and picturesque incidents and greatly enlarged it to make the scene imposing enough to stand out on the crowded wall of the RA's gallery.

In 1797–99, Malton showed five other views of the interior and exterior of St. Paul's, knowing that the historic association of the building would make the works acceptable exhibition pieces. However, the topographical interest still predominated with Malton, who was not touched by the Alisonian aesthetic as were his immediate successors in the field of drawing historic buildings, Turner and Girtin. His accurate draughtsmanship did influence Turner, though, who studied perspective under Malton in 1789. Malton's use of a low viewpoint to heighten the dramatic impact of a building was developed further by both Turner and Girtin during the 1790s.

John "Warwick" Smith, 1749–1831

A native of Cumberland, Smith took drawing lessons from Sawrey Gilpin, RA, who introduced him to his major patron, the second Earl of Warwick. The latter supported Smith's Italian tour of 1776–81, from which Smith returned in company with Francis Towne. He traveled extensively in the Lake District of Wales, which resulted in his *Select Views in Great Britain* (1784–85). *Select Views in Italy* appeared between 1792–99. He first exhibited with the SPW in 1806 and was elected a full member the following

year. He served as secretary in 1816 and was president in 1814, 1817, and 1818. His last exhibit at the SPW was in 1823.

5. *The Coliseum, Rome* 1802

Watercolor over pencil
514 x 807 20¼ x 31¾
Insc.: Signed and dated in pen and black ink, LL:
 J. Smith 1802.
Exh.: SPW, 1807, no. 31.
Lit.: B. S. Long, "John 'Warwick' Smith," *Walker's
 Quarterly*, 1928, p. 27, no. 24.
Coll.: John Mitchell & Son, 1968. B1977.14.6287

Sir George Beaumont approved of only one picture in the SPW show of 1807: Smith's *View of the Coliseum.*[1] Two other versions of the subject by Smith are known: there are minor differences between them, but they were based on drawings made on the spot during his stay in Italy in 1776–81.[2] Both are earlier, smaller renditions, and it seems likely that although this watercolor is dated 1802, it was the work exhibited five years later. Smith hesitated to join the SPW until he was sure of its success in the first year: after that, he contributed regularly until 1823. His style was essentially old-fashioned, which was why Beaumont singled him out. Earlier in his career, though, he had been one of the first at the crossroads between the old and new methods in watercolor. Ackermann noted that in his early works, he was "the first artist who attempted to unite depth and richness of colour, with the clearness and aerial effect of Cozens."[3] What he failed to point out was that Smith's "depth and richness of colour" was due to the influence of two fellow artists in Rome, Francis Towne and William Pars.

Smith was not a leader but a quick follower, always ready to take advantage of the advances made by his compatriots. By the time he joined the SPW, his style had lost its freshness, but his reputation was still high enough to make him a valuable ally of the younger and more advanced artists of the Society. Another conservative artist, J. C. Ibbetson, must have been thinking of the contrast between the works of Smith and those of his fellow exhibitors when he wrote, "No one, I believe, ever came so near the tint of nature as Mr. John Smith: they will always retain their value when the dashing, doubtful style has long been exploded."[4] But for those who championed the new "dashing, doubtful style," Smith was old-fashioned: as Nicholson said of him, "He could not alter his method of practice, and probably thought it beneath him to do so, or go on like the others in the endeavour to give strength of effect and depth of colour. He stood still, and was left behind."[5]

1. Farington, *Diary*, 4, p. 134, May 8, 1807.
2. One is in the BM, from the Earl of Warwick's collection, repr. in the BM *Quarterly*, 1936–37 XI, opp. p. 12. The other was sold at Sotheby's, March 26, 1975, lot 165.
3. *Library of Fine Arts*, 1833, v. I, p. 311.
4. J. C. Ibbetson, *An Accidence, or Gamut of Painting*, 1803, p. 11.
5. Roget, I, p. 298.

Samuel Shelley, 1750–1808

Born at Whitechapel, Shelley gained the Society of Arts premium at the age of twenty. He practiced as a miniaturist and exhibited at the RA from 1774. He varied his portraits with fancy pictures and "history in small," which by the turn of the century were increasing in size and technical complexity. He was a founding member of the SPW, where his works provided a change from the large number of landscapes. He was first treasurer of the SPW, and was elected president in 1806. In the first show, his exhibits were the most expensive, averaging £26.10.6 each.

6. *Rasselas and his Sister* 1804

Watercolor, bodycolor, over pencil on cream wove
555 x 385 21⅞ x 15⅛
Insc.: Signed and dated in pen and brown ink, LL: *S.
 Shelley. 1804.*
Exh.: SPW, 1805, no. 151, as "Rasselas, Prince of
 Abysinnia, his sister, etc., conversing in their
 summer rooms on the banks of the Nile."
Lit.: OWSC, 11, 1933–34, p. 32.
Coll.: Sotheby's, Oct. 18, 1961, no. 158, bt. by
 Colnaghi's. B1975.4.1609

Samuel Johnson's *Rasselas* was an essay disguised in novel form on the subject of the choices and limitations of life. It was appropriate material for an exhibition watercolor for two reasons: first, it was a suitably serious and respected piece of literature, and second, the action took place in the "happy valley," which gave Shelley scope to create an exotic scene. In technique, Shelley's works resembled Richard Westall's in the use of transparent stipple based on miniature technique for the faces of his figures, but the washes in the costumes and background were looser and more atmospheric than Westall's. Shelley's exhibition watercolors like *Rasselas* formed an important link between the eighteenth-century figure tradition of Westall and Wheatley and the work of Bonington and the Stephanoffs in the 1820s.

John Robert Cozens, 1752–1797

Pupil of his father, Alexander, Cozens exhibited at the SA from 1767–71 and showed one history painting at the RA in 1776. The same year he left for Italy via Switzerland with Richard Payne Knight, returning to London in 1779. In 1782 he made a similar journey with William Beckford, traveling as far south as Naples, and while in Rome, giving drawing lessons to Sir George Beaumont. On his return to England in 1783, he produced watercolors on commission, mostly based upon his Italian drawings. in 1794, he became incurably insane, and he was put under Dr. Monro's care. His watercolors reached a wide group of young artists patronized by the doctor, including Turner and Girtin, Cotman, the Varleys, De Wint, Linnell, and Hunt.

7. *The Lake of Albano and Castel Gandolfo*
 c. 1780

Watercolor over pencil
445 x 642 17½ x 25¼
Exh.: Agnew, 1967, no. 49; PML-RA, 1972, no. 60; YCBA, *English Landscape*, 1977, no. 73; YCBA, *Cozens*, 1980, no. 93.
Lit.: A. J. Finberg, "The Development of British Landscape Painting in Watercolours," *The Studio*, Winter 1917–18, repr. pl. 2; Bell and Girtin, "The Drawings and Sketches of John Robert Cozens," *Walpole Society*, 23, 1934–35, no. 147v; F. Hawcroft, *Watercolours by John Robert Cozens*; exhibition catalogue, Manchester, Whitworth Art Gallery, and VAM, 1971, p. 19, no. 28.
Coll.: C. Morland Agnew; C. Gerald Agnew; D. Martin Agnew; Agnew, 1967. B1977.14.4635

Cozens did not undergo the usual apprenticeship of an eighteenth-century watercolorist to a printseller or a topographer. He was trained instead by his father, Alexander, a creator of systems for composing landscape. The son's work did not depend upon the association of a sign or symbol with the component parts of a landscape, as his father's "blot" drawings did. His form of association was one of aesthetic sensibilities mirrored in a landscape, an approach which made him particularly suited to the tastes and feelings of the circle who employed him — Richard Payne Knight, William Beckford, Sir George Beaumont, and Dr. Monro — some of the greatest collectors, connoisseurs, and art theorists of Cozen's generation. His views of the mountains of Switzerland and the valleys and ruins of Italy embodied for them in visual form the awesome, measureless Sublime of Burke, and the more indirect melancholic grandeur they associated with the great ancient civilizations in ruin. Cozens prefigured the Romantics in his ability

> "to mingle with the Universe and feel
> What I can ne'er express, yet cannot all conceal."[1]

In a technical sense, he broke through traditional limits as well, and his influence upon watercolorists of the next generation, through Dr. Monro's "academy" and through the Beckford sale in 1805 was great.[2] His *Lake of Albano and Castel Gandolfo,* a large, highly finished work executed in the studio, has direct connection with the early exhibition watercolors of Girtin, Turner, Varley, and others. The scene is carefully composed: the left half, with its overarching tree, is similar to one of Claude's drawings for the *Liber Veritatis* (LV 35), which had been published in mezzotint by Boydell starting in 1777.[3] Cozens's debt to Claude is also apparent in the golden atmosphere of the distant sunset. The limited color range in Cozen's watercolors was passed on to Girtin, who, according to Pyne, "retained more of his manner than either Turner or Varley."[4] For the very reason that Pyne dismissed Cozens's work as "being at most little more than merely tinted chiaroscuro," Constable admired it.[5] He saw a Cozens watercolor hanging with four oils by Claude in Sir George Beaumont's dining room, and wrote to his wife that "the sun glows on them as it sets."[6]

1. Byron, *Childe Harold's Pilgrimage*, canto IV, line CLXXVII.
2. Beckford Sale, Christies, April 10, 1805, ninety-four drawings by Cozens, sold for a total of £509.10.6.
3. For a discussion of all of the versions of this subject, see YCBA, *Cozens*, 1980, no. 93.
4. *Somerset House Gazette*, 1824, II, p. 65.
5. Ibid.
6. Leslie, *Constable*, p. 109.

Francis Nicholson, 1753–1844

A native of Pickering in Yorkshire, Nicholson studied for three years with an artist in Scarborough, twice visiting London, where he received instructions from Conrad Martin Metz. He began his career as an animal portraitist at Pickering but settled in 1783 at Whitby, where he produced portraits and watercolors of local picturesque sites. He first exhibited at the RA in 1789 and moved to London around 1803. In 1799 he was awarded a prize for his stopping-out process by the Society of Arts. A founding member of the SPW, he became a fashionable teacher of watercolor and was able to retire from professional practice in 1815, having exhibited a total of 277 watercolors at the SPW. In 1820 he published *The Practice of Drawing and Painting in Water-colours.*

8. London Bridge and the Monument c.1795

Watercolor and pen and black ink
283 X 410 11⅝ x 16¼
Lit.: Hardie, III, p. 235.
Coll.: Spink and Sons, 1960. B1977.14.6232

Once given to Thomas Malton, Jr., this drawing was attributed to Francis Nicholson by Andrew Wilton. A provincial artist who worked in Yorkshire most of his career, Nicholson is better known for his views of Scarborough, Whitby, Ripon, and Harrogate, which he often multiplied in the following manner:

> My process was by etching on a soft ground the different views of the place, from which were taken impressions with blacklead. This produced outlines so perfectly like those done by the pencil, that it was impossible to discover any difference. This was nearly half the work, and in the long days of summer I finished them at the rate of six daily.[1]

Even with this expedient, Nicholson could not keep up with the demand for his watercolors: they were forged and copied frequently within his lifetime. There are at least three similar views of the bridge by Malton, and at least one of them was executed over an etched outline.[2]

Nicholson showed a certain ingenuity in his experiments with watercolor: he was also one of the first to invent a stopping-out technique. However, both his multiplication process and his stop-out were cumbersome, and with the decline of tinted drawings, when coloring became more important than line, his soft-ground etchings were of little use. Nicholson's color is seen at its early best here. In spite of his concern with pigments that were permanent, much of his work has faded badly because of his use of indigo. As a member of the SPW, his palette was later influenced by the prevailing golden tones of the Society style, but here he worked in a range of soft blues, grays, and tans very similar to Dayes's and Girtin's at the same period. The watercolor is a good example of the late tinted topographic manner which immediately preceded the innovations of Turner and Girtin.

1. R. Davies, "Francis Nicholson: Some Family Letters and Papers," *OWSC*, 8, 1931, p. 9.
2. Witt photos 2530/A10, A11, A14. The drawing with the etched outline A11 was sold at Christies on March 1, 1977, lot 139.

9. Bonnington Linn 1806–07

Watercolor
521 X 648 20½ x 25½

Exh.: SPW, 1807, no. 24, as *Boniton Lin, a fall of the Clyde*; Spink, 1973, no. 64; Edinburgh, National Gallery, *The Discovery of Scotland*, 1978, no. 5.9.
Lit.: OWSC 8, 1931, p. 26.
Coll.: Bt. 1926 by Laing Art Gallery, Newcastle upon Tyne. c. 9987. Tyne and Wear County Council Museums (Laing Art Gallery, Newcastle upon Tyne).

In the catalogue of the sale of Nicholson's works after his death, a note accompanied over 1,400 sketches bound into volumes which read, "in 1806 Mr. Nicholson visited Scotland for the purpose of obtaining subjects to paint for the third water-colour exhibition."[1] The following year almost one-third of his exhibits were of scenes in Scotland, including this watercolor of Bonnington Linn. There are three falls on the upper reaches of the River Clyde: Stonebyers, Corra Linn, and Bonnington, and Nicholson sketched them all. He was treading familiar ground, for the falls had been a popular part of picturesque tours of Scotland for the last quarter of the eighteenth century. Jacob More had exhibited paintings of the falls at the Society of Artists in 1771; Sandby published engravings of them in 1778; and in 1802 Turner exhibited a large watercolor of Stonebyers at the RA.[2] John Wilson's poem *The Clyde*, published in 1808, claimed that the beauties of the river surpassed those of ancient Greece. Stonebyers was considered the most spectacular fall, and Nicholson exhibited three watercolors of it during his membership at the SPW. He showed only one of Bonnington, which was thought to be the least picturesque. In an 1842 note to his son-in-law, Nicholson mentioned a later version of the subject executed in oil.[3] The influence of the SPW style is evident in this watercolor: not only is the color scheme a warm, golden tone, but the details are generalized and subordinated to the overall composition. Compared with Turner's grander landscape of the Stonebyers fall, with its bathing nymphs and subtle play of light, Nicholson's view is somewhat old-fashioned and static. A much more dramatic waterfall by Nicholson was the *Gordale Scar* (Whitworth Art Gallery), which was probably exhibited at the SPW's first show (no. 135).

1. Reprinted in OWSC, 8, 1930–31, p. 38.
2. The More of *Bonnington Linn* is repr. in D. & F. Irwin, *Scottish Painters at Home and Abroad*, 1975, pl. 156. The Turner is repr. in Wilton, *Turner*, no. 343.
3. OWCS, 8, 1931, p. 26.

Thomas Stothard, 1755–1834

A Londoner, Stothard was apprenticed to a Spitalfields silk designer. In 1777 he entered the RA schools and

exhibited at the Society of Artists. In the early 1780s he worked with Blake and designed illustrations for books and magazines. He also painted in oils, becoming ARA in 1791 and RA three years later. He toured the Lake District and Scotland in 1809, and in 1815 he visited Paris with Sir Francis Chantrey, the sculptor. From 1814 to 1834 he was librarian at the RA. His designs included drawings for Roger's *Poems* (1812), *The Novelist's Magazine*, and the *Ladies' Poetical Magazine*.

10. *The Tenth Day of the Decameron* *c.* 1824

Watercolor over pencil
271 x 203 10¹¹/₁₆ x 8
Exh.: YCBA, Fifty Drawings, 1977, no. 29; YCBA, *Selected Watercolors*, 1980.
Lit.: A. C. Coxhead, *Thomas Stothard*, 1906, p. 142.
Coll.: Gerald M. Norman Gallery, 1973. B1975.4.1757

In 1825 Pickering's translation of Boccaccio's *Decameron* was published, with ten illustrations designed by Stothard. The artist's interest in the subject dates at least as early as 1819–20, when he exhibited eight pictures from Boccaccio at the RA. In both the exhibited works and the illustrations, Stothard chose to show the settings for Boccaccio's stories, rather than depicting the individual tales. He made a watercolor for each day, showing the young men and women in their elegant palace retreat. This watercolor was the last in the series: two others are extant, one in the BM and the other in a private collection in London.¹ A small version of the BM watercolor was in the Haldimand collection.²

1. BM 1886.6.7.3, repr. in Hardie, I, pl. 140. London private collection, repr. in Wilton, *British Watercolors*, 1977, pl. 31. An album of drawings by Stothard in the BM contains preliminary sketches for several of the *Decameron* subjects (LB 152).
2. Sale, Christies, March 18, 1980, lot 279.

William Blake, 1757–1827

Son of a hosier in London, Blake began to draw under Henry Pars in 1767 and was apprenticed to the engraver James Basire in 1772. He also studied at the RA schools, exhibiting there in 1780, the same year in which he met Fuseli. In 1783 he published *Pastoral Sketches* and in 1789 printed *Songs of Innocence*, which was issued with its companion, *Songs of Experience*, in 1794. Both, along with the Prophetic Books of the 1790s, were printed by a process he invented himself, a kind of relief etching technique. Between 1800 and 1803

he lived at Felpham in Surrey and worked for the poet William Hayley. In 1809–10 he held an exhibition of his works, mostly temperas, which he claimed were executed in fresco. The exhibition was not a success. In 1818 he met John Linnell, and through him, a circle of young artists who admired his work, including Samuel Palmer, Edward Calvert, and George Richmond. During the 1820s he worked on a set of illustrations in watercolor for the *Book of Job* and on another for Dante's *Divine Comedy*.

11. *Christ Healing the Blind Man* *c.* 1800

Tempera on canvas, varnished
267 x 365 10½ x 14³/₈
Exh.: London, BFAC, *Exhibition of the Works of William Blake*, 1876, no. 123; Carfax and Co., *Exhibition of Works by William Blake*, 1906, no. 14; Tate, 1934, no. 8; London Arts Council, *Tempera Paintings by William Blake*, no. 28; VMFA, Richmond, 1963, no. 383.
Lit.: W. Rossetti, *The Annotated Catalogue of Blake's Paintings and Drawings*, 1863, p. 150; Gilchrist, *Blake*, p. 174; *Journal of the Warburg and Courtauld Institutes*, 1938, no. 1, pl. 10; G. Keynes, *William Blake's Illustrations to the Bible*, 1957, p. 105; D. Bindman, *Blake as an Artist*, Oxford, 1977, p. 123.
Coll.: Thomas Butts; Thomas Butts, Jr., sold at Foster's, June 29, 1853, lot 85; Henry Willett, sale Christies, April 10, 1905, lot 21; A. B. Clifton; Mrs. Clifton. B1977.14.90

In the introduction to his catalogue, under the heading *The Invention of a Portable Fresco*, Blake explained why he was obliged to hold his own exhibition in 1809:

> The execution of my Designs, being all in Water-colours, (that is in Fresco) are regularly refused to be exhibited by the *Royal Academy*, and the British Institution has, this year, followed its example, and has effectually excluded me.... It is therefore become necessary that I should exhibit to the Public, in an Exhibition of my own, my Designs, Painted in Water-colours.¹

Blake felt the stigma attached to watercolor, but like the founders of the SPW he was convinced that as he practiced it, watercolor was capable of equalling the power of oil. In 1799 he was commissioned by Thomas Butts to produce fifty small pictures from the Bible at one guinea each.² This work is from that series, which was completed in 1800. It was executed in what Blake called "The Ancient Method of Fresco

Painting Restored": he apparently did not know that fresco and tempera are different techniques.[3] When he suggested that his designs were suitable "to ornament the altars of churches," he must have had early Renaissance predella panels in mind.[4] The Butts series do resemble such Italian temperas in their linear clarity and lack of shadow.

Blake's insistence on his own originality, his admitting no precedents except for the ancient Italian masters, obscured the fact that his experiments were very much a part of his time. His use of a ground of chalk or whiting was hardly a new discovery: it was the traditional method of eighteenth-century distemper painting, and more recently it had gained notoriety as an integral part of "the Venetian Secret," a technique which was meant to give the transparency and brilliance of a Titian to oil painting. Blake's use of animal glue instead of the usual egg white as the medium may have come about through a mistranslation of Cennini's treatise on tempera painting, but it could also be attributed to Blake's desire to gain the rich viscosity of oil for his medium.[5] It also gave his work the luster of varnish: this had been a concern of watercolor artists like Gainsborough and Westall long before Blake's temperas. Blake's experiments in preserving the transparency of watercolor, while adding to it the density of oil, must be seen in the wider context of the current desire to combine the best of both techniques.

1. Blake, *Poetry and Prose*, p. 518.
2. Tate, *Blake*, 1978, p. 75.
3. Blake, *Poetry and Prose*, p. 520.
4. Ibid., p. 539.
5. Tate, *Blake*, 1978, p. 75.

Adam Buck, 1759–1833

Born in Cork, Ireland, Buck worked there and in Dublin before moving to London in 1795, when he exhibited at the RA for the first time. He later exhibited at the Dublin Hibernian Society in 1802, at the BI in 1808–09, and at the SBA in 1829–33. He was a successful teacher of portrait drawing, but was best known to the public as the author of sentimental fancy pictures, many of which were engraved by Ackermann. He illustrated Sterne's *Sentimental Journey* in 1801 and in 1812 issued the first part of a series of outlines after Greek vases, a continuation of Sir William Hamilton's *Collection of Engravings from Ancient Vases* (1791–97). Around 1830 he engraved a series of portraits, *Friends to a Constitutional Reform of Parliament*. Buck's brother Frederick (1771–c. 1840) and his son Sydney (fl. 1839–49) were also portrait miniaturists.

12. *Portrait of a Family* 1813

Watercolor and scraping over pencil on card
445 x 419 17½ x 16½
Insc.: Signed and dated in pen and gray ink on term base, LR: *ADAM BUCK/1813*.
Exh.: RA, 1814, no. 481; SBA, 1829, no. 581, as *Portrait of a Family with the bust of a deceased child* (?); YCBA, *Fifty Beautiful Drawings*, 1977, no. 25; YCBA, *Portrait Drawings*, no. 101.
Lit.: YCBA, *Selections*, no. 70.
Coll.: D. H. Farr, New York, 1936; M. R. Schweitzer, New York, 1966. B1977.14.6109

For a discussion of the identity of the sitters and the objects in this watercolor, see YCBA, *Portrait Drawings*, no. 101. In this small full-length watercolor portrait, Buck conflated two portrait traditions of the last generation, put them in the currently fashionable neoclassic mold, and so achieved a new and highly finished format that was far more suitable for exhibition than his portrait miniatures. As a miniaturist, Buck was familiar with the portrait drawings popularized by Richard Cosway and Henry Edridge, in which the face of the sitter was highly finished in stipple and watercolor, and the rest of the composition loosely drawn in pencil and left uncolored. An example of this type is Edridge's *Hon. George Pryce Campbell as a Midshipman* (YCBA).[1] At the beginning of the century, Buck and other miniature painters took this form a step further by filling the entire composition with stipple and watercolor to give it the finish and depth of a small oil.

In the present case, he also drew on the portrait tradition in oil of the conversation piece, specifically, John Zoffany's groups like *The Townely Collection* (Townely Hall Art Gallery and Museum), where the sitters as well as the composition were elevated above mere portraiture by their association with the art of antiquity.[2] Buck was not painting an accurate catalogue of a gentleman's collection of vases and furniture: he was expressing the man's interests by introducing the finest available examples of ancient art and neoclassic design. As an experiment in combining miniature technique with the larger concerns of high art and strength of coloring currently shared by most watercolor artists, Buck's portrait was a highly successful advance, bridging the gap between the eighteenth-century portrait tradition and nineteenth-century watercolor portraits by John Linnell and George Richmond.

1. Repr. YCBA, *Portrait Drawings*, no. 92.
2. Repr. in London, National Portrait Gallery, *Johan Zoffany*, 1976, no. 95.

Edward Dayes, 1763–1804

Dayes entered the RA schools in 1780, and studied under the mezzotinter William Pether as well. He exhibited at the RA from 1786 until his death, and at the Society of Artists in 1790 and 1791. He was primarily a topographic draughtsman, but he also produced subject pictures and an occasional miniature. His writings on art, including *Professional Sketches of Modern Artists* and *Instructions for Drawing and Colouring Landscapes*, were published posthumously along with *An Excursion through Derbyshire and Yorkshire* in 1805. He committed suicide in 1804.

13. *Queen Square* 1786

Watercolor
437 x 660 17¼ x 26½, including a contemporary
 wash border of 1¼ inches
Insc.: In pen and black ink, LL: *E. Dayes / 1786.*
Exh.: RA, 1787, no. 582; Agnew, 1968, no. 6;
 PML-RA, 1972–73, no. 82, repr.
Engr.: In aquatint by Dodd and Pollard, July 1, 1789,
 one of a set of four London squares; the others
 were Bloomsbury, Grosvenor, and Hanover.
Coll.: Agnew, 1968. B1977.14.4639

Before this drawing was engraved, Dayes exhibited it and another of Grosvenor Square at the RA.[1] His technique, a gray monochrome heightened with simple blues and greens, and the details strengthened with penwork, was essentially the same as Sandby's, but the strong play of light and shadow and the elegantly attenuated figures owe more to architectural topographers like Thomas Malton, Jr. Around 1795 Dayes's work became more elaborate, and his *Instructions for Drawing and Colouring Landscape*, published posthumously, shows his interest in strengthening watercolor technique through the direct application of color and glazing. His palette and his use of atmospheric effects to enliven his topographical views influenced the early works of his pupil Girtin.

1. The drawings of Hanover and Bloomsbury Squares are in the
 BM (LB6 and LB11).

Richard Westall, 1765–1836

Westall was apprenticed to a silver engraver in his native town of Hereford. He first exhibited at the RA in 1784 and was admitted to the RA schools the following year. Elected ARA in 1792 and RA in 1794, he exhibited a steady stream of historical subjects, fancy pieces, and genre scenes. Westall worked extensively as a book illustrator and contributed to Boydell's Shakespeare Gallery, but his oils were never as well received as his watercolors and drawings. The BI bought one large painting from him in 1813. Before her accession to the throne, Queen Victoria took drawing lessons from Westall. At the end of his life he was a pensioner of the RA, having speculated unsuccessfully in old master paintings.

14. *Rosebud, or the Judgement of Paris* 1791

Watercolor and bodycolor over pencil
321 x 380 12¾ x 15⅜
Insc.: In pen and black ink, LR: *R. Westall 1791.*
Exh.: RA, 1791, no. 411.
Engr.: by W. Nutter (le Blanc, 3, no. 25).
Coll.: Fine Art Society, 1969. B1977.14.4357

Several contemporaries, including Rudolph Ackermann and James Northcote, gave Westall credit for the new depth possible in watercolor. One of them wrote,

> The entire development of that powerful union of richness and effect which at length elevated this art to vie with the force of painting in oil, was left to the genius of Richard Westall to complete. . . . Not only the cognoscenti, but the professors themselves, were for some time at a loss to discover by what means he was enabled to produce such splendour of colours, and depth of effect. It was not readily believed that his drawings were executed with the same mateials that everyone possessed.[1]

Westall contributed to the changes in watercolor, at least in figure painting, but his innovations did not measure up to those made by Turner and Girtin. His work during the 1790s showed the same concerns as that of many other artists: depth for watercolor and transparency for oil. Westall's use of bodycolor and gum to give richness to his watercolors were expedients which exhibitors at the RA — Gainsborough and Sandby, to name two — had been using since the 1770s. Westall's contribution was to combine this strengthened technique with a fashionable figure style based on a mixture of rococo and neoclassic elements, which he used with equal facility for book illustrations or for more ambitious exhibition pieces like the Ashmolean's *Boreas and Orytheia*.[2] When compared to the style of other figure painters of his day, Westall's work shows a concern for the superficialities of a scene which is missing in the more idealized, high art tradition of Fuseli or Flaxman.

This watercolor, an illustration to a poem by Matthew Prior (1664–1721), demonstrates Westall's

approach to elevated, poetic art. It is a costume piece, with elegant figures in exotic attire, and as such, relates to the tradition of portrait painting by Reynolds and Gainsborough, when they dressed their sitters to look like Van Dycks or Holbeins. Westall's work bears even more resemblance to that of the book illustrators of the day, William Hamilton and Thomas Stothard, but his crisp draughtsmanship, rich colors, and mixed methods, especially when used for ambitious exhibition watercolors, place him somewhere between these traditions. His work was a precedent for figure painters of the next generation, whose watercolors leaned more toward the romantic and intimate than to the grand and historic. Bonington, the Chalons, and the Stephanoffs, both in their technique and in subject matter, owed an important debt to Westall.

1. *Repository of Arts*, June 1813, p. 23.
2. Repr. in Wilton, *British Watercolours*, pl. 36.

George Barret, Jr., 1767–1842

Born in Orchard St., London, Barret was the son of an RA, a fashionable painter of landscape. Little is known of his career between his father's death in 1784 and 1800, when he first exhibited at the RA. His sister and his brother James were also artists. A founding member of the SPW, his early exhibits were mostly scenes along the Thames in the vicinity of London. His later works were compositions, studies of light and atmosphere after the manner of Claude, often quite large. In 1840 he published *The Theory and Practice of Water-colour Painting*.

15. A View of London from Highgate 1820

Watercolor over pencil, scraping and gum, laid down on card
518 x 813 20⅜ x 32
Insc.: Signed and dated in pen and brown ink, LL: *George Barret 1820*.
Exh.: The Mayor's Picture Exhibition, Borough of Acrington, 1908.
Coll.: G. Yates, Esq., J.P.; Agnew, Feb. 1970.
 B1977.14.6101

For the first twenty years of his membership in the SPW, about one-third of Barret's exhibits were landscapes around London and the Thames. These were varied with views in Wales, coast scenes around Hastings, and an occasional sunrise or twilight composition. Not until around 1825 did the idealized Claudian landscapes for which he is now best known

become the staple of his exhibition work. The present watercolor is an example of the sort most often exhibited during the first half of his career. The care with which the foreground foliage was stopped-out and recolored was pleasantly balanced with distant atmospheric effects, and the whole composition is notable for the warm color scheme from which Barret rarely varied. In 1824, Samuel Palmer wrote in his notebook, "Carefully avoid getting into that style which is elegant and beautiful but too light and superficial; not learned enough — like Barret. He has a beautiful sentiment and it is derived from Nature, but Nature has properties which lie still deeper. . . ."[1]

1. A. H. Palmer, *Life*, p. 15.

16. Classical Landscape — Evening c. 1820–30

Watercolor and bodycolor over pencil, scraping, on white wove faded tan, laid down on canvas
775 x 1264 30½ x 49¾
Coll.: G. Keep, Nottingham; bt. by the Castle Museum, Nottingham, in 1920. Castle Museum, Nottingham.

In 1819 the SPW instituted premiums which were to be awarded each year by a lottery, "as an incitement to produce works of greater importance 'for the benefit of the exhibition and the improvement of the Society.' "[1] That year there were three premiums awarded, of £30 each, and Barret, Cristall, and C. Varley were the winners. In later years, as the Society became more prosperous, the number of premiums awarded was increased. The only requirement for these premium watercolors was that they had to be large: figure paintings had to be thirty inches long, and landscapes were to be at least thirty-nine inches.[2] Although the present watercolor may not be the one produced by Barret in 1820, it is by reason of its size and elaboration almost certainly a premium work. It is a good example of the ambitious type of watercolor which Barret felt was appropriate for the SPW shows during the latter half of his career.

1. Roget, I, p. 399.
2. Ibid.

John Glover, 1767–1849

Born at Houghton-on-the-Hill, Leicestershire, Glover took drawing lessons from John "Warwick" Smith and William Payne (c. 1760–c. 1830). He was a drawing master at Lichfield from 1794, and he began to exhibit at the RA the following year. In 1805 he was

a founding member of the SPW, exhibiting 176 watercolors there between 1805 and 1812. He was the leader of the group who constituted the Society of Painters in Oil and Water-Colours in 1813. From 1810 to 1827 he exhibited oils at the BI and resigned from the SPW in 1817 in order to try for election at the RA. He was unsuccessful, but held yearly exhibitions of his own work between 1818 and 1824. In 1824 he was active in the foundation of the SBA, and in 1831 he emigrated to Tasmania.

17. *The Thames at Isleworth* c. 1805–10

Watercolor and pencil
673 x 1106 26½ x 40
Exh.: Agnew, 1970, no. 232.
Coll.: Agnew, 1970. B1977.14.6181

Although never exhibited during the artist's lifetime, this beautifully worked-out drawing demonstrates the skeleton and understructure of an exhibition watercolor as it looked while still in the studio. A conservative in style and technique, Glover began his work not with direct touches of color but with underlying washes of local tint. A pupil's account describes his method:

> He invariably made a drawing in Indigo, Indian Red, and Indian ink, and then he coloured it. He had a glass of water, and a white plate on which he mixed his tints; and he worked with a spread camel's hair pencil [brush]. . . . Mr. Glover always used the common drawing board and the drawing paper by Whatman. . . . Before he commenced his neutral tint he put on the paper a gradation of warm colour, beginning at the top with water farthest from the sun and increasing the strength to the bottom of the picture, or rather till he was below the horizon. He used Yellow Ochre and sometimes Light Red. If he had a soft cloudy effect to give, he made the paper damp, and while it was in that state he put in the sky. Then, with his neutral tint of Indigo and Indian Red he put in his distances, and nearly finished his work as he came to the foreground, reserving washes of this neutral tint to complete his effect. After this he used colour. He used very few colours, and these the most simple. Mr. Glover rarely used the sponge. Neither had he any occasion to practice any device to alter his work. He was not liable to mistakes.[1]

His mastery of technique is indeed evident, not only in the skillful brushwork of the preliminary washes, but in his sure feel for the scale of the composition and in the breadth and freshness of the atmosphere, which

would have been subdued and polished to a golden Claudian glow in a more advanced state. The spontaneity of the drawing makes it look like a study, but its size makes it more likely to be a studio work based upon open-air sketches, an exercise in translating a fresh Thames scene into a finished exhibition piece. It is similar to the river sketches made by Turner at the same period.[2] Glover had just moved from Lichfield to London in 1805, and the year before, Turner had bought a small house at Isleworth: both must have enjoyed exploring and drawing the previously unknown landscapes along the Thames between London and Windsor. W. H. Pyne was probably thinking of works such as this one when he wrote of Glover's art: "hints happily conceived, although obscurely defined, excite pleasing images in the mind of those to whom his art is addressed, who, such is the magic of painting, charmed into admiration of the style, finished the picture in their minds."[3]

1. Roget, I, pp. 306–07.
2. For example, see Wilton, *Turner*, nos. 412 and 413.
3. *Somerset House Gazette*, I, p. 132.

18. *Hilly Landscape with River and Cattle* c. 1810

Watercolor over pencil
210 x 324 8¼ x 12¾
Exh.: YCBA, *English Landscape*, 1977, no. 95.
Coll.: L. G. Duke; Colnaghi, 1961: an inscription on the back of the old mount states that the drawing was sold at Sotheby's on March 24, 1820, no. 149. B1977.14.4682

Glover was in the vanguard of artists attempting to raise watercolor to the level of oil painting. With Barret, Varley, and Havell, he was responsible for the Indian summer of the classic pastoral landscape, and he contributed to the corporate style of the SPW, which is demonstrated in this simple topographic scene. Its unpretentious approach and its golden tone, as if Glover had viewed the landscape through a Claude-glass, are marks of the early Society manner. The work has been dated c. 1820–30, but stylistically and on the strength of the old inscription, it should be dated earlier, c. 1810.[1]

 Glover's admiration for the old masters — and his desire to rival Claude in particular — made his watercolors popular with the more conservative patrons of the day, especially those who could not afford an original painting by that master. Constable was a severe critic of Glover's work, rightly considering much of it to be but pale imitation.[2] Like his own master, Payne, Glover was a popular teacher, his methods of execution being easily copied. He was known for his habit of splitting the end of a brush into

sections, "dipping them in jet black Indian ink, or grey, . . . and by a rapid, yet seemingly adventitious scrambling over the surface of his design, [he] prepare[d] the light and elegant forms of the birch or willow, the graceful sweepings of the branches of trees of larger growth."[3] But contrivances like this could not save Glover from the just criticism of fellow artists, who would have agreed with W. H. Pyne that Glover's art "has more of manner than of style, and with reference to the painter-like execution of Turner, Varley, Robson, Fielding, and that of other accomplished hands, it may be characterised under that significant appellation, *trick —*."[4]

1. YCBA, *English Landscape*, 1977, no. 95.
2. R. B. Beckett, ed., *John Constable's Correspondence*, 1964, v. 2, p. 290.
3. *Somerset House Gazette*, I, p. 133.
4. Ibid., p. 145.

Joshua Cristall, 1768–1847

Son of a Scottish sailor, Cristall was born in Cornwall. He worked in china and glass factories in Aldgate and Shropshire and subsequently for a London printer. Entering the RA schools in 1792, he was taken up by Dr. Monro. In 1802–03 he toured north Wales, his second trip being made in company with Cornelius Varley. In 1803 he exhibited for the first time at the RA and in 1805 was a founding member of the SPW. He made several sketching trips: to the Lake District in 1803, Hastings in 1807, and Scotland in 1818, exhibiting finished works from all three tours. Elected president of the SPW in 1820, he moved to Goodrich in Herefordshire two years later, leaving Copley Fielding to preside unofficially until 1831, when he resigned the office. After his wife's death in 1839 he decided to return to London, which he did in 1841. He was an honorary member of the Chalon Sketching Society.

19. The fish-market, Hastings 1808

Watercolor over pencil, scraping
762 × 1028 30 × 40½
Exh.: SPW, 1808, no. 37; VAM, *Cristall*, 1975, p. 45, no. 1.
Lit.: Review of the Publications of Art, 1808; Williams, *Watercolours*, p. 219; Binyon, pp. 82–83; Hardie, II, p. 136; VAM, *British Watercolours*, p. 92.
Coll.: Acquired by the VAM in 1873 from Colnaghi's. VAM 431–1873. Victoria and Albert Museum, London.

Cristall was an innovator in the long tradition of coastal and sea painting: he was the first to treat the life and activities of fishermen and sailors with any degree of seriousness. Hastings, Dover, and Margate, the three ports which he visited during his 1807 tour, were at that time in the national consciousness because of their proximity to France and because of the current war. Cristall did not infuse his works with patriotic feeling, however, but he did paint this scene on a new grand scale.

Large and impressive as this watercolor is, it was not Cristall's most popular exhibition piece of 1808. Priced at £63, it neither sold nor received much critical acclaim, except for a brief notice to the effect that it needed more finishing.[1] Cristall's tour de force that year was another coastal subject, no. 58, *Coast of Sussex, pushing off a boat to a vessel in distress*, which was bought by the Duke of Argyle for £105.[2] One critic wrote that the "spirit of Cristall's art, as displayed in this picture, is manly. Where others are satisfied to tickle with their sprightlinesses the fancies of the superficial, and paint things to sell, he is all heart and soul, and fails not to improve, where they seem only to hope to entertain."[3] Although Cristall's *Fishmarket* conveyed no heroic action meant to improve the viewer's heart, it was still an ambitious attempt to combine the notions of high art painting with the visual qualities of light and atmosphere that the picturesque movement had made current. His figure style, monumental and simplified, was influenced by Raphael and his followers; Cristall traced many prints after their work in his student years.[4] But it was in the rendering of light that Cristall excelled. The complexity of the composition, with its still lifes and local incident, the sunlight seen through canvas, and the strong lights and shadows were something entirely new and particularly suited to the transparent art of watercolor. Farington noted that "In consequence of Crystall's drawings made last summer, . . . a host of artists are prepared to go to Hastings."[5] In 1809 Heaphy exhibited the sensation of that year's SPW show, his *Fishmarket*, and Barret showed two scenes at Hastings as well. Another artist who was probably inspired by Cristall's work was Turner, who made a watercolor of the Hastings fishmarket in 1810 and again in 1824.[6]

1. *Review of the Publications of Art*, 1808.
2. SPW *Price Book*, 1808.
3. *Review of the Publications of Art*, 1808.
4. Many of these tracings are in the Victoria Art Gallery, Bath.
5. Farington, *Diary*, v. 5, p. 60, May 11, 1808.
6. Wilton, *Turner*, nos. 503, 510.

20. Arcadian Shepherds 1811

Watercolor over pencil
1088 × 939 43¼ × 37¼

Exh.: SPW, 1811, no. 111; VAM, *Cristall*, 1975,
 p. 105, no. 235.
Coll.: W. G. S. Dyer. Dyer Collection.

Most of the members of the SPW who worked in the pastoral mode were landscapists. Cristall, however, was primarily a figure painter, and his exploration of the form was much more varied as a result. In his later years, small, modern pastorals of Scottish girls or fishermen, descendants of Wheatley's peasants, were Cristall's most frequently exhibited subjects. In the first five years of the SPW, though, he exhibited more neoclassic versions of the pastoral, scenes of "nature embellished and made sacred by the memory of Theocritus and Virgil," in Alison's words.[1]

The subject of this watercolor is taken from the seventh eclogue of Virgil, which describes a singing match between two shepherds, Corydon and Thyrsis. Not only is this the largest known watercolor by Cristall, it is also one of the most ambitious and compositionally complex. In terms of figure painting, no precedent for it exists in watercolor. An antecedent can be found, however, in the paintings of James Barry, Professor of Painting at the RA schools during the 1790s, when Cristall studied there. Barry's smooth and monumental figures, seen in his paintings for the Society of Arts, had an impact on the younger artist's developing style, as did the casts from ancient statuary from which Cristall drew as a student. One writer criticized the resemblance of Cristall's figures to these antique casts, but praised his background as being "highly poetic."[2] Such opinions, and Barry's sad end, may have weighted Cristall's decision to devote less time to historic or classical subjects and to concentrate instead on the more popular modern pastoral. He did execute a smaller oil version of this composition, however, now in the Bristol Art Gallery. It was probably the work exhibited in 1815 at the SPW as *Shepherds Conversing* (no. 304).[3]

1. Alison, *Essay*, p. 64.
2. *Repository of Arts*, June 1811, p. 345.
3. Repr. VAM, *Cristall*, 1975, p. 21.

21. *Young Woodcutter* 1818

Watercolor, scraping, over pencil on cream wove
390 x 358 15 3/8 x 14 1/8 (14 3/8 x 11 3/8 sheet pasted
 over drawing on lower right)
Insc.: Signed and dated, scraped out, LR: *J. Cristall /
 1818.*
Exh.: SPW, 1818, no. 224, as *A Peasant Boy* (?);
 Agnew, 1970, no. 231.
Coll.: Agnew, 1970. B1975.4.1484

Rustic figures accounted for at least one-third of Cristall's exhibited work. In preparation for these he made pencil and wash sketches of actual people, often annotating them with place names and occupations, from which he could work up a finished watercolor in his studio. An example of this type of sketch is the YCBA's pencil drawing of *Isaac Willis*, of 1816, which was inscribed with the date, the sitter's name, and the location, Birchett's green.[1] Although the features of the boy are somewhat idealized, it is possible to make a connection between this drawing and *The Young Woodcutter*. Not only do the boy's features and apparent age match, but the costume is extremely close. To make the finished watercolor, Cristall probably worked from several such notations, modifying the stiff awkwardness of the boy's stance to a more graceful pose, and altering details of costume, for example the neck cloth and the long trousers, to give the figure a quainter, more old-fashioned appearance. The same boy may also have been the model for an earlier exhibition work of 1814, *Boy with a Sleeping Child* (SPW no. 191).[2] The influence of Barret can be seen in the bright patchwork of foliage, where the leaves have been scraped and stopped-out and then filled with pale, sunlit colors.

The figure of the peasant boy, like most of Cristall's, has a monumental simplicity, but the feeling of the work is far from the epic pastoral of *The Arcadian Shepherds*. It is much closer in spirit to the eighteenth-century fancy pictures of Gainsborough and Wheatley — a country figure, simple, clean, and charming, painted for the enjoyment of exhibition visitors who had little contact with real peasants or rural figures.[3] A critic in the *Magazine of the Fine Arts* summed up this type as

> a class of persons, in districts remote from cities,
> manufacturing towns, and seaports, [who] retain
> a primeval health, strength, and agility, and
> produce numerous instances of beauty. In the
> actions to which they are accustomed, they have a
> natural grace, as we may see in mountaineers,
> whose general deportment, influenced by the local
> habits of their lives, is remarkably easy and
> elegant.[4]

1. B.1975.4.1632, repr. YCBA, *Portrait Drawings*, no. 100.
2. VAM, *Cristall*, no. 220, repr.
3. Compare Gainsborough's *Cottage Children*, MMA, repr.
 Waterhouse, *Gainsborough*, 1958, no. 807.
4. *Magazine of the Fine Arts*, 1821, reprinted in VAM, *Cristall*,
 pp. 34–35.

22. *Gil Blas* c. 1820–1822

Brush and brown wash over pencil
331 x 398 13 x 15 5/8

Insc.: In pen and brown ink, signed (cut from old
 mat): *Joshua Cristall*; in pencil on verso: *J. Cristall.*
Coll.: Abbott and Holder, 1974. B1977.14.4314

Cristall joined the Chalon Sketching Society in 1812
and remained an honorary member after his retirement
to Herefordshire in 1822. His presence in the Society
must have helped to shift the earlier emphasis upon
poetic landscape toward the figure. Examples of the
subjects chosen by him, a *Landscape* from Theocritus
or *The Moon, under any of its appearances, or as
Diana the Huntress,* were characteristic of his classic-
pastoral approach.[1] This drawing demonstrates his
ability to adapt to a more recent literary subject.
Although the figures are in picturesque costume, the
friezelike composition and the figure in the bed still
retain the simplicity and repose of Cristall's antique
designs.

1. Uwins, *Memoir,* I, pp. 191–92.

Robert Hills, 1769–1844

Born in Islington, Hills took drawing lessons from
John A. Gresse (1741–94). Entering the RA schools in
1788, he first exhibited there in 1791. With J. C.
Nattes, W. H. Pyne, and James Ward he was part of a
Sketching Society around 1800. Between 1795 and
1815 he produced 780 etchings of various animals:
these were meant, like Pyne's *Rustic Figures,* for artists
who wanted characteristic poses or groups of animals
with which to embellish their landscapes. A founding
member and the first secretary of the SPW, he exhibited
animals and landscapes from the Lake District, Surrey,
and Kent, often collaborating with other artists in
exhibition watercolors. In 1815 he visited Waterloo
and the following year published his *Sketches in
Flanders and Holland.* He visited Jersey in 1831 and
again in 1833 in company with G. F. Robson.

23. *Landscape and Cattle* 1807

Watercolor over pencil
483 x 610 19 x 24
Insc.: Signed and dated in pen and brown ink, LR:
 Robt Hills 1807.
Lit.: VAM, *British Watercolours,* p. 186.
Coll.: William Smith; bequeathed to VAM, 1876.
 VAM 3049-1876. Victoria and Albert Museum,
 London.

A somewhat faded but typical example of Hills's
highly finished exhibition watercolors. Although it is

not possible to identify exactly, the present watercolor
may have been one of the six works exhibited in 1807
under the title *Cattle:* for each of these Hills asked
between two and three guineas. Because of its size and
elaborateness, however, it seems more likely to have
been one of the two watercolors exhibited the
following year entitled *Cattle on a road* (nos. 222 and
328), for which Hills charged fifteen and twelve
guineas.

24. *A Village Snow Scene* 1819

Watercolor, touches of bodycolor, scraping out, over
 pencil
324 x 425 12¾ x 16¾
Insc.: Signed in pen and black ink over pencil, LR: *R.
 Hills 1819.*
Exh.: Tokyo, Institute of Art Research, 1929, pl. xlii;
 Sheffield, Graves Art Gallery, *Early Watercolours
 from the Collection of Thomas Girtin Jnr.,* 1953,
 no. 62; Leeds City Art Gallery, 1958, no. 65; RA,
 The Girtin Collection, 1962, no. 59; PML-RA,
 no. 87; YCBA, *Selections,* 1977, p. 75.
Lit.: Binyon, p. 83; Hardie, II, p. 140, pl. 115.
Coll.: T. Girtin; Tom Girtin; John Baskett, 1970.
 B1977.14.4907

Early members of the SPW had no qualms about
imitating an old master painting. Francis Nicholson
and his pupil Miss Smith copied Rembrandt's *The
Mill,* while Glover set up his easel at the Louvre
between a Poussin and a Claude and put the best parts
of each into his own work. Such pictures were not
exact copies: instead, they were pastiches based upon
what the artist perceived to be the most beautiful
elements in an old master painting. In this practice,
artists drew upon the teaching of Reynolds in his sixth
Discourse: "The great use of studying our predecessors
is, to open the mind, to shorten our labour, and to give
us the result of the selection made by those great minds
of what is grand or beautiful in nature."[1] The tradition
of such winter scenes as this can be traced back through
Peter Brueghel the Elder to the Limbourg brothers, but
the direct precedent for this watercolor was a Rubens
oil, *Barn in Winter,* in the Royal Collection. It had
been exhibited at the BI in 1819, and Hills made at
least three variations upon it in watercolor between
1819 and 1820. Of the two others, one is in the
Spooner and one in a private collection in London.[2]
The former is the largest and was probably the work
exhibited at the RA in 1820 (no. 620).
 Hills's interest in the depiction of snow dates at
least as early as 1812, when he exhibited *A man
perishing in a Snow Storm* (SPW, no. 37) accompanied
by lines from Thomson's *Winter.* His technique in the
present work shows his mastery of the strengths and

limitations of watercolor when he leaves untouched large areas of white paper for the snow-covered ground and roof. The scraping out of the snowflakes is successful innovation and makes pleasant contrast with his usual stippled buildup of the animals and figures. Although his technique had precedent in the miniature tradition of Henry Edridge, Richard Cosway, and Richard Westall, Hills may also have been drawn to the method through stipple engravings after the animal subjects of George Morland and Stubbs. Hills was the first to use stipple consistently for landscape, although it was later employed by Danby and Jackson, among others. The precision of touch which it allowed suited Hills's painstakingly accurate style in delineating animals, and the overlapping and buildup of single touches of color made possible a much richer effect than simple superimposed washes. It was a technique especially suitable for exhibition watercolors, where old master tone and the solidity of oil were desirable. Hills's work was an important link between the eighteenth-century stipple tradition and the tightly controlled technique developed by Hunt, Palmer, and Lewis during the 1830s and after.

1. Reynolds, *Discourses*, p. 101.
2. Spooner Coll. repr. Witt, photo 1769/E9; priv. coll. repr. Wilton, *British Watercolours*, no. 90.

Paul Sandby Munn, 1773–1845

The son of a landscape painter and godson of Paul Sandby, Munn was born at Greenwich. He was given drawing lessons by Sandby and began to exhibit at the RA in 1799. He was a member of Girtin's Sketching Club and later was secretary under Cotman. With the latter, who shared lodgings with him between 1802 and 1804, Munn toured Wales in 1802 and Yorkshire in 1803. Both artists sold their drawings at Munn's brothers' print shop. Munn was an exhibitor at the SPW from 1805, showing forty watercolors in all, mostly scenes in the Lake District and Wales. In 1811 he settled in Hastings and supported himself by teaching.

25. Pale Melancholy c. 1804

Brush and gray wash
232 x 306 9¹/₈ x 12¹/₁₆
Coll.: Manning Galleries, 1971. B1975.4.1673

For the poetic source and for other versions of this subject, see William Havell's drawing (no. 42). In spite of the fact that Munn was ten years Cotman's senior,

the older man's style was for several years heavily influenced by him. From 1802 to 1804 Munn was Cotman's landlord at 107 New Bond St., and they took sketching trips together to Wales and Yorkshire during this period. While Cotman headed the Sketching Society, Munn was its secretary, and at least one meeting was held at their lodgings in 1803.[1] The result of this close contact can be seen in Munn's treatment of the present subject. The simple layering of washes in the sky, and the flat, bloblike touches in the foliage and on the rocks are very close to Cotman's technique in his last known Sketching Society subject, *Behold yon Oak* of January 26, 1804.[2]

1. VAM, *Sketching Society*, 1971, p. 2.
2. Rajnai and Allthorpe-Guyton, *Cotman*, 1979, p. 46, no. 26, pl. 13.

Thomas Girtin, 1775–1802

Son of a brushmaker, Girtin was born in Southwark. His first master was a Mr. Fisher of Aldersgate St., and in 1788 he became a pupil of Edward Dayes. He is also said to have colored prints with Turner for J. R. Smith at this period. In 1794 he toured the Midlands with the antiquarian James Moore, and in the same year he began to exhibit at the RA. Dr. Monro employed him along with Turner around 1795. He made tours of north England and Scotland in 1796, visited southwest England and north Wales the following year, and was again in north Wales in 1800 with Sir George Beaumont. In 1799 he was a member of a sketching club, "The Brothers," along with Louis Francia and R. K. Porter. From 1801 to 1802 he was in Paris, making a panorama of the city similar to the Eidometropolis, his panorama of London, which was exhibited in 1802.

26. The Ouse Bridge, York 1800

Watercolor over pencil on white laid
327 x 525 12⁷/₈ x 20⁵/₈
Insc.: In pen and black ink, LC: *Girtin 1800.*
Exh.: London, *International Exhibition*, 1862, no. 813; London, BFAC, *Drawings in Water Colours by Artists Born Before 1800*, 1871, no. 100; London, BFAC, *The Works of Thomas Girtin*, 1875; London, Grosvenor Gallery, *Drawings by the Old Masters and Watercolour Drawings by Deceased Artists of the British School*, 1877–78, no. 311; Norwich, Castle Museum, *Loan Collection of Drawings*, 1903, no. 59; London, Grafton Galleries, *An Historical Collection of British Water Colours*, 1911,

no. 185; London, RA, *The First Hundred Years of the Royal Academy 1769–1868*, 1951–52, no. 511; London, Agnew, *Loan Exhibition of Water-colour Drawings by Thomas Girtin*, 1953, no. 30; Sheffield, Graves Art Gallery, *Early Water-colours from the Collection of Thomas Girtin Jnr.*, 1953, no. 51; Leeds, City Art Gallery, *Early English Water-colours*, 1958, no. 49; London, RA, *The Girtin Collection*, 1962, no. 161; Reading, Museum and Art Gallery, *Thomas Girtin and Some of his Contemporaries*, 1969, no. 50; Victoria, 1971, no. 18; PML-RA, 1972, no. 93; Manchester, Whitworth Art Gallery, and London, VAM, *Watercolours by Thomas Girtin*, no. 71, pl. 32; YCBA, *English Landscape*, 1977, no. 118.

Lit.: N. Lytton, *Watercolour*, 1911, pl. 9; R. Davies, *Thomas Girtin's Watercolours*, 1924, pl. 78; T. Girtin and D. Loshak, *Thomas Girtin*, 1954, no. 382i, fig. 63.

Engr.: In mezzotint by S. W. Reynolds, *Liber Naturae*, May 1, 1824, repr. 1883.

Coll.: T. C. Girtin; G. W. Girtin; Tom Girtin; J. Baskett, 1970. B1977.14.363

Girtin exhibited a *View of the Ouse Bridge, York* at the RA in 1797 (no. 789). This was probably the watercolor in the Ashmolean, but may have been the smaller version in the BM, both of which show the other side of the bridge.[1] The YCBA's watercolor is a view of the southeast side: there is also a drawing at the York City Art Gallery of around 1797 which was taken from the same vantage point but further downstream.[2]

Girtin's early training under Dayes gave him a sure command of architectural draughtsmanship so evident in this watercolor, his final and most impressive treatment of the Ouse bridge. The bridge and the buildings around it are solidly conceived and drawn, with all the rough textures of crumbling stone and brick carefully rendered with direct touches of color and pen highlights. The watercolor is both picturesque and topographic, but Girtin's powerful imagination, his ability to impress an emotion upon landscape, mark an important departure from these traditions. From about this period, his art became one of increasing reduction. As in J. R. Cozens's work, so in Girtin's, a low-toned palette and restraint of detail resulted in an intensification of mood and atmosphere. Associative response became more important than mere recognition of an historic spot. Girtin's achievement was not as broad or spectacular as Turner's, but its effects were immediately graspable by other artists, and of tremendous importance in raising the status of watercolor art.

1. Girtin and Loshak, *Thomas Girtin*, 1954, no. 153, i, ii.
2. Ibid., no. 180, fig. 30.

Thomas Heaphy, 1775–1835

Born in London, Heaphy first studied under an artist named Simpson and then with the watercolorist John Boyne. He was apprenticed to the engraver John Meadows, and, at the end of his apprenticeship in 1796, entered the RA schools. He exhibited a self-portrait at the RA the following year and was appointed Portrait Painter to the Princess of Wales in 1803. He made his name at the SPW: he was an exhibitor there in 1807 and a member the following year. He resigned after the 1811 exhibition, probably realizing that the fortunes of the SPW were waning, and tried unsuccessfully to be elected ARA. In 1813 he held his own show in Pall Mall. The following year he went to Spain to make watercolor studies of Wellington and his officers (many of these are in the National Portrait Gallery), and from these he developed an ambitious modern history painting, which was engraved in 1822. In 1823 he was the president of the newly formed SBA and in 1834 was instrumental in founding the NSPW.

27. *Robbing a Market Girl* 1807

Watercolor, traces of bodycolor, some pen work and gum, over pencil
600 x 453 23⅝ x 17⅞
Insc.: Signed and dated in pen and black ink, LR: *T. Heaphy 1807.*
Exh.: SPW, 1807, no. 117. Companion to no. 139, *Young Gamblers.*
Lit.: Roget, I, p. 243: Whitley, *Heaphy*, pp. 14, 35, no. 50: OWSC, 26, 1948, p. 31.
Coll.: Bt. by Lord Kinnaird, 1807, from SPW exhibition; Cyril and Shirley Fry, 1967. B1975.3.176

"Heaphy had struck out in a new and pleasing style of execution," wrote Pyne, "and manifested an excellent feeling for coloring."[1] Although both the watercolors by him in this exhibition are too faded to enable one to give a proper estimate of his palette, his execution in them is evidently different from that of any of his predecessors or contemporaries in watercolor. During the 1790s, as an apprentice to the engraver John Meadows, Heaphy worked on a number of plates after Richard Westall's watercolors, work which he found distasteful. Westall's figures, firmly based upon elegant neoclassical formulas, were indeed antipathetic to the style developed by Heaphy. So was the work of the other major figure artist in watercolor, Joshua Cristall, whose generalized and massive forms were drawn from antique and seventeenth-century Italian models. In an age when all painters, even watercolorists, looked to the art of the past for

education and inspiration, Heaphy turned to yet another old master tradition, that of the Dutch school. Although the work of Teniers and Van Ostade was admired by many connoisseurs, it was not as respectable as the French or Italian precedent, mainly because the low subject matter treated by such artists was not "subservient to a moral purpose."[2] For artists interested in finish and detail, however, the Dutch tradition of carefully rendered textures was the proper precedent.

The only contemporary artist whose style had any relation to Heaphy's was David Wilkie, who built upon the Dutch genre tradition in paintings like *The Village Politicians* (RA, 1806) and *The Blind Fiddler* (RA, 1807). Wilkie paid Heaphy tribute when he wrote in 1810, "The industry of [Heaphy] is beyond all example. When I think of the number of highly finished objects which he has in these pictures of his, and compare them with what I myself have done in the same time, my labour seems idleness."[3] The works of both Heaphy and Wilkie differed from the Dutch inspired picturesque genre scenes of Wheatley and Morland in their uncompromising attitude toward subject matter. In Heaphy's watercolors especially, the fishwomen and peddlers were unpleasantly real. In *Robbing a Market Girl*, two of his subjects are banditti, but they bear no comparison to the glamorized characters in Mortimer or Wilson's work. Their costumes are not picturesquely tattered, but are dirty and ragged, and the girl's plight is in no way softened or glossed over. In the signpost pointing to Epsom and in the title of the companion piece, *Young Gamblers*, we see that there are no just deserts in this unsavory tale; in Heaphy's world, crime pays. In this, he went beyond Wilkie, whose subjects might be low but were never bald depictions of immorality or unpleasantness.

It may have been Heaphy's insistence on painting vulgar subjects, combined with his extraordinary prices, that led to his downfall as a watercolor painter. In 1811 he charged only fifty guineas for a full-length portrait in oil, yet asked three hundred guineas each for two of his exhibition watercolors.[4] The public was ready to admire his wonderful command of technique, but they would not put a high value on works that continued to display such disregard for any higher moral. Critical reaction, which had at first been divided between admiration for his abilities and regret that he used them to such ends, became increasingly negative. "We observe," said the writer of the *Repository of Arts* in 1811,

> no alteration in the performances of Mr. Heaphy, nor can we perceive that he has advanced one step towards a refined taste. His characters, though judiciously varied, are too coarse, his views of human nature too low, and the scenes he

exhibits are deficient in that moral effect which can alone excuse the representation of vulgarity.... With the example of Hogarth before him he may learn the art of exhibiting an impressive moral lesson or a poignant satire. He will not then mistake the means for the end and content himself with the credit of wasting his skill in the delineation of brutish character and manners.[5]

1. *Somerset House Gazette*, I. p. 194.
2. *Repository of Arts*, June 1810, p. 429.
3. Whitley, *Heaphy*, p. 18.
4. Ibid., p. 19.
5. *Repository of Arts*, June 1811, p. 345.

28. *Inattention* 1808

Watercolor, some stipple, pen work, and gum, over pencil
645 x 502 25 3/8 x 19 3/4
Insc.: Signed and dated in pen and brown ink, LR: *T. Heaphy 1808*; on an old mount, in pen and brown ink; *Inattention by TH' Heaphy/bought by Viscount Kinnaird out of the Bond Street Exhibition/1808.*
Exh.: SPW, 1808, no. 183.
Lit.: Whitley, *Heaphy*, pp. 15, 35, no. 61; OWSC, 26, 1948, p. 31.
Coll.: Lord Kinnaird, 1808; Cyril and Shirley Fry, 1967. B1975.3.175

One of Heaphy's chief concerns was expressing emotion. In this, he was in the mainstream of a tradition that dated to the Renaissance and had been taken up again in the seventeenth century by Charles Le Brun, the director of the French Academy. Le Brun had reduced the expression of emotion to a series of theoretic rules which he advanced in his lecture *The Expression of the Passions* (1696), illustrated with diagramatic heads. In the eighteenth century, this was further elaborated by Johan Lavater in his widely read *Physiognomische Fragmente* (1775–78), for which Fuseli made several illustrations and wrote the introduction to the first English translation in 1792. This was the immediate aesthetic background for Heaphy's exhibition watercolors. In 1821 he advertised his own contribution on the subject of the passions, *Studies of Character and Expression, from the Old Masters*, a series of reproductive drawings of heads which apparently were never engraved.

Heaphy's interest in the subject did not prevent him from breaking away from tradition in one important respect. Instead of depicting the abstract, ideal type of an emotion in his early watercolors, he concentrated on every local and individual characteristic he could. For Heaphy expression was not an end in itself but a means of revealing an intense

psychological moment. The "squinting blackguard" in *Inattention* was not a perfect type of anger or fear. His expression is, however, the pivot upon which the drama of the scene depends. If the screaming magpie — a symbol of thievery — makes the girl look up from the ballad she is absorbed in, the two peddlers will lose the chance to steal the purse she has dropped on the doorstep.

The scene has the exactness of a Dutch courtyard by de Hoogh, but it has been enlivened by a Hogarthian narrative. The quality of stop-action, the powerful feeling that the artist has caught the thieves in the very act, is given added force by the clarity of detail. Heaphy's miniature technique enabled him to capture accurately the textures of the costumes, baskets, and dead game, but he contrasted this with transparent washes for the broader rendition of the foliage, sky and cottages. His combination of the two methods looks forward to the work of W. H. Hunt and J. F. Lewis.

Ramsay Richard Reinagle, 1775–1862

Son of the painter Philip Reinagle, RA, (1749–1833), he first exhibited at the RA in 1788 at the age of thirteen. In 1796 he traveled to Italy, returning to England via Holland. Around 1800, in conjunction with Constable, he purchased Ruisdael painting for £70. Throughout his life he continued to deal in old masters and occasionally to act as a restorer. He exhibited a panorama of Rome with T. E. Barker in 1803. Two years later he was an exhibitor at the SPW and was made a member the following year. President of the SPW in 1809, he resigned after the 1812 exhibition. He was elected ARA in 1814 and RA in 1823. In 1848 he was forced to resign his diploma, having exhibited another artist's painting under his own name. He died a pensioner of the Academy.

29. *Fishermen Hauling their Net Ashore on the Bay of Naples* 1812

Watercolor, gum and scraping over pencil
953 × 1397 37½ × 55
Insc.: Signed and dated in pen and brown ink, LR: *R. R. Reinagle 1812.*
Exh.: SPW, 1812, no. 206; London, *International Exhibition*, 1862, no. 889.
Lit.: *Repository of Arts*, May 1812, p. 308.
Coll.: John Allnutt, sale Christies, June 19, 1863, lot 321; Spink & Son, 1977. B1977.14.148

Reinagle's exhibition watercolors fall into three categories: by far the greatest number were picturesque scenes from the Lake District, followed by a number of Italian landscapes, and finally, a small group of "compositions." Until the time he joined the SPW, much of his work was in bodycolor, in the tradition of Sandby and Zuccarelli, but after 1805 he devoted himself to watercolor and oils. In the latter, his style was influenced by De Loutherbourg, and in the former, by Turner and Cristall. In particular, it was Turner's combination of homely genre with heroic landscape, as in his painting *Sun Rising through Vapour* (NGL), exhibited in 1807, that inspired Reinagle to produce such a grand watercolor as this.[1]

Turner's *Scarborough Town and Castle: Morning; Boys Catching Crabs* (private coll.), exhibited in 1811, and Cristall's Hastings watercolors like the *Fishmarket* (no. 19) were the direct precedents for Reinagle's Italian view.[2] Aside from their desire to create important works of art in watercolor, Reinagle and Cristall shared the habit of noting carefully the effects of weather, time of day, and location of their scenes. Cristall put this information on his sketches, while Reinagle liked to include it in his exhibition titles. The full title of this work was *Fishermen hawling* [sic] *their Net under the Cliffs and Town of Vico, in the Bay of Naples, with a Group of Tunny and other Fish — Evening.* Constable once wrote of Reinagle that "he views nature minutely and *cunningly*," but he was capable of combining close observation with a breadth and grandeur of vision which few of his fellow watercolorists were ever able to equal.[3]

1. Butlin & Joll, *Turner*, no. 69.
2. Wilton, *Turner*, no. 528.
3. Leslie, *Constable*, p. 17.

Joseph Mallord William Turner, 1775–1851

Turner was born in Maiden Lane, Strand, and briefly studied perspective under Thomas Malton II in 1789. The same year he entered the RA schools and exhibited for the first time in 1790. A member of Dr. Monro's "academy" around 1794–96, he worked with Girtin copying drawings by J. R. Cozens. During the 1790s he toured England and Wales, and he visited Scotland in 1801. He was elected ARA in 1799 and RA in 1802. The same year he visited Paris and Switzerland. From 1804 he exhibited at his own gallery in Harley St. as well as at the RA. Walter Fawkes of Farnley became a patron at about this time, buying many Swiss watercolors. In 1819–20 Fawkes

held an exhibition of watercolors in his London home in which Turner's watercolors were the central focus. Turner toured the Rhine in 1817 and in 1819 visited Italy for the first time. In 1828 he returned to Italy, and he made a broad European tour in 1833. Further trips to Switzerland and Italy were taken in 1836, 1840, and in the four following years. He exhibited at the RA until 1850.

30. *Glacier and Source of the Arveiron, going up to the Mer de Glace* 1802–03

Watercolor, scraping over pencil
685 x 1022 27 x 40¼
Exh.: RA, 1803, no. 396; Grosvenor Place (Fawkes's house), 1819, no. 39; Leeds, *Exhibition of Paintings, Curiosities . . . at the Music Hall for the relief of the Mechanic's Institute*, 1839, no. 61, Leeds, City Art Gallery, *Turner Watercolors from Farnley Hall*, 1948, no. 4; Agnew, London, *Centenary Loan Exhibition of Turner Watercolours*, 1951, no. 45; Bath, The Holburne of Menstrie Museum of Art, *Turner Watercolours from Farnley Hall*, 1959, no. 1; New York, Gerson Gallery, *Turner Water-colours*, 1960, no. 9; VMFA, Richmond, 1963, no. 146; Agnew, London, *Turner*, 1967, no. 41; PML-RA, 1972–73, no.98; London, RA, *Turner*, 1974–75, no. 65, YCBA, *English Landscape*, 1977, no. 125; Toronto and YCBA, 1980–81, *Turner and the Sublime*, no. 24.
Lit.: F. Wedmore, *Turner and Ruskin*, 100, opp. p. 100; W. Armstrong, *Turner*, 1902, p. 246; Sir C. Holmes, "The Genius of J. M. W. Turner," *The Studio*, London, 1903, pl. 47; Finberg, *Turner*, pp. 101, 466, 481, 503; Hardie, II, p. 118; J. Russell and A. Wilton, *Turner in Switzerland*, Zurich, 1976, p. 45; Wilton, *Turner*, no. 370.
Coll.: Walter Fawkes and descendants until 1961; Agnew 1961. B1977.14.4650

The most profound demonstrations of the radical changes which took place in watercolor at the beginning of the nineteenth century were Turner's exhibition pieces. When the *Glacier and Source of the Arveiron* was shown at the RA in 1803, it was proof that watercolor could be used successfully as an alternative to oil in a work of complexity and ambition. Turner's achievement stemmed from two lifelong concerns: technical flexibility and the desire to expand the creative limits of his art. His refusal to give up watercolor in favor of the more respected medium, oil, led him to invent watercolor techniques that made it possible to use either medium equally. At the same time, his ambition to create important works of art made him attempt subject matter no watercolorist had

dealt with successfully before. In this work, he used a closed composition, rocky precipices, impenetrable mists, and a gloomy color scheme to achieve a sense of horror and claustrophobia which were associated closely with the eighteenth-century concept of mountains as sublime objects.

This watercolor was probably the first bought by Turner's patron and friend, Walter Fawkes of Farnley Hall. Fawkes acquired a number of Swiss watercolors from Turner and invited him to Farnley in Yorkshire, where the artist made a series of watercolors which Ruskin felt were "the culminating points of his career."[1] Fawkes was responsible for the first exhibition of contemporary watercolors in a private collection: in April 1819 he opened a suite of rooms in his London house to the public. In the first two he displayed twenty-five works by various members of the SPW — Glover, Varley, Nicholson, De Wint, and Fielding — but the strength of the collection was an apartment containing forty watercolors by Turner, including the Swiss subjects. A final room held twenty more sketches in bodycolor by Turner, executed at Fawkes's house in Yorkshire. With the exception of Girtin, the exhibition covered the entire range of watercolor's development over the last twenty years, and marked the extraordinary achievement of Turner and his contemporaries.

1. Ruskin, *Modern Painters*, in *Works*, III, p. 234.

30a. *The Devil's Bridge* c. 1803–04

Watercolor, white wax crayon, and scraping
1060 x 762 41¾ x 30
Exh.: Glasgow, Corporation Art Galleries, "Fine Art Loan Exhibition in Aid of the Royal Infirmary," 1878, no. 390; London, Guildhall, "Loan Exhibition of Works by J. M. W. Turner RA, and of a Selection of Examples by Some of his Contemporaries," 1899, no. 120; Birmingham, Art Museum, "Exhibition of Works by J. M. W. Turner," 1899.
Lit.: F. Wedmore, *Turner and Ruskin*, 2, 1900, opp. p. 256; W. Armstrong, *Turner*, 1902, p. 255; C. G. Holme, editor, *The Genius of J. M. W. Turner*, 1903, pl. 23; Webber, *Orrock*, 1, p. 99; A. Graves, *A Century of Loan Exhibitions 1813–1912*, 3, 1914, p. 1355; A. Wilton, *Turner in Switzerland*, 1976, pp. 60 and 135; Butlin & Joll, *Turner*, 1, p. 99; Wilton, *Turner*, p. 341, no. 360; Wilton, *Turner and the Sublime*, 1980, p. 116.
Coll.: Possibly W. Fawkes, W. H. Fawkes, E. Forbes-White—according to Guildhall catalogue of 1899; William Houldsworth, sale Christies, May 23, 1891, lot 30, bought in, William Houldsworth, sale Christies, May 16, 1896, lot

50; McLean; Thomas Mackenzie; Eleanor Clark, bequeathed to Joseph Clark (nephew); Mrs. DeCoursey Fales; E. V. Thaw. B1981.12

A brilliant watercolor of c. 1803–04, this recently rediscovered work is related to the series of large, finished Swiss subjects which Turner executed for Walter Fawkes (see nos. 29 and 30). Although the Guildhall catalogue of 1899 states that the work was in the Farnley collection, and that it belonged to W. H. Fawkes, the son of Turner's patron, there is no contemporary evidence to support the assertion.[1] In subject, however, it is directly linked to Fawke's watercolor *The Passage of St. Gothard taken from the Center of the Devil's Bridge* (Kendal).[2] It must have been conceived as a pair with the Kendal watercolor in the same way that Turner coupled two oils of *The Passage of St. Gothard* and *The Devil's Bridge* for John Allnutt in 1804.[3] Similarly, there is a large unfinished watercolor, *The Great St. Bernard Pass* (BM), which was probably meant as a pair with the *Mer de Glace* (no. 30). Why Turner completed the oils, but only one in each pair of watercolors, remains a matter of guesswork.

Compositionally, the watercolor is similar to another of Fawke's Swiss scenes, *The Fall of the Reichenbach* (Bedford), both works being constructed on strong architectural verticals and enclosed spaces which derive from Turner's earlier gothic interiors.[4] There is a preliminary study for the painting of *The Devil's Bridge* (BM, TB LXXV-34), but both sketch and finished oil differ in composition from this watercolor.[5] In all three, the artist employed an obscuring mist over the top half of the view, but in this case, a break in the clouds reveals distant snow-capped peaks, emphasizing by contrast the depth of the abyss. The sketch was used again in 1809 for a horizontal format print of the bridge.[6]

Technically, the watercolor is both innovative and informative, demonstrating Turner's tremendous advances over his contemporaries. Here, his layering of washes, his use of a brush dipped in water and a handkerchief for stopping out, his dry brush work for textural effects and scraping for lights are clearly seen. The beginnings of figures, goats and a bird, have been put in with white crayon, and the artist's fingerprints in wet pigment modelled the distant ridges and mountain peaks.[7] Compared to Glover's unfinished Thames scene (no. 21), Turner's watercolor is not only closer to completion: it is technically far more complex and impressive. Although it is not as polished as the *Mer de Glace* or the *Lake Geneva*, Turner may have considered this watercolor completed, and he might have exhibited it at his Harley Street Gallery in 1804. Perhaps he felt that at this stage, the values of suggestiveness and obscurity enhanced the power and gloom of the scene more than any amount of detail

could do. In ambition, technique, and composition, *The Devil's Bridge* demonstrates exactly why Turner was the pivotal figure for the development of exhibition watercolors.

1. London, Guildhall, "Loan Exhibition of Works by J.M.W. Turner RA," 1899, no. 120.
2. Wilton, *Turner*, no. 366.
3. Butlin & Joll, *Turner*, nos. 146 and 147.
4. Wilton, *Turner*, no. 367.
5. Wilton, *Turner in Switzerland*, 1976, p. 60.
6. Rawlinson, *Turner's Liber Studiorum*, 1878, p. 44, no. 19.
7. A contemporary's description of Turner at work on a watercolor, "he tore, he scratched, he scrabbled at it in a kind of frenzy," (recounted by Hawkesworth Fawkes, typescript by Edith M. Fawkes, National Gallery Library, London, quoted in Wilton, *Turner*, p. 104), further testifies to his aggressive manipulation of the medium.

31. Lake of Geneva with Mont Blanc *c.* 1803

Watercolor, gum, and scraping
714 x 1130 28⅛ x 44½
Insc.: Signed in pen and brown ink, LL: *JMW Turner RA*; and initialled on boat at left: *JMWT*; on wall at right, *ARRETE*.
Exh.: Grosvenor Place (Fawkes's London House), 1819, no. 25 (?); Fine Art Society, *John Ruskin's Collection of Turner's Drawings*, 1878, no. 68; London, RA, 1886, no. 12; YCBA, 1981, *Turner and the Sublime*, not in catalogue.
Lit.: Sir W. Armstrong, *Turner*, 1902, p. 254; Finberg, *Turner*, p. 480; YCBA, *Selections*, 1977; Wilton, *Turner*, no. 370.
Coll.: John Ruskin; J. Budgett and by descent to R. A. Budgett; sale Sotheby's, June 17, 1970, lot 17; bt. John Baskett, 1970. B1977.14.6301

Competing with the old masters, trying to outdo them in their particular field of achievement, was Turner's way of expanding his own creative limits. This was especially true for watercolor, which had a much narrower subject range traditionally than oils. Here, Turner used watercolor to create a lucid, tranquil composition along the lines of a painting by Claude. The transparent quality of his medium gave Turner's work a delicacy of atmosphere that fully equalled that of his model. It was this ability to create watercolors as strong as oils and his use of watercolor technique to give clarity to paintings that made Sir George Beaumont dislike Turner's works so heartily.

Lake Geneva was based on sketches Turner made while on his tour of Switzerland in 1802.[1] It was a most unusual example of Turner's Swiss pictures, though, which were mostly concerned with the desolate grandeur and sublimity of the mountains. In subject as well as in spirit, it is closer to Turner's Welsh

watercolors done around the turn of the century, for instance, the *Cader Idris* (private coll.) of c. 1799, where he was trying to rival the paintings of Richard Wilson.[2] The *Lake Geneva* was probably his last and greatest attempt to compete in watercolor with Claude. There is a smaller, untraced version of the scene of c. 1808.[3]

1. Probably taken from p. 35 of the *France Savoy Piedmont* sketchbook (BM), Turner Bequest LXXIII.
2. Wilton, *Turner*, no. 259, repr in color (detail) on p. 55.
3. Ibid., no. 382.

32. *Whiting Fishing off Margate* 1822

Watercolor, bodycolor, and scraping over pencil
430 x 646 16¹⁵/₁₆ x 25⁷/₁₆
Insc.: signed and dated in brush and brown ink, LL:
 JMW Turner RA 1822.
Engr.: In mezzotint by T. Lupton, 1825, reduced plate
 also made of this subject; chromolithograph by
 unknown engraver pub. by M. & N. Hanhart, c.
 1852–56.
Exh.: W. B. Cooke's Gallery, London, 1823.
Lit.: W. Thornbury, *The Life of J.M.W. Turner*, RA,
 1877, p. 634; Finberg, *Turner*, p. 485; Wilton,
 Turner, no. 507.
Coll.: B. G. Windus; Mrs. Fordham; Mrs. Henry
 Folland; Christies, Oct. 5, 1945, lot 5; bt. Mitchell
 Gallery; Robert Slack, 1980. B1980.31

Margate was a source of inspiration for Turner throughout his career. He executed over a dozen watercolors of the port, including his earliest extant drawings, done on a visit to his mother's relatives in the mid 1780s. This watercolor and its companion, *The Storm* (BM), were exhibited at Cooke's Gallery in Soho Square in 1823.[1] Cooke paid the artist £189 for the two.[2] Turner's lifelong habit of classifying landscape types is evident in his pairing of a calm sunrise with its opposite, a scene of wreckage and destruction. In this watercolor, he combined the accuracy of topography in his depiction of the fishermen's activities with a highly sophisticated technique and composition. His growing interest in capturing atmosphere and transient effects of color can be seen in the brilliantly observed sunlit sails, the details of the boats, and in the shimmering coastline. Turner executed another watercolor of Margate, a shore scene, for the *Southern Coast* series in approximately the same year.[3]

1. Wilton, *Turner*, 1979, no. 508.
2. W. Thornbury, *The Life of J.M.W. Turner, R.A.*, 1877, p. 634.
3. YCBA 1975.4.965, repr. in Wilton, *Turner*, no. 470.

John James Chalon, 1778–1854

Chalon's father brought his family from Geneva to England, where he became the Professor of French at Sandhurst. Chalon entered the RA schools in 1796. He first exhibited with the SPW in 1806, becoming a member the following year. In 1808, with Francis Stevens and his own brother Alfred, he founded the Society for the Study of Epic and Pastoral Design. The Sketching Society lasted till 1851, and Chalon attended 971 meetings. At the SPW's decision to admit oils, Chalon resigned and began to exhibit at the RA. He was elected ARA in 1827 and RA in 1841.

33. *Music: Composition in a Garden* c. 1832

Brush, gray and brown wash, over pencil, with
 contemporary mount watermarked 1832
323 x 451 12³/₄ x 17³/₄
Insc.: in pen and brown ink on mount, LL: *John J.
 Chalon*; BC: *Music/Sketched at a Meeting of a
 Society for the Practice of Design.*
Coll.: Mrs. Mavis Strange, 1972. B1975.4.1899

Not only in subject matter but in figure style, this Sketching Society design owes a debt to Stothard's *Decameron* illustrations of 1825. Along with Stothard, the Chalons helped to establish the vogue for Watteau inspired *fêtes galantes* during the late 1820s, both in drawings made at the evening meetings of artists, commonly known at this period as *conversazioni*, and in their exhibition pieces. Baudelaire described one of the brothers' work as "*Claude melé de Watteau, . . . belles fêtes d'après-midi dans les grands parcs italiens.*"[1]

1. Musée Rath, Geneva, *Deux Artistes Genevois en Angleterre*, 1971, catalogue by R. Loche, intro., n.p.

John Varley, 1778–1842

Varley was born in Hackney and apprenticed to a silversmith in 1791. Upon his father's death he gave up the apprenticeship and was studying drawing with J. C. Barrow by 1793, with whom he went on a sketching trip to Peterborough in 1797. The following year he exhibited at the RA and at this period studied with J. P. Neale. Around 1800 he became part of Dr. Monro's circle and later was a member of Cotman's Sketching Club. He toured Wales four times between 1799 and 1803, traveling part of the last tour with Cristall and Havell. With them, he was a founding member of the SPW, where he exhibited a total of 730 watercolors. As a teacher, his pupils included Cox, Fielding, Hunt, Linnell, Mulready, and Finch. By 1812

he charged a guinea per hour for lessons. His publications made his methods even better known: *A Practical Treatise on the Art of Drawing Perspective*, *Precepts of Landscape Drawing*, and a *Treatise on the Principles of Landscape Design*, all of which appeared between 1815 and 1821. In 1818 he met Blake, and it was at Varley's instigation, and in one of his own sketchbooks, that Blake drew his visionary heads. In 1828 Varley published the first part of his *Treatise on Zodiacal Physiognomy*, with engravings by Linnell, evidence of his lifelong interest in astrology. His brothers Cornelius and William were also artists.

34. *Harlech Castle and Tygwyn Ferry* 1804

Watercolor and bodycolor over pencil
392 x 515 15⅝ x 20¼
Insc.: Signed and dated in pen and black ink, LL: *J. VARLEY 1804*; on verso in later hand: *Teguin Ferry and Harlech Castle N. Wales/by J. Varley 1804.*
Exh.: SPW, 1805, no. 5; London, P. & D. Colnaghi and Co., and New Haven, Yale University Art Gallery, *English Drawings and Watercolours from the Collection of Mr. and Mrs. Paul Mellon*, 1964–65, no. 77; Victoria, 1971, no. 47: PML-RA, 1972–72, no. 119; YCBA, *English Landscape*, 1977, no. 171.
Coll.: Bt. from SPW in 1805 by Lord Ossulston; Agnew, 1962. B1975.4.762

After Girtin's death in 1802, Varley was the most assiduous promoter of his style and technique. For young artists and amateurs alike he was an inexhaustible fund of information, full of easily remembered sayings like "Nature wants cooking" or "Every picture ought to have a *look-there.*"[1] However, his greatest influence was not in his daily teaching but in his exhibition work. It was on the walls of the SPW's gallery that artists and the public alike looked for his most valuable lessons, for it was into his exhibition watercolors that he put his soundest, most careful planning. He was a prolific exhibitor, showing 703 works in his thirty-two years as a member of the SPW. His prices were generally in the low to middle range, thus making his exhibited "lessons" available to the modest collector or student. In the SPW's first exhibition, Varley had four views of Harlech Castle, ranging in price from thirteen guineas to as little as one and a half guineas.[2] The two most expensive were not sold, but the success of the present composition inspired Varley to make a second version for exhibition the following year (no. 118).

Like the majority of Varley's exhibited works, it is a partly topographic, partly poetic view. In it, his understanding of Girtin's technique is seen at its best and most natural. As his career advanced and the demands of his teaching increased, Varley's own method became more and more a formula, but here, the composition has a sense of breadth and repose approaching that of Girtin's finest late works.

1. Hardie, II, p. 101.
2. SPW Price Book, 1805.

35. *Dolbadern Castle* *c.* 1805

Watercolor, scraping, over pencil
502 x 663 19¾ x 26⅛
Exh.: SPW, 1805, no. 168; Agnew, 1963, no.7.
Lit.: Hardie, II, pl. 86.
Coll.: Bt. from SPW in 1805 by Mr. Ord; Agnew, 1963. B1977.14.4653

As a piece of topography, Varley's view of *Dolbadern Castle* leaves much to the imagination. This was exactly what the artist intended, however, for Varley set out to convey the mood rather than the details of the scene. Like Girtin, he approached landscape partly as topography, but more importantly as a vehicle for emotion or feeling. The particular mood of a landscape depended for them upon the association which came to mind upon viewing it. For Varley, the lake and castle brought forth a melancholic sense of past grandeur in ruin, of the inevitable changes wrought by time upon man's creations. Unlike earlier watercolorists of the Picturesque, like Rooker or Hearne, who would have utilized careful rendering of the broken textures of architecture and foliage to convey a sense of the past, Varley subordinated most of the details of the scene in order to bring out this mood as fully as possible. He also chose subdued colors reminiscent of J. R. Cozens's palette. Having worked at Dr. Monro's around 1800, he would have been brought into direct contact with Cozens's work.

Contrary to the practice of both Cozens and Girtin, Varley did not hesitate to add or alter pictorial motifs which would aid his purpose, as for example his inclusion of the foreground hillock and the two contemplative figures upon it. In this, his practice was akin to Turner's, who had exhibited a painting of *Dolbadern* in 1800 in which he achieved a sublime effect by dramatically heightening the hill upon which the castle was situated and by using strong contrasts of light and shadow in the stormy sky.[1] But for Varley, the view of Dolbadern Castle was more elegiac than sublime, and his debt to Girtin was far more important than Turner's influence.

Varley exhibited only three views of Dolbadern Castle, all before 1811. Perhaps the composition seemed old-fashioned and so not worth repeating as

his style evolved. This work, at least in pictorial method if not technique, does resemble Richard Wilson's eighteenth-century idyllic landscapes, such as his view of *Dolbadern Castle and Llyn Peris*.[2] But Varley continued to exhibit Welsh scenes such as this under a different guise. The same sort of mountain and ruined tower made regular appearances in his "compositions," which he exhibited frequently during the latter half of his career.

1. Coll. RA, repr. Butlin & Joll, *Turner*, no. 12.
2. Coll. National Gallery of Victoria, repr. W. G. Constable, *Richard Wilson*, 1953, pl. 37b.

36. Suburbs of an Ancient City 1808

Watercolor over pencil
702 x 940 27⅞ x 37 three one-inch strips added at bottom
Insc.: Signed in pen and black ink, LR: *J. Varley.*
Exh.: SPW, 1808, no. 163: SPW Loan Show, 1823, no. 196: Spink, 1973, no. 86.
Coll.: Bt. from SPW in 1808 by Thomas Hope; sale, Hope coll., Christies, July 20, 1917, lot 8; Basil Taylor. Mrs. Basil Taylor.

"With respect to classical designs of landscape," wrote John Varley in 1816,

> which exhibit the remains of towns and buildings, it will add much to the decision and variety which are required, if, generally, the ruins of stone walls, or arches of bridges, accompany the representations of pools of water which are near to them: for as our general associations of classic scenes require the introduction of buildings, and occasional straight forms and lines, there should be but few portions of the picture without some fragment, especially near the foreground.[1]

Varley thus set out what he felt were the necessary compositional elements in epic landscape. Eight years earlier he had expressed the same ideas even more fully in his major exhibition piece for 1808, *Suburbs of an Ancient City*. In it, he created an ideal landscape that was meant to elevate the viewer's mind, to make him think of the grandeur and simplicity of the ancients. To achieve this in landscape was a relatively new thing, but to do it in watercolor was even more innovative: only Turner had created watercolors of this ambition and scale before. Varley's written instructions were limited to listing the elements, or building blocks, of his composition, but his exhibition watercolor demonstrated *how* they were to be used. The arches, pools, fragments, and straight lines were all included and were meant to make the viewer think

of classical ruins in their original splendor. These elements were reinforced by the composition, with its balanced juxtaposition of horizontals and verticals. The sense of balance was never forced: every element, even the textures and the disposition of light were considered with careful regard to their importance and relation to the whole.

Varley added another dimension to the classical associations of his watercolor by basing it upon the ideal landscapes of Poussin. The latter's influence was particularly strong in the architecture and the structure of the foreground. The mountainous background, however, was certainly drawn from Varley's experience of Wales, and his clear washes gave a delicacy to the aerial distances which was possible only with watercolor. Varley's figures were classical, but as Taylor pointed out, the foreground figure of the old man was more suggestive of Blake than of Poussin.[2] Varley did not yet know Blake: the resemblance was probably due to the use of a common source, perhaps Ghisi's engraving after Michelangelo's *Abias*.[3]

Suburbs of an Ancient City was bought at the SPW exhibition by Thomas Hope, whose interest in the Antique had already been evidenced in the neoclassic remodeling of his London house as well as in his publications of 1807, *Household Furniture and Interior Decoration* and an essay in *The Director*, "The Utility of Remains of Antiquity." The latter was a defense of the recent purchase for the nation of the Townley collection of ancient sculptures. Hope paid £42 for the watercolor, the highest price Varley had yet charged for one of his works.[4] In 1823 Hope sent the painting to the SPW's first loan exhibition of watercolors, a historic survey of watercolor painting over the last generation. Then, as now, it represented a leading watercolor artist's ambitions and talents at their most impressive level.

1. Varley, *Treatise*, pl. F.
2. Spink, 1973, no. 86.
3. Repr. A. Blunt, *The Art of William Blake*, 1959, pl. 30A.
4. SPW Price Book, 1808.

37. Vauxhall Bridge c. 1815

Watercolor over pencil
240 x 378 11⁷⁄₁₆ x 14⅞
Insc.: On verso in pencil: . . . *hall Bridge.*
Exh.: Agnew, 1966, no. 61.
Coll.: A. R. Johnson; Thomas Agnew & Sons, 1966.
B1975.4.1621

38. The Thames near the Penitentiary 1816

Watercolor, gum, over pencil, laid down on card
292 x 409 11½ x 16⅛

Insc.: Signed and dated in pen and blue ink, LR: *J. Varley 1816.*

Exh.: Sheffield, Graves Art Gallery, *Early Watercolours from the Collection of Thomas Girtin Jr.,* 1953, no. 105; London, RA, *The Girtin Collection,* 1962, no. 77; Reading Museum & Art Gallery, *Thomas Girtin and some of his Contemporaries,* 1969, no. 67.

Lit.: B. S. Long, *List of Works Exhibited by John Varley,* OWSC, 2, 1925, pl. 3.

Coll.: Palser; T. Girtin, 1923; Tom Girtin; John Baskett, 1970. B1975.3.1080

Alongside his more elevated compositions and picturesque views in Wales, Varley exhibited a steady stream of scenes around London. Although this watercolor and the previous one cannot be identified positively as exhibition works, they may stand for the type, which was aimed at London viewers with local associations. Varley enabled his many pupils to try such subjects by taking a house each summer at Twickenham and encouraging them to spend much of their time sketching out of doors.[1] These studies were the material from which they drew finished works along the lines of these examples, which are too carefully composed and executed to be watercolors done on the spot. The subjects are unpretentious views, very much in the tradition of Sandby; yet both are typical of the compositional rules which Varley set forth in his *Treatise on the Principles of Landscape Design,* published in the same year that the view near the penitentiary was executed. In it, the crumbling building gave Varley the chance to demonstrate how to handle the textures of stone, plaster, and tile, and to juxtapose its solidity to the leafy trees on either side.

One of Varley's precepts was that in landscape "the execution of the figures must depend upon the broad and obvious, than on subtle and refined distinctions."[2] In both these examples the figures demonstrate his words. They are made up of a few simple touches of color which suggest rather than explain the details of costume. Such works, when exhibited, were often purchased by amateurs of watercolor, who, armed with a paint box and brush, wanted to learn something of his art by copying Varley's simpler compositions. W. H. Pyne objected strongly to watercolorists' catering to this demand. He felt that in these small, quickly turned out watercolors, "The artist is too frequently obliged to curb his fancy, and only display as small a portion of his faculty, just as much as amateurs may choose to dictate ere they purchase his works, not daring to copy more."[3]

1. A. T. Story, *The Life of John Linnell,* 1892, I, p. 25.
2. Varley, *Treatise,* 1816, general observations on pls. C & D.
3. *Somerset House Gazette,* p. 14.

Andrew Wilson, 1780–1848

A native of Edinburgh, Wilson was a pupil of Alexander Nasmyth (1758–1840). He came to London in 1797 and enrolled in the RA schools, but soon after traveled to Italy, where he studied at Rome and in Naples. After a brief visit to London in 1803, he settled for three years in Genoa, in spite of the French occupation, disguising himself as an American citizen. While there he collected old masters, and, after his return to London, the collection was auctioned in 1807 in London. Many of the pictures were left on his hands, including Ruben's *The Brazen Serpent,* now in the National Gallery, London. Wilson was a founding member of the AA but exhibited at the RA as well. He taught for a while at Sandhurst and from 1818 to 1826 at the Trustee's Academy in Edinburgh. In 1826 he moved permanently to Italy. His house was a center for visiting English artists, and he is mentioned frequently in Wilkie's Italian journal. He died while on a visit to Edinburgh.

39. *Tivoli* 1810

Watercolor, touches of bodycolor, and scraping over pencil

774 x 1181 29½ x 46½

Insc.: In pen and black ink, LL: *Andrew Wilson / 1810.*

Exh.: RA, 1811, no. 265; SPW Loan Exhibition, 1823, no. 102.

Coll.: Sir Robert Harry Inglis, Bart.; Lady Inglis; Sophie, Countess of Leven and Melville; Fine Art Society, 1975. B1977.14.357

Painted while he was living in London, Wilson's watercolor of *Tivoli* was probably based on sketches made during his three-year stay in Italy. His view shows not only the circular Temple of Vesta and the Temple of the Tiburtine Sibyl, but the entire range of the town and the surrounding landscape. Tivoli's associations with the Antique and its dramatic falls had made it a popular sketching spot since the seventeenth century. Wilson's watercolor was far from a sketch, though: it was an important, large-scale work which demonstrated that a watercolorist could produce works as strong as an oil painter. In fact, Wilson imitated the style of two of the most respected painters of the last generation, Richard Wilson and Phillip De Loutherbourg. From Wilson he took the balanced calm of his Italian compositions, and he included the popular device of a sketcher in the foreground, of which Wilson was particularly fond. De Loutherbourg's influence can be seen in the grandly conceived rocky structure of the landscape

and in the dramatic recession into deep space. But Wilson was not merely imitating oil paintings; he was capitalizing on watercolor's transparency, and he captured a sense of distant sunlit atmosphere that gives added grandeur to an already impressive view. Interestingly, in the SPW's first loan exhibition of 1823, the only watercolors of Tivoli were this one by Wilson and J. M. W. Turner's imaginary composition of 1817 (priv. coll.).[1]

1. Wilton, *Turner*, 1979, no. 495, pl. 168.

the other). Let those humbler intellects which can only understand common feeling and every-day life have, too, their little gentle gratifications. Why should not the poor in spirit be provided for as well as the tremendous geniuses? If a child takes a fancy to a penny theatrical print, let him have it; if a workman want a green parrot with a bobbing head to decorate his humble mantel-piece, let us not grudge it to him.[1]

1. Thackeray, *Stray Papers*, 1901, p. 211, reprinted from the *Pictorial Times*, April 8, 1843, no. 2, *The Objections against the Art Unions*.

Alfred Edward Chalon, 1781–1860

The younger brother of John James, Chalon was born in Geneva as well. He entered the RA schools in 1797 and was a member of the AA in 1808. The same year he was a founding member of the Society for the Study of Epic and Pastoral Design, and he attended 874 meetings between 1808 and 1851. He first exhibited at the RA in 1810 and in 1812 was elected ARA, becoming a full RA in 1816. He was best known for small, full-length watercolor portraits. He was Painter in Water-Colours to Queen Victoria.

40. Gil Blas c. 1820–1822

Brush and brown wash over pencil, with contemporary mount
315 x 340 12⅜ x 13⅜
Insc.: In pen and brown ink, on mount, LL: *A.E. Chalon*; at bottom center: *Gil Blas and the Doctor Cuchillo / Nous eûmes le tems de nous donner quelques coups de poing et de nous arracher l'un / à l'autre une poignée de cheveux avant que l'Epicier et son parent present nous separer.*
Coll.: Abbott and Holder, 1974. B1977.14.4310

The modified ambitions of watercolor artists were seen most clearly in the evolution of the subjects which they chose to draw at the Sketching Society. Earlier poetic landscape inspired by the works of Thomson, Cowper, and Collins, gave way in the 1820s to anecdotal figure pieces inspired by popular historical novels and publications of medieval costume and armor. This, as well as Cristall's and Uwins's drawings (no.s 22 and 45), are examples of this later type, illustrations to Le Sage's picaresque novel *Gil Blas*. Thackeray, tongue in cheek, defended this humbler genre, admonishing artists not to

neglect your little picture out of "Gil Blas" or "The Vicar of Wakefield" (of course it is one or

John Sell Cotman, 1782–1842

A native of Norwich, Cotman came to London in 1798. First employed coloring prints at Ackermann's Repository, he was taken up by Dr. Monro in 1799. The following year he exhibited six drawings at the RA and was awarded the Large Silver Palette by the Society of Arts. The same year, he visited Bristol and south Wales. About the time of Girtin's departure for Paris in 1801 he became a member of the Sketching Society and eventually its head. With P. S. Munn he toured north Wales in 1802 and Yorkshire and Lincolnshire in 1803. Over the next two years he made extended visits to Yorkshire, staying with the Cholmeley family at Brandsby and with John Morrit at Rokeby Park. He returned to Norwich in 1806 and joined the Norwich Society of Artists, of which he was president in 1811. Dawson Turner became his chief patron about this time: Cotman worked at Yarmouth in 1812 for him, and he toured Normandy in 1817, 1818, and 1820 at Turner's urging. *The Architectural Antiquities of Normandy*, published in 1822, was the result of these visits. Three years later, he was made an exhibitor of the SPW. In 1834 he returned to London to become the drawing master at Kings College School. His son Miles Edmund (1810–1858) was also an artist.

41. Bridge in a Continental Town c. 1830

Watercolor and bodycolor over pencil, laid down on card
349 x 521 13¾ x 20½
Exh.: Norwich, Castle Museum, *Loan Collection of Drawings in the New Picture Gallery*, no. 59; London, Tate Gallery, *Exhibition of Works by John Sell Cotman and Some Related Painters . . .*, 1922, no. 104; Victoria, 1971, no. 6.
Lit.: W. F. Dickes, *The Norwich School of Painting*, 1905, p. 348.
Coll.: Said to have been bought from Cotman's widow by the Geldart family; Agnew, 1967. B1975.4.1901

When the SPW first opened its gallery in 1805, Cotman was conspicuously absent. By that date, he had become a well-respected figure in the field of watercolour painting. He exhibited at the RA from 1800, worked under the patronage of Dr. Monro, and became the head of Girtin's Sketching Society around 1802. He was singled out by a fellow artist that same year, along with Turner and Girtin, as one of the three leading watercolorists in London.[1] As such, his noninvolvement with the SPW seemed inexplicable. It has been discovered recently in the family papers of the Cholmeleys, Cotman's Yorkshire patrons, that he was blackballed. The reason is still a mystery, but Mrs. Cholmeley felt that "he must have some personal enemies among them."[2] Whatever the reason, his failure to be elected must have contributed to his decision to leave London for Norwich in 1806. He exhibited with the AA in 1810–11, but it was not until 1825 that he was elected an exhibitor at the SPW.

By this date, his palette had intensified, with striking reds, blues, and greens which were in complete contrast to his former restrained work. For his purpose, though, which was to make the works stand out in a crowded room, the bright color scheme made sense. But his keyed-up palette was not entirely due to the pressures of exhibiting in London again. Since the beginning of his career, Cotman, like many others, had admired and emulated the paintings of the old masters. Early drawings such as his *Harlech Castle* and *Classical Landscape* (Norwich) of around 1809 show Cotman working under the influence of Poussin.[3] But there were other masters whom Cotman admired even more for their use of color. In his work of the 1820s and 1830s, his use of deeply saturated blues and reds was a sign of his continued interest in the Venetian school, and, in particular, the Bellinis. Dawson Turner, Cotman's friend and patron, owned a Giovanni Bellini (now at Birmingham) which Cotman must have studied with care.

Cotman's statement to Turner, that "City and Town Scenery & Splendid Architecture mixed up with Elegant Landscape make up the compositions of the day," sums up his own exhibition work in the 1830s.[4] The present example is a rich jumble of every current exhibition subject: picturesque figures punctuate the foreground, while an imaginary town full of "Splendid Architecture" fills the middle ground, backed immediately by a range of mountains. Even portraiture is not left out: there is a tradition that the dark figure in the foreground is Cotman himself.[5] The arch in the center of the scene may be a reminiscence of the bridge at Toledo, while the domed cathedral might be an interpretation of the Superga near Turin. Cotman could have known these only through paintings or engravings, but that made little difference in a work of "splendour and imagination."

1. Rajnai and Allthorpe-Guyton, *Cotman*, 1979, p. 15.
2. Ibid.
3. Ibid., pls. 65, 66.
4. Cotman to Turner, Nov. 25, 1828 (see p. 11).
5. Note from Agnew in drawing's file.

William Havell, 1782–1857

Havell was born at Reading into a large family of artists. His early education must have come from his father, who was a drawing master. On a tour of Wales in 1802 he met the Varleys and Cristall. By 1804, the first year he exhibited at the RA, he was living in London. At the age of twenty-three, he was the youngest member of the SPW at its foundation in 1805. In 1807 he toured the Lake District with Reinagle and in 1812 was at Hastings with Cox. The same year he published *A Series of Picturesque Views of the River Thames* and until 1816 worked as an illustrator for *Peacock's Polite Repository*. In 1815 the BI rejected his *Walnut Gathering at Petersham*, which probably contributed to his decision to accompany Lord Amherst's embassy to China in 1816. He left the ship in 1817, however, and went alone to India, where he supported himself for eight years by painting portraits in watercolor. On his return to England, he rejoined the SPW in 1827, but in 1828 went to Italy, where he worked in company with Uwins. Returning to England in 1829, he exhibited at the RA, BI, and SBA, but his works were no longer popular. He died a pensioner of the RA.

42. *Pale Melancholy* c. 1804

Brush and gray wash over pencil
281 × 398 11 1/16 × 15 11/16
Coll.: Mavis Strange, 1972. B1975.4.1814

This drawing, as well as Munn's version of the subject (no. 25), demonstrates the way in which the early sketching societies used poetic passages to elevate landscape. The theme came from William Collins's poem *The Passions, an Ode for Music*, lines 57–68. Two further drawings executed the same evening by Joshua Cristall and John Varley are in the VAM.[1] Both of these are more pastoral and elegiac than Havell's, which, although it is an idealized composition, is based upon memories of the mountains and streams of Wales that he had sketched on tours made in 1802 and 1803. On the basis of style, both the VAM's drawings as well as the Havell and Munn can be dated c. 1804, the year in which Cristall joined the Society. It has been stated that Havell's involvement with the Sketching Society did not begin until 1809, but the present work and his *Death of Milo* (VAM), a monochrome drawing

of the same period, demonstrate that he was at least twice a visitor at Cotman's Sketching Society five years earlier.[2]

1. VAM, *Sketching Society*, pls. 14 and 15.
2. A. Bury, "William Havell," OWSC, 26, 1948, p. 6; and Reading, *Havell*, 1970, p. 3.

43. *Landscape with Figures* c. 1804

Watercolor, scraping, gum, over pencil, laid down on card
439 x 403 17¼ x 15⅞
Exh.: Sheffield, Graves Art Gallery, *Early Water-colours from the Collection of Thomas Girtin Jr.*, 1953, no. 58; Reading Museum and Art Gallery, *Thomas Girtin and some of his Contemporaries*, 1969, no. 92.
Coll.: G. W. Girtin; T. Girtin; Tom Girtin; John Baskett, 1970. B1975.3.961

For the first three years of his membership in the SPW, approximately one-third of Havell's exhibits were of subjects in Wales. On his tours there in 1802 he met the Varleys, and the following year met Cristall and worked in company with Benjamin Barker, who was later a member of the AA. Although it is not possible to connect this watercolor with an exhibited work, it probably dates from this early period in Havell's career. In style and subject it is similar to his *Retirement* (coll. Mrs. B. Knight), and both represent a characteristic modern English pastoral, usually a scene in Wales or the Lake District, in which the presence of shepherds or peasants underlined the idyllic nature of the scene.[1] Francis Stevens's *Romantic Landscape* of 1812 (Whitworth Art Gallery) is a further example of this type, which was popular for the first fifteen years of the SPW's existence.[2]

1. Repr. in Reading, *Havell*, 1970, pl. 2, cat. no. 5.
2. D.104.1892.

44. *Carew Castle, Pembrokeshire* 1805

Watercolor, scraping, and gum over pencil
528 x 727 20¾ x 28⅝
Insc.: Signed and dated in pen and black ink, LL: W. HAVELL / *1805*.
Exh.: SPW, 1805, no. 95; Empire Art Loan Exhibition Society, *Early British Watercolours*, Australia, 1948–49, no. 87; Worthing Art Gallery, *English Watercolors from the Whitworth Art Gallery*, 1956, no. 28; Reading, *Havell*, 1970, no. 4; Spink, 1973, no. 33.
Lit.: F. Owen, "William Havell," *Connoisseur*, Feb. 1978, p. 96, repr. pl. 100A.

Coll.: Bt. 1898 by the Whitworth Art Gallery. D.2.1898. Whitworth Art Gallery, Manchester.

Exhibited at the SPW in 1805, *Carew Castle* demonstrates why, at the age of twenty-three, Havell was invited to join in the first exhibition. His ambitions and his command of watercolor technique, even at this early stage in his career, equalled those of the strongest members of the Society. This work shows the influence of Turner in the coloring and in the elaboration of the foreground and foliage, but it is closer to Turner's earlier watercolors of around 1800, like *St. Agatha's Abbey, Easby, Yorkshire* (Whitworth), than to his more ambitious works like the *Glacier and Source of the Arveiron* (no. 30) and the *Lake of Geneva* (no. 31).[1] Later in his career, Havell considered that, in oil at least, he was on a par with Turner. He even felt that in his painting *Walnut Gathering at Petersham* (SPW, 1815, no. 128), which was refused by the BI, he had surpassed Turner.[2] The fact that most of his contemporaries did not agree with him probably contributed to his decision to leave England in 1816.

1. Wilton, *Turner*, 1979, no. 274.
2. Roget, I, p. 296.

Thomas Uwins, 1782–1857

Born in Pentonville, Uwins was apprenticed to an engraver, Benjamin Smith, on Boydell's recommendation. At the age of sixteen he was admitted to the RA schools and first exhibited there in 1799. He supported himself by teaching and by watercolor portraiture, but soon found more employment making drawings for publishers like Thomas Tegg and Ackermann. He drew the fashion plates for Ackermann's *Repository of Fine Arts* and occasionally wrote for the magazine under the name "Arbiter Elegantarium." He became an exhibitor at the SPW in 1809 and was a member the following year. He served as secretary in 1813, 1817, and 1818, the year in which he retired to devote himself to book illustration in order to pay off a debt. He visited France in 1817 and in 1820 settled in Scotland, first at Perth and then in Edinburgh. He was elected a member of the Sketching Society in 1821 and remained an honorary member after his departure for Italy in 1824. Until 1831 he lived in Italy. On the strength of his Italian subjects he was elected ARA in 1832 and RA in 1838. In 1845 he was appointed Surveyor of the Queen's pictures, and in 1847 he succeeded Sir Charles Eastlake as Keeper of the National Gallery. In 1855 he retired to Staines.

45. Gil Blas c. 1820–1822

Brush and brown wash over pencil, with contemporary
 mount
325 x 419 12¾ x 16½ (image)
442 x 520 17⅜ x 20½ (sheet)
Insc.: Signed in pen and brown ink on mount, LL: *T.
 Uwins*; at bottom center: *Gil Blas while practising
 medicine under Dr. Sangrado / encounters Dr.
 Cuchillo at the bedside of the Grocer.*; bottom
 right: *Le petit médecin me dit en souriant D'un air
 plein de malice: / Vous croyez que ces remédes lui
 sauveront la vie? / Gil Blas.*
Coll.: Abbott and Holder, 1974. B1977.14.4336

Uwins was elected a member of the Chalon Sketching
Society in 1821, but resigned at the end of that year
because he was unable to attend their meetings. He
remained in close touch with many artists in the
group, however, and rejoined them in 1831 upon his
return from Italy. The first written account of the
Society appeared in his *Memoirs.*[1] For other examples
of Sketching Society drawings taken from Le Sage's
Gil Blas, see Cristall (no. 22) and A. E. Chalon
(no. 40).

1. Uwins, *Memoir*, I, pp. 163–207.

46. Festa di San Antonio, Bay of Naples c. 1840

Watercolor and touches of bodycolor over pencil,
 squared in pencil
182 x 838 7⅛ x 33
Coll.: Fine Art Society, one of a pair, 1978. B1978.36.4

Uwins made his name at the SPW with rustic pastorals:
gleaners, lacemakers, and hop pickers executed in a
style influenced by Cristall and Heaphy. The first half
of his career as an exhibitor ended in 1818, when he
resigned from the SPW. After a hiatus of twelve years,
Uwins returned to exhibiting, this time in oils at the
RA. During his six-year residence in Italy, his figure
style lost the monumental simplicity it had had under
Cristall's influence. He developed a lighter style,
becoming a painter of the continental picturesque. He
was elected RA on the strength of his pretty genre
scenes of Neapolitan life, like *An Italian Mother* (RA),
which he exhibited from around 1830 onward.

 This is an unusual example of a finished
compositional study in watercolor for an exhibited
oil. Figure painters often used watercolor in their
studies: Wilkie made brilliant sketches of this sort for
many of his paintings. It was rare, however, for a
painter to make as complete a watercolor as this in
preparation for an oil. Uwins's early training in
watercolor must have made it a comfortable medium

for working out his composition, and perhaps he felt
he could sell the smaller finished watercolor at a
provincial exhibition, while saving the more impressive
oil for the RA. Uwins exhibited two scenes of the Festa,
the first in 1839 and a second, to which this work is
probably related, in 1841. His repetition of the theme
was a matter of expediency rather than of choice:
patronage demanded that he produce the sort of work
for which he was best known. In 1841, the same year
that the painting *The Bay of Naples on the 4th of June;
various Groups returning from the Festa of Saint
Antonio* was exhibited, Uwins wrote: "The public
have chalked out a course for me; because I have done
some Italian subjects successfully, no one will have
anything else from my hand, and they who 'live to
please must please to live.' "[2]

1. *The Hop Gatherer*, VAM 260-1876 is a typical example of his
 early exhibition watercolor style.
2. Uwins, *Memoir*, I, p. 108.

David Cox, 1783–1859

Born at Deritend near Birmingham, Cox studied at
Joseph Barber's drawing school and with a miniaturist
named Fieldler in 1798. Around 1800 he was painting
stage scenery for the Birmingham Theatre Royal.
Moving to London in 1804, he took lessons from John
Varley and exhibited at the AA in 1809. President of
that Society in 1810, he was elected an exhibitor of the
SPW after the closing of the AA's last show. In 1813 he
was a full member of the SPW. For the next twelve
years he continued to teach extensively and he
published several manuals, including a *Treatise on
Landscape Painting and Effect in Water Colour*
(1814), *Progressive Lessons on Landscape for Young
Beginners* (1816), and *The Young Artist's Companion*
(1825). The following year he visited Belgium and
Holland, and he was in France in 1829 and 1832. He
took up oils in 1839 and two years later moved to
Birmingham. Between 1844 and 1856, he spent a part
of each year at Bettws-y-Coed in Wales.

47. Millbank c. 1812

Watercolor over pencil, scraping
279 x 540 11 x 21¼
Exh.: Cox, 1976, no. 5.
Coll.: Davis and Long, 1976. B1977.14.134

Most of Cox's early career was spent as a teacher, first
of private pupils, later as a drawing master at the
Military College at Farnham, and then at a ladies'
seminary in Hereford. He reached an even larger

audience with his drawing manuals, beginning with his *Treatise on Landscape Painting* (1814), in which were shown "the appropriate effects of Nature, adapted to the different characters of Landscape composition."[1] The influence of his teacher John Varley is evident not only in Cox's method of teaching by "effects" but in the landscapes he was producing at this stage in his life, as in the present Thames scene. There is a Varley watercolor of almost the identical view but dated 1816; perhaps the two sketched it together but Varley chose not to work up his drawing into a finished watercolor until a few years later.[2] The drawings differ in one important respect, though. In his palette of this period Cox preferred the warm, reddish tints of Girtin to Varley's more silvery colors. While Varley recommended three blues, cobalt, Prussian, and Indigo, Cox was satisfied with Indigo alone.[3] The latter is one of the most fugitive of pigments, and as a result of its use, Cox's watercolor has faded badly, and the sky has disappeared completely.

1. D. Cox, *A Treatise on Landscape Painting*, 1814, Introduction, n.p.
2. Winchester College coll.
3. "John Varley's list of Colours," 1816, reprinted in Hardie, II, p. 106. Cox's palette is given in his *Treatise*.

48. Antwerp — Morning 1832

Watercolor over pencil
181 x 250 7⅛ x 9⅞
Insc.: Signed in brush and red ink, LL: *D. Cox / 1832*; inscribed in pencil on verso: *Antwerp mor*[nin]*g*.
Exh.: SPW, 1832, no. 47; Cox, 1976, no. 27.
Lit.: Wilton, *British Watercolours*, p. 181, pl. 6.
Coll.: Davis and Long, 1976. B1977.14.137

Two versions of this view were executed, the present one and a later watercolor which was reproduced in the 1845 edition of Ackermann's *Art of Painting in Water-colours*. Both were based on sketches made during his 1826 journey through Belgium and Holland. This one shares with Barret's atmospheric morning effects a warm color scheme, but in the overall treatment owes more to Turner's work of *c.* 1820–25, like his *Whiting Fishing off Margate* (no. 32) and to Bonington's coastal scenes. Cox usually sold such small exhibition watercolors for ten guineas at this period: they were often bought for the portfolios of collectors like Mrs. Haldimand (see p. 28).

49. On the Moors, near Bettws-y-Coed 1856

Watercolor and some bodycolor, laid down on card
455 x 666 17⅞ x 26¼
Insc.: On verso in pencil: *on the moors near Bettsw-y-Coed - N.W.*
Exh.: SPW, 1856, no. 179; VAM, *Forty-two Watercolours*, 1977, no. 34.
Lit.: L. Binyon, *English Water-Colours*, 1933, p. 145; T. Cox, *David Cox*, 1947, p. 110, repr. p. 120; N. Solly, *A Memoir of the Life of David Cox*, 1873, p. 286; VAM, *British Watercolours*, 1980, pp. X, 87.
Coll.: Rev. Chauncey Hare Townshend; bequeathed to VAM, 1869. VAM 1427-1869. Victoria and Albert Museum, London.

As John Murdoch has pointed out, this watercolor was one of Cox's most successful embodiments of the Burkeian Sublime.[1] The landscape is vast, obscure, dark, full of rough, irregular lines and abrupt changes. Added to this is Cox's juxtaposition of the awesome strength of the storm to the angry defiance of the bull.[2] The artist must have been frustrated by the reviews of his exhibition pieces during the 1850s: he was repeatedly praised for his dashing execution and his wet, windy effects. But these were his means, not his end: as he himself put it, his exhibition watercolors were *"the work of the mind."*[3] His pictures were an intensification of the old-fashioned associative art of his youth, where landscape served to communicate an intellectual idea or a mood. Although he was willing to adopt stronger techniques as he grew older, he remained true to the spirit of early exhibition watercolors, when most of his coexhibitors were concentrating on high finish and Pre-Raphaelite "truth" of detail instead. The wide gulf between Cox's creative approach and that of many other artists in the 1850s is evident in a comparison between this work and Lewis's *Frank Encampment* (no. 80), which hung in the same SPW exhibition in 1856. Ruskin wrote how Cox's "drawings of English moors . . . gain in gloom and power by the opposition to the Arabian sunlight; and Lewis's finish is well set off by the impatient breadth of Cox."[4]

1. VAM, *Forty-two Watercolours*, 1977, no. 34.
2. Three years before *On the Moors* was shown, Cox executed a watercolor of two bulls confronting each other across a rocky gorge, entitled *The Challenge* (Ashmolean). This was perhaps inspired by Landseer's painting exhibited at the RA in 1844, *Coming Events Cast their Shadows before them, or The Challenge*, and the tradition of using animal to represent human passions can be traced even further, back to James Ward, Sawrey Gilpin, and George Stubbs.
3. Roget, II, p. 162.
4. Ruskin, *Academy Notes*, 1856, in *Works*, XIV, p. 78.

Samuel Prout, 1783–1852

Born at Plymouth, Prout was employed in 1801 by John Britton to make drawings for his *Beauties of*

England and Wales (1803–13). He moved to London with Britton in 1802, toured the southeast of England in 1803–04, and returned to Devonshire in 1805. By 1808 he had returned to London, joining the AA in 1810 and the SPW in 1819, where he exhibited 511 watercolors during his career. The same year he made his first trip to the Continent, visiting northern France. In 1821 he toured Belgium and the Rhine and in 1824 was in Italy. Later visits to Germany and Switzerland provided more material for exhibition work, which after 1819 was made up entirely of continental views. He published a number of drawing manuals, including *Bits for Beginners* (1817), *Progressive Fragments* (1817), *Prout's Drawing Book* (1820), and *A Series of Easy Lessons in Landscape Drawing* (1820). In 1845 he became Ruskin's neighbor at Denmark Hill.

50. *The Porch, Rheims Cathedral* c. 1840

Watercolor, bodycolor, pen and brown ink, some scraping
421 x 273 16⅝ x 10¾
Insc.: Signed in brush and brown ink, LR: *S Prout*.
Exh.: Agnew, 1967, no. 167; Victoria, 1971, no. 29.
Coll.: A. E. Peacock; Agnew, 1967. B1975.4.1360

Aside from his regular exhibits at the SPW, Prout

> had established a useful and steady connection with the country dealers — that is to say, with the leading printsellers in the country towns and principal watering places. He supplied them with pretty drawings of understood size and price, which were nearly always in tranquil demand by the better class of customers. The understood size was about ten inches by about fourteen or fifteen, and the fixed price, six guineas. The dealer charged from seven to ten, according to the pleasantness of the drawing.[1]

The present watercolor is an example of this type; small in scale, yet with pleasant pen work and warm coloring. Prout's method had much in common with eighteenth-century topographers — he "seems to have had a regular mechanical system in preparing his drawings, laying them in sepia, or brown and grey, the outlines gone over with a pen in which warm brown colour was used."[2] Like Edward Lear, Prout was primarily a draughtsman rather than a painter in watercolors. His exhibition watercolors were usually more elaborate than this one and of a higher price.

1. J. Ruskin, *Notes by Mr. Ruskin on Samuel Prout and William Hunt*, 1879, p. 43.
2. Roget, II, p. 478.

Thomas Sully, 1783–1872

British by birth, Sully moved with his family from Horncastle to Charleston, South Carolina, when he was nine. He studied at Richmond and in 1801 at Norfolk, Virginia, and in 1806 he went to New York. The following year he was in Boston, where he met Gilbert Stuart. In 1809 he settled in Philadelphia. Patrons there financed the artist's trip to London the same year, where he was influenced not only by Benjamin West and Sir Thomas Lawrence, but by Turner and the new watercolor school headed by Varley, Havell, and Glover. He returned to Philadelphia in 1810, and did not visit England again until 1838, when he painted a portrait of Queen Victoria. He remained based in Philadelphia, although he traveled for his portrait commissions.

51. *Page from a Notebook with Pigment Samples*
 c. 1814–38

Watercolor, pen and brown ink, on buff wove
298 x 241 11¾ x 9½
Insc.: In pen and brown ink, numerous color notes relating to each pigment sample.
Coll.: Langdon Sully, sale, Christies, Feb. 22, 1966, lot 68. Mr. and Mrs. Paul Mellon.

52. *Page from a Notebook with Pigment Samples*
 c. 1814–38

Watercolor, pen and brown ink, on buff wove
298 x 235 11¾ x 9¼
Insc.: In pen and brown ink, numerous color notes relating to each pigment sample.
Coll.: Langdon Sully, sale, Christies, Feb. 22, 1966, lot 68. Mr. and Mrs. Paul Mellon.

Sully visited London in 1809–10 to study portrait painting and the great works of art in English collections. While there, he must have become interested in the recent advances in watercolor, and he may have met John Varley or some of his associates. After his return to Philadelphia in 1810, Sully began a notebook on watercolor, which he continued to use until 1838. The pigments noted on these two pages were based on Varley's recommended list of colors, published in 1816.[1] Further pages were devoted to Varley's exercises in beginning and forwarding a landscape, and to making copies of watercolors by the leading artists of the day, including Turner, Girtin, and Havell. Later notes on color schemes were taken from Frank Howard's *Colour as a Means of Art* (1838).

The freshness of the color samples on these pages demonstrates what an early nineteenth-century

palette looked like when unfaded by exposure to sun. The notes that accompany them vary from suggestions on how they should be used — for example, Burnt Sienna is good "for rich banks of earth in Evening Sunshine" — to comments on the durability of a color like purple lake: "it is less liable to fade than brighter lake." The second page has directions on how to mix the primary colors, Gamboge, Indigo, and Vermillion, to get secondary and tertiary colors. Sepia, Sully wrote, was "useful for sketching."

1. Repr. Hardie, II, p. 106.

Peter De Wint, 1784–1849

Of Dutch parentage, De Wint was born in Stone, Staffordshire. He was apprenticed in 1802 to the engraver John Raphael Smith, who let him leave after four years in exchange for eighteen oil paintings, to be executed and delivered over the next two years. In 1806 he shared lodgings with William Hilton near John Varley's house. He took lessons from Varley, met Dr. Monro, and visited Lincoln with Hilton all within that year. The following year he exhibited three drawings at the RA, and in 1808 he exhibited with the AA and at the BI. He entered the RA schools in 1809. In 1810 he was an exhibitor at the SPW and married Hilton's sister Harriet. He became a full member of the SPW in 1811. Between 1814 and 1816, he was making illustrations for Cooke's *Picturesque Delineations of the South Coast of England*. He traveled to France in 1828, his one trip abroad, and subsequently made tours of England and Wales. Between 1827 and 1841 he made several drawings for *The Oxford Almanac*.

53. Harvesters in a Landscape in Sussex c. 1820

Watercolor over pencil, scraping
655 x 981 25 ¾ x 38 ⅝
Lit.: Sir W. Armstrong, *Memoir of Peter De Wint*, 1888, pl. 19.
Coll.: Charles Frederick Huth; Christies, July 6, 1895, lot 65, bt. Vokins; Josiah Vavasseur, of Kilverstone, Thetford, Norfolk; Second Lord Fisher; Third Lord Fisher; Christies, Nov. 9, 1976, lot 132; Somerville and Simpson, 1977. B1977.14.140

Throughout his career, De Wint modified his loose, suggestive style to meet the exigencies of the exhibitions. The degree of finishing which he lavished on his exhibition watercolors is demonstrated by *The Cricketers* (VAM) of 1815 and *The West Front of Lincoln Cathedral* (VAM), exhibited in 1841.[1] Both show how De Wint was influenced by what was currently popular at the SPW: the former was influenced by Cristall and Reinagle's large figure pieces, while the latter owes a debt to Prout and Mackenzie. In the context of his daily work, these are formal and somewhat dry, but impressive in size and technical elaboration; both were probably De Wint's most ambitious exhibition watercolors in their respective years. But he showed less monumental works as well, as in the present watercolor, where the artist combined his wet transparent wash technique with carefully amplified foreground figures and foliage. In spite of Uwins's statement in 1811 that "hay-making, reaping, etc., are general, and known to everybody, and this is against it as an exhibition scene," De Wint exhibited numerous harvest scenes.[2] This one probably dates from around 1815–20 and is comparable to his oil *A Cornfield* (VAM), which was shown at the RA in 1815 and, like most of his oils, remained unsold during his lifetime.[3] His exhibition watercolors, however, were always in demand, as were his services as a teacher.

1. VAM, nos. 515 and 1021–1873. The latter is reproduced in D. Scrase, *Drawings and Watercolours by Peter De Wint*, Cambridge, 1979, pl. 47.
2. Uwins, I, p. 35.
3. Repr. in Tate, *Landscape*, no. 260, pp. 108–09.

54. Study for 'Elijah' 1828

Pen and brown ink
181 x 280 7 ⅛ x 11
Lit.: H. Smith, "Some recently discovered studies for Peter De Wint's 'Elijah,' " *Burlington Magazine*, 121, Sept. 1979, pp. 582–83, repr. fig. 36.
Coll.: Hammond Smith. B1980.41.1

55. Study for 'Elijah' 1828

Pen and brown ink
242 x 410 9 ¹⁵/₁₆ x 16 ⅛
Lit.: H. Smith, "Some recently discovered studies for Peter De Wint's 'Elijah,' " *Burlington Magazine*, 121, Sept. 1979, pp. 582–83, repr. fig. 37.
Coll.: Hammond Smith. B1980.41.2

In 1829 De Wint exhibited a now lost watercolor, *Elijah* (SPW, no. 147), which was accompanied in the catalogue by a quote from 1 Kings (19th: 19–20). It was bought by Lady Cawdor for eighty guineas, the highest price De Wint ever received for a watercolor.[1] The work was described by a contemporary critic as "a classical composition, being a new feature in the practice of an artist who has hitherto . . . devoted his rare talents to the familiar and ordinary characters of landscape."[2] Perhaps inspired by his brother-in-law,

William Hilton, a history painter and Keeper at the RA, De Wint once again abandoned his usual practice and produced an ambitious and elaborate exhibition watercolor. This and the following drawing are two of five extant studies for the composition. Both show that De Wint relied on the pen and ink style of seventeenth-century Italian masters like Rosa, Claude, and Guercino to help in the working out of his composition. The two drawings come from an album of the artist's drawings put together by his granddaughter, Miss H. H. Tatlock. One other figure study for the watercolor was recently on the London art market.[3]

1. Mrs. De Wint's price lists of the artist's works, Usher Art Gallery, Lincoln.
2. *Literary Gazette*, 1829, p. 307.
3. Christies, March 2, 1976, lot 70.

Anthony Vandyke Copley Fielding, 1787–1855

Born at East Sowerby, Yorkshire, Fielding was one of four brothers, all artists in watercolor. His family moved to the Lake District in 1793, and in 1807 he was in Liverpool, teaching drawing and selling his works. He toured Wales in 1808 and the following year moved to London, where he became one of the Varley circle. An exhibitor at the SPW in 1810 and a full member in 1812, Fielding was to exhibit 1,748 watercolors on the SPW's walls. Treasurer in 1817, secretary in 1818, and acting president upon Cristall's retirement to the country in 1822, Fielding was made president officially in 1831, remaining in office until 1854. He lived for some years in coastal towns: from 1817 to 1819 he was in Hastings, from 1829 to 1847 at Brighton, but he always maintained a London studio. He died at Worthing.

56. *Landscape with Limekiln* 1809

Watercolor, scraping, and gum over pencil
232 x 321 9 1/8 x 12 5/8
Insc.: Signed and dated, scraping out LL: *C.V.F. 1809.*
Exh.: YCBA, *English Landscape*, 1977, no. 191, pl. CLVII.
Coll.: L. G. Duke, (3178); Colnaghi, 1961.
 B1977.14.4678

The strong influence of John Varley's style is evident in this watercolor, both in the method of laying simple washes and in the low-toned generalizing of forms. It was executed in the same year that Fielding moved from the Lake District to London, where he lived a few

streets away from Varley's studio.[1] It has been suggested that the present drawing was based on sketches made on Fielding's 1808 tour of Wales, and that the mountain in the background is Cader Idris: it could equally as well be a scene in the Lake District or Lancashire, which were the subjects of the five watercolors Fielding chose to exhibit in 1810.[2] Upon his election as a member of the SPW, the number of his exhibits became, in the words of one critic, "appalling."[3] After 1813 he showed an average of over forty watercolors at every show. Fielding's interest in the depiction of shimmering atmospheric effects, which became a significant feature of his later marine and mountain scenes, is demonstrated at an early stage in this work, where the smoke and some of the lights have been carefully taken out with water or scraped.

1. Fielding lived in Wells St., Varley in Golden Square.
2. YCBA, *English Landscape*, no. 191, p. 108.
3. *Repository of Arts*, May 1817, p. 352.

57. *A View of Snowdon from the Sands of Traeth Mawr, taken at the Ford between Pont Aberglaslyn and Tremadoc* 1834

Watercolor, bodycolor, scraping and gum over pencil
647 x 920 25 1/2 x 36 1/4
Insc.: Signed and dated in brush and brown ink, LR: *Copley Fielding 1834.*
Exh.: SPW, 1834, no. 93; PML-RA, 1972, no. 129.
Lit.: OWSC, 3, 1925–26, p. 23; OWSC, 12, 1934–35, p. 69.
Coll.: P. Polak, 1968. B1977.14.4640

As president of the SPW and as one of its most prolific contributors, Fielding and his watercolors were well known and popular with fellow members and the public alike. Coastal scenes and views in Wales and the Lake District were his exhibition themes: he was particularly admired for his misty moorland landscapes. The tremendous number of watercolors he exhibited led to some repetition — in all, he exhibited sixteen views of Snowdon and Traeth Mawr. It also led to technical and compositional formulas. Concentrating on breadth and distances, Fielding often glossed over his foregrounds, saving his efforts for atmospheric effects, half tones of purple and gray brown which relate his watercolors to the work of G. F. Robson.

 Fielding exhibited his first view of Snowdon from Traeth Mawr at the SPW in 1818 (no. 220). He did not repeat the subject until 1833, when he was probably inspired by Turner's watercolor of *Lancaster Sands* (BM), which was exhibited that year at Moon, Boys, and Graves gallery in Pall Mall East.[1] Fielding's sublime and stormy sky and the distant mountains owe a debt to Turner's watercolor, but unlike Turner,

he did not use his figures or any foreground incident to reinforce the fleeting beauty of the scene.

1. Wilton, *Turner*, no. 803.

58. Shipping off Staffa 1842

Watercolor, bodycolor, scraping, and gum
308 x 415 12⅛ x 16¼
Insc.: Signed and dated in brush and gray ink, LL:
 Copley Fielding 1842.
Exh.: SPW, 1842, no. 141; Agnew, 1972, no. 94.
Coll.: Miss D. J. Hart; Agnew, 1972. B1975.4.1811

Staffa is a small island off the west coast of Scotland. Fielding probably visited it first in 1839, for between 1840 and 1854 he exhibited eight views of Staffa as well as two watercolors of a cave on the island. Of Fielding's sea pictures Ruskin wrote, "had he painted five instead of five hundred such, and gone on to other sources of beauty, he might, there be little doubt, have been one of our greatest artists."[1]

1. Ruskin, *Modern painters*, in *Works*, III, pp. 398–99.

59. The Head of Loch Fyne, with Dindarra Castle
1850

Watercolor, bodycolor and gum over pencil
305 x 407 11⅞ x 16
Insc.: Signed and dated in pen and brown ink, LL:
 Copley Fielding 1850; insc. on verso in pencil:
 *View looking to the Head of Loch Fyne / With the
 Castle of Dindarra in the Distance / Argyllshire /
 C.F.*
Exh.: SPW, 1852, no. 273.
Coll.: The Nuttal collection; Agnew, 1974.
 B1977.14.4316

Commenting on the SPW show of 1846, David Cox wrote "I have at present sold only two ten-guinea drawings. . . . Fielding has sent more than forty drawings, some large, and a great number appear to be sold."[1] Although Cox and Fielding were at this date respected senior members of the SPW, Fielding was consistently more popular with the public. His smooth and dextrous exhibition pieces were in many ways the antithesis of Cox's, whose approach was intellectual and who executed his watercolors with dash and speed to capture the immediacy and excitement of the rough, windy, Welsh landscape. Fielding worked quickly as well, but merely to be able to produce large numbers of drawings. His facility was limited to a repertoire of visual effects: sparkling, scraped-out highlights for water and melting atmospheric distances,

enlivened by stock touches like his flock of birds sweeping over the waves. He developed an unchallenging, pleasant formula which the public liked, and he varied it only according to whether his subject was a mountain, marine, or moorland scene. Fielding first exhibited a view of Dindarra Castle in 1825 (no. 32), and he showed ten more watercolors of Loch Fyne over the next thirty years.

1. W. Hall, *Biography of David Cox*, 1881, p. 158.

James Stephanoff, 1787–1874

Son of a Russian portrait painter, Stephanoff and his brother Francis Philip (c. 1788–1860) worked in close association all their lives. Both began exhibiting at the AA and, upon its dissolution, at the SPW. James became a member in 1819. The same year, he was engaged in the illustrations for Pyne's *Royal Residences*, and he later contributed to annuals like *The Literary Souvenir, The Keepsake*, and *The Forget-me-Not*. With A. C. Pugin, Charles Wild, and his brother, he illustrated *The Coronation of George IV* (1825–37). In 1830 he was appointed Historical Painter in Water-Colour to King William. His exhibited work included scenes from British history, literature, and events of current interest. He was a member of the Chalon Sketching Society in 1809, but resigned after seventeen attendances.

60. Lalla Rookh c. 1826

Watercolor, bodycolor, scraping on cream wove,
 surface losses, and rubbing
356 x 423 14 x 16⅝
Exh.: SPW, 1826, no. 277, as "Feramorz relating the
 story of a Peri to the Princess Lalla Rookh and her
 attendants, in the Valley of Gardens; Fadladeen,
 in one of his most lofty moods of Criticism."
Lit.: Roget, I, pp. 533–34.
Coll.: J. S. Maas and Co., 1971. B1977.14.4384

Stephanoff's *Lalla Rookh* epitomizes the change which took place in figure painting during the 1820s. It is an image taken from the "light, sweet, meringue-like verse" of Thomas Moore and is painted in a matchingly jewellike style.[1] Bonington was the acknowledged master of this sort of picture, but it was Stephanoff who introduced it to the SPW. Although Westall and Shelley had painted such scenes a generation before, their works were never as closely packed with details and incident as Stephanoff's little cameos. In the decade after *Lalla Rookh* was exhibited, the type became so immensely popular that

it was somewhat of a cliché, provoking one critic to remark, "to say the truth, we are beginning to weary of terrace gardens and alcoves, and peacocks, and guitars, and lovers in lace and feathers."[2] Another version was exhibited in 1829 and engraved for the *Literary Souvenir* by F. Bacon. A smaller watercolor of the subject, dated 1822, is in the VAM.[3]

1. *Cambridge History of Literature*, 1961, p. 105.
2. *Athenaeum*, Feb. 1836, p. 167.
3. VAM 3001-1876.

George Fennel Robson, 1788–1833

Born at Durham, where he took drawing lessons from a local master named Harle and copied woodcuts by Bewick. He went to London in 1804, where he supported himself by selling drawings at Crib's, a gilder and frame-maker in Holborn. His connections were good: on arriving in London was introduced to Sir Thomas Lawrence and was soon part of the Varley circle. In 1807 he first exhibited at the RA and in 1810 was a member of the AA. He visited Scotland that year, making several subsequent tours and publishing *Scenes of the Grampian Mountains* in 1814. Other trips were made to Somerset, Dorset, the Isle of Wight, Wales, Ireland, and to Paris in 1814, but Scotland and his native city provided him with the majority of his exhibition subjects. In 1813 he became a member of the SPW and was elected president in 1820. He exhibited one biblical subject in 1818, *Hagar and Ishmael*, but many more of his exhibition pieces were based on Scott's poetry. In 1826 he was commissioned by Mrs. Haldimand to assemble an album of watercolors that represented the current state of the art: part of this was exhibited at the SPW in 1827. In 1832 he was elected an honorary member of the Chalon Sketching Society, which he attended fifty-nine times, although his poor eyesight kept him from active participation.

61. *A Highland Landscape* c. 1825

Watercolor, scraping, and gum
463 x 762 18¾ x 30
Exh.: Agnew, March 1977, no. 222.
Lit.: Wilton, *British Watercolours*, 1977, no. 119, pl. 194.
Coll.: Agnew, 1977. Mr. and Mrs. Paul Mellon.

"A large and most efficient contributor," Robson exhibited an average of thirty-two watercolors every year.[1] As a result, not every exhibition piece was free of faults, and the artist was criticized for his mannered use of purples and browns.[2] The present work is not free of defects. The composition is a striking one, but the colors are occasionally glaring, as in the distant blue of the mountain, and the figures are out of scale. Robson's ability to draw animals was not as great as Robert Hills's, with whom he collaborated on several exhibition watercolors. But taken as a whole, the work is highly dramatic and forceful. It is related both in technique and spirit to Copley Fielding's and Francis Danby's most ambitious mountain scenes.

1. *Repository of Arts*, May 1818, p. 290.
2. *Lo Studio*, May 1833, reprinted in OWSC, 11, 1933–34, p. 58.

62. *Loch Coruisk* c. 1826–32

Watercolor, bodycolor, scraping, and gum, laid down on card
451 x 654 17¾ x 25¾
Coll.: Fine Art Society, 1972. B1977.14.6254

Uwins described Robson's first visit to the Highlands:

> That he might enter entirely into the romance of the country, he dressed himself as a shepherd, and with his wallet at his back, and Scott's poems in his pocket, he wandered over the mountains, . . . fixing firmly in his mind the various aspects of nature, and collecting a fund of observations on which he might draw for the rest of his life.[1]

Between 1826 and 1832, Robson exhibited six watercolors of Loch Coruisk, appending to three of them quotes from Scott's *Lord of the Isles*. One was in the Haldimand collection, but the largest and most impressive is now in the VAM.[2] The present version is certainly one of those exhibited, but it is impossible to identify it exactly. Robson was best known at the SPW for "delineating the sublime scenery of the Scottish Alps."[3] In this twilight view of the lake, he combines a Burkeian color scheme and a sense of vastness with the immensely popular writings of Sir Walter Scott:

> A scene so rude, so wild as this,
> Yet so sublime in barrenness,
> Ne'er did my wandering footsteps press,
> Where 'er I happ'd to roam.
>
> No marvel thus the Monarch spake;
> For rarely human eye has known
> A scene so stern as that dread lake,
> With its dark ledge of barren stone.[4]

In the VAM's *Loch Coruisk*, Robson included the heroes of the poem, Robert the Bruce and his followers, who give a sense of the smallness of humanity, even of

royalty, in contrast the the grandeur of nature. The present watercolor is a simpler composition, in which intensely "sad and fuscous" colors take the place of narrative and supply the solemnity of mood present in the landscape.

1. *Lo Studio*, 1833, reprinted in owsc, 16, 1938, p. 39.
2. Christies, March 18, 1980, lot 273, repr.; vam 1426-1869, repr. Hardie, III, pl. 215.
3. *Arnold's Magazine*, III, 1834, p. 194.
4. *Lord of the Isles*, canto III, stanzas XIII–XIV.

63. *St. Paul's from Southwark by Sunset* 1833

Watercolor and scraping over pencil
591 x 895 23¼ x 35¼
Exh.: spw, 1833, no. 55, as *London, Evening*; Manchester, *Art Treasures Exhibition*, 1857, no. 142.
Lit.: Roget, I, p. 457: owsc, 2, 1933–34, p. 58: Hardie, II, p. 229.
Coll.: W. Leaf; Christies, May 8, 1875, lot 467; Christies, June 20, 1978, lot 117; John Baskett, 1978. B1978.26.4

Critics considered this work Robson's finest contribution to the spw in 1833, the last in which he would exhibit.[1] He was particularly fond of twilight scenes "where he could dip his pencil in the purple gloom," and where his characteristic blending of half tones of light and shade gave an atmospheric quality that few artists could rival.[2] Because Robson was a follower of Varley's method, detail was never his strong suit: he sought for grand general effects and, most important, for the associative value of a landscape. Robson ordered the scene with this Alisonian quality uppermost in his mind. Here the association is one of strong religious significance: the promise of Eternity symbolized by the cathedral stands out against the transient present represented by the river. All human activity is placed in the foreground, in the front of the viewer's mind, but beyond, and always dominating this view of daily life, towers the shadowed symbol of religion. Robson's rich command of association did not stop there, however, and in the scene, St. Paul's and the Thames stand equally as reminders of England's historic greatness, of her religious struggles and her naval power.

1. *Lo Studio*, May 1833, reprinted in owsc, 11, 1933–34, p. 58.
2. *Arnold's Magazine*, III, 1834, p. 367.

William Turner of Oxford, 1789–1862

Born at Blackbourton, Oxfordshire, he was apprenticed to John Varley around 1804. In 1808 he became an exhibitor at the spw and at the end of the same year, a member. Returning to Oxford, he became a successful drawing master, sending 455 watercolors to the spw in all. The titles of his exhibits indicate tours of the Lakes, Bristol, Wales, Salisbury Plain, north Devon, Cornwall, Sussex, and Scotland, but his native Oxfordshire provided him with his most congenial subjects. His annotated catalogues of the spw shows, with records of prices and buyers, are in the vam Library.

64. *Kingly Bottom, Sussex* 1835

Watercolor and scraping over pencil
540 x 759 21¼ x 29⅞
Exh.: spw, 1835, no. 83 (?)
Lit.: M. Hardie, "William Turner of Oxford," owsc, 9, 1931–32, p. 4; vam, *British Watercolours*, 1980, p. 386.
Coll.: Mrs. Ellison; gift to vam 1860. F.A. 546. Victoria and Albert Museum, London.

A steady contributor to the spw shows, Turner produced large exhibition watercolors such as this one throughout his career. In his mastery of simple flat washes, he showed his debt to Varley, but his ability to capture the effect of an endless expanse of landscape demonstrated his knowledge of Dutch seventeenth-century painting, in particular the works of Philips Koninck and Jan Van Goyen. This watercolor is a beautiful example of Turner's skill in varying his wide prospects with effects of sun and shadow flitting across the landscape, and in accenting his foreground with delicately detailed figures. He exhibited five views of Kingly Bottom between 1835 and 1850, accompanying several with pastoral poetic tags. These were a sort of landscape which inspired one critic to comment that Turner "has given to a flat country an equal grandeur with mountain scenery."[1]

1. *Review of the Publications of Art*, 1808, p. 288.

65. *Donati's Comet* 1858

Watercolor and bodycolor over pencil
257 x 366 10⅛ x 14⅜
Insc.: Signed in pen and black ink, LR: *W. Turner / Oxford*; dated in detail on old mount, now lost.
Exh.: spw, 1859, no. 264, as *Near Oxford — Half-past 7 o'clock P.M., Oct. 5, 1858*; pml-ra, 1972–73, no. 130; ycba, *English Landscape*, 1977, no. 194, pl. xxxv.
Coll.: Colnaghi, 1965. B1975.4.1767

Turner's *Donati's Comet* is a good example of an artist's deliberate choice of equally powerful subject matter and technique for an exhibition watercolor. The comet was at its highest point of visibility on October 5, and in his title Turner noted with scientific exactness the time and place from which he viewed it. The work was an accurate record of an astronomical event, related to the tradition from which Constable's sky studies had come. At the same time, however, it was a brilliant bit of Alisonian sublime. The stillness of the evening landscape, its quiet expanse of emptiness, invites a comparison with the intensity and the sudden variations of light and deep blue of the sky. Through this juxtaposition, Turner indirectly calls up feelings of awe and infinity: the result is a meditative sense of man's insignificance in the face of the universe.

The technique Turner used was an intensification of his usual transparent methods. Like many of his fellow artists, he mixed bodycolor with his pigments to give his works a density not attainable with simple clear washes. In this case, probably influenced by the technique of Lewis's *Frank Encampment*, exhibited two years earlier, Turner built up his deep ultramarine sky with infinitesimally small touches, thereby achieving great strength of tone and subtlety. The work must have stood out at the exhibition of 1859, in spite of its relatively small size. The only other artist who exhibited a view of the comet that year was Samuel Palmer, who had a propensity for pastoral visions and found in it a most appropriate subject.[1]

1. Untraced. William Dyce exhibited an oil of the comet at the RA in 1860 (no. 141), which is now in the Tate (no. 1407). Repr. in Tate, *Landscape*, 1973, fig. 319.

William Henry Hunt, 1790–1864

Hunt's father, a tinman in Covent Garden, apprenticed him in 1804 to John Varley. His fellow students there were John Linnell and William Mulready, the latter of whom persuaded him to enter the RA schools in 1808. He exhibited three oils at the RA the previous year. In 1809 he helped with the decorations and scene painting at the Drury Lane Theatre. Through the Earl of Essex, for whom he worked at Cassiobury, he met Dr. Monro and frequently sketched at Monro's house near Bushey. In 1824 he became an exhibitor at the SPW and in 1826 a member. From this period he devoted himself entirely to watercolors, specializing in genre subjects and still lifes from 1827.

66. *The Outhouse* 1838

Watercolor and bodycolor over pencil
540 x 749 21¼ x 29½

Insc.: Signed in brush and brown ink, LR: *W HUNT 1838*.
Exh.: SPW, 1838, no. 262, as *Interior of a Wood House* (?); London, P. and D. Colnaghi, *A Loan Exhibition of Drawings, Watercolours, & Paintings by John Linnell and his Circle*, 1973, no. 135.
Lit.: Wilton, *British Watercolours*, 1977, no. 139, p. 190, repr.
Coll.: Gift of Charles Fairfax Murray, 1912, no. 739. The Fitzwilliam Museum, Cambridge.

To vary the still lifes in which he specialized after 1827, Hunt exhibited a small but steady number of interiors. Many of these were rustic in nature: barns, wood houses, and kitchens were most often specified in the titles. After 1848 his exhibits were entirely of still lifes, portraits, and landscapes. The present watercolor may have been exhibited in 1838 under the title *An Interior* (SPW, no. 82), but was probably no. 262 in the same show. Of the six classes specified by Ruskin in his *Notes on Hunt*, the work falls into the second, which depict country life with the added interest of some passing sentiment. This type, which Ruskin described as "almost always overfinished, and liable to many faults,"[1] was evidently painted with the idea of pleasing less critical viewers at the SPW, whose notions of art were limited to the appreciation of high finishing and sentiment.

Although the present work has a pretty girl in it to add interest, it is essentially an essay in light, shade, and texture, and it is direct and unsentimental in approach. It is a transitional watercolor, having the breadth of his earlier work, but the technique looks forward to his later stipple method. In it, he wielded the tip of a brush like a pen to accent and used a dry brush to give the rough texture of wood. Bodycolor is evident in the drawing, but not as an underbase to reflect light, as in his later still lifes. It is used as Cattermole and Lewis employed it in the same period: to give density to certain pigments, enabling them to approximate the solidity of oil.

1. Ruskin, *Works*, XIV, p. 442.

67. *Plums and Mulberries* c. 1860

Watercolor, bodycolor, and gum over pencil, laid down on card, oval
190 x 242 7½ x 9⅝
Insc.: Signed in brush and brown ink, LR: *W. HUNT*.
Exh.: SPW, 1860, as *Plums and Mulberries*, no. 260 (?)
Lit.: Hardie, III, p. 108.
Coll.: Martin Hardie. B1977.14.5923

The technical control in Hunt's late work made his exhibition pieces marvellously accurate and allowed

him to capture textural effects like the bloom on the plums perfectly. Ruskin admired Hunt's fruit pieces, writing that it was this class of work "on which a great part of the artist's reputation very securely rests."[1] Since Hunt exhibited at least a dozen watercolors under the title "plums" and even more simply as "fruit," it is not possible to tell exactly when this watercolor was exhibited, but a date of *c.* 1860 fits with a *Plums and Mulberries* exhibited that year.

1. Ruskin, *Works*, XIV, p. 443.

John Linnell, 1792–1882

The son of a carver and gilder, Linnell was born in Bloomsbury. He studied under John Varley and at the RA schools and formed part of the Monro circle along with W. H. Hunt around 1805. In 1807 he began to exhibit at the RA and the BI, and in 1812 he became a member of the SPW. He resigned in 1820, when oils were excluded. In 1818 he met William Blake and commissioned several important works from him. He exhibited both landscapes and portraits in oil. In 1851 he moved to Redhill in Surrey and devoted his remaining years to landscape. In 1861 he declined membership in the RA, a belated offer. His eldest daughter Hannah married his protégé Samuel Palmer in 1837.

68. Mrs. William Wilberforce and Child 1824

Watercolor and bodycolor, scraping, on a scored gesso
ground on panel
362 x 267 14¼ x 10½
Insc.: Signed and dated in pen and brown ink, LR: *by John Linnell 1824*; in pen and brown ink, LL: *Water Colours Mʳˢ William Wilberforce.*
Exh.: London, Arts Council, *Samuel Palmer and his Circle,* 1957, no. 110; YCBA, *Fifty Drawings,* 1977; YCBA, *Portrait Drawings,* 1979, no. 107.
Lit.: YCBA, *Selections,* no. 77.
Coll.: R. E. Abbott; Christies, Nov. 4, 1955, unspecified lot; L. G. Duke (3125), 1955 to 1961. B1977.14.5308

For details of the portrait's commission and the sitters' biographies, see YCBA, *Portrait Drawings,* 1979, no. 107. The present watercolor is an experimental version of an untraced oil, exhibited by Linnell at the RA in 1824 (no. 50) and known only by a compositional sketch in the artist's record books.[1] As Noon points out, the experimental technique of this portrait was probably inspired by Blake's temperas, and he draws particular attention to those of around

1820, like *The Arlington Court Picture* (National Trust).[2] A much closer parallel, not only in technique but compositionally, is one of four temperas executed in 1810 for Thomas Butts, *The Virgin and Child in Egypt* (VAM).[3] In 1821, Linnell was copying Blake's watercolor illustrations to *The Book of Job* (PML), then in the Butts collection: it seems likely that he knew the early tempera as well.

Although inspired by Blake to experiment with gesso grounds and watercolor, Linnell's purpose was dissimilar to the older man's. While Blake wanted to retain the linear quality of watercolor and its transparency, Linnell was more interested in trying to imitate the bold brushwork possible with oil. Linnell's portrait is also different in spirit from Blake's work. In his tempera of 1810, Blake sought to capture the spirit of an early Renaissance madonna. Linnell was more interested in the surface charm of such early panel pictures. Although probably not meant for exhibition, Linnell's portrait demonstrates the influence of Blake's technical experiments and the ongoing interest in expanding watercolor methods.

1. Print Room, British Museum.
2. Repr. in Tate, *Blake,* 1978, no. 307.
3. Repr. in ibid., no. 214.

Samuel Jackson, 1794–1869

Born in Bristol, Jackson became a successful drawing master there, where he took part in organizing the first exhibition of Bristol Artists in 1824, and in 1832, the Society of Bristol Artists. He was also a member of Bristol's Sketching Society during the 1830s. In 1823 he was elected an exhibitor of the SPW and withdrew in 1848, having exhibited a total of forty-six works. In 1827 he traveled to the West Indies, and he made later trips to Switzerland in 1855 and 1858.

69. Romantic Landscape *c.* 1830

Watercolor, touches of bodycolor, and scraping over
pencil
216 x 297 8⅝ x 11¾
Insc.: On verso in pencil: *Jackson of Bristol.*
Exh.: SPW, 1831, no. 395, as *The Pitch Lake in the Island of Trinidad* (?); Bristol, City Art Gallery and Museum, *The Bristol School of Artists,* 1973, no. 167.
Coll.: Agnew, 1965, as Francis Danby. B1975.4.1647

A trip to the West Indies in 1827 provided Jackson with material for a number of exhibition watercolors from 1828 to 1845. This one was probably done *c.* 1830, and it may have been the item exhibited in 1831 at the SPW as *The Pitch Lake in the Island of Trinidad* (no. 395). Eighteenth-century artists who traveled this far afield had done so generally as

scientific recorders or cultural reporters, as, for example, William Alexander (1767–1816) accompanied Lord Macartney's mission to China in 1792. Even as late as 1816, William Havell had set out with Lord Amherst on a similar embassy to the Far East. Jackson's trip was, according to Roget, for reasons of health, but the opportunity of collecting material for unusual exhibition watercolors probably contributed to his choosing the West Indies over Italy or the Alps.[1] William Wells (1764–1836) had exhibited views of Norway at the first SPW show for the same reason, but Jackson's views had a further advantage in their associative link with British trade. Jackson may have been courting the patronage of merchants with business there, and as Bristol was a port in the West Indian trade, he may have had specific patrons in mind.

Jackson's early technique was close to Francis Danby's (1793–1861) in the use of flat washes, but exposure to the SPW exhibitions certainly inspired him to try the more complex methods seen in this watercolor: sponging, scraping out, and touches of bodycolor for accent. The influence of Copley Fielding is evident in the dramatic effects in the sky, while the careful elaboration in the foreground, the wiped out lights, glazing, and flicks of the knife owe something to Barret's and, ultimately, to Turner's work. But the view is more than an accurate record of the flora and fauna of an unknown spot — Jackson created an image of sublimity, of primitive, unspoiled nature.

1. Roget, I, p. 523.

James Duffield Harding, 1797–1863

Harding's father, a pupil of Sandby's, sent his son to Samuel Prout for drawing lessons. At the age of thirteen, Harding began to exhibit at the RA. He was an associate of the SPW in 1820, and a member the following year. In 1824 he visited Italy for the first time, and made frequent sketching tours on the continent thereafter. In 1846 he resigned from the SPW, but rejoined ten years later, having failed to become an ARA. His work was widely known due to his contributions to the popular annuals, and he published several portfolios of lithographs after his own drawings, including *Sketches at Home and Abroad* (1836), *Harding's Portfolio* (1837), and *The Park and the Forest* (1841). He taught drawing to Ruskin, among others, and his lessons on art were published in *The Lithographic Drawing Book* (1832), *Harding's Drawing Book* (1841), *Principles and Practice of Art* (1845), and *Lessons on Trees* (1852).

70. *French Coast Scene with Fisherboy* 1829

Watercolor, bodycolor, gum, scraping, over pencil, laid down on card
375 x 272 19⅞ x 10⅞
Insc.: Signed and dated in brush and gray ink, LR: *J D Harding 1829.*
Coll.: William Selkirk, sale, Sotheby's, May 3, 1961, lot 91. B1975.4.1535

As a painter of the continental picturesque, Harding worked extensively for the landscape annuals which became popular during the 1830s. Figures rarely played such an important role in his watercolors, but in this case, he concentrated on one for a particular reason. Executed in the same year that Harding was preparing lithographs for his *Series of Subjects from the Works of the Late R.P. Bonington*, the fisherboy seems almost an exercise in assimilating Bonington's watercolor technique. It could not be mistaken for a work by him, however: Harding enlarged the scale beyond anything Bonington might have conceived, and his touch was not as assured. Aside from these differences, though, it is a representative example of work by an artist who was influenced in technique, style, and subject matter by Bonington.

71. *The Grand Canal, Venice* 1835

Watercolor, bodycolor, and gum over a pencil sketch, some penwork, scraping, laid down on wood panel
780 x 1060 30¾ x 41¾
Exh.: SPW, 1835, no. 177; Agnew, 1976, no. 93, repr. on cover; J. B. Speed Art Museum, *Ruskin and Venice*, 1978, no. 12, p. 45.
Lit.: Redford, *Art Sales*, v. 2, 1888, p. 157; Graves, *Art Sales*, v. 2, 1921, p. 11; Roget, II, p. 189.
Coll.: Sir G. F. Moon, sale Christies, 1872, bt. Agnew; Agnew, 1976. B1977.14.4411

Harding was in Venice in 1834, when he made sketches for this ambitious exhibition watercolor. He took the view of the Grand Canal from the vicinity of the Ponte dell' Accademia, facing east toward the domes of Sta. Maria della Salute. His choice was undoubtedly influenced by a lithograph after a small Bonington drawing which he had made four years before for the *Series of Subjects from the Works of the Late R. P. Bonington*. The two views are almost identical, the most striking difference between them being the scale: Harding's *Venice* was as large as an oil and meant specifically for exhibition.

By 1835 the Grand Canal was an all too familiar scene on the walls of the SPW, but the size and technique of Harding's watercolor made the critic of the *Literary*

Gazette report that as "frequently as this magnificent assemblage of objects has been brought before the eye by many of our best artists, no nobler or more satisfactory representation of it has ever appeared than that under our notice. It is one of the most powerful and masterly drawings that we ever met with."[1] Other critics compared it favorably with scenes of Venice exhibited that year by Prout and Turner. Harding's style was not much influenced by the former, from whom he had taken drawing lessons around 1811, but Turner's works were as important an antecedent as Bonington's, especially in Harding's choice of scale and technique.

Turner had exhibited two oils of Venice in 1833 and 1834, *The Bridge of Sighs, Ducal Palace, and Custom-house, Venice: Canaletti Painting* (Tate) and *Venice* (National Gallery, Washington, D.C.), which stood as direct precedents for Harding's watercolor.[2] That he set himself in competition with Turner's paintings and attempted to outdo them in watercolor was pointed out by the critic of *Fraser's Magazine*, who thought that Turner's *Venice from the Porch of the Madonna del Salute* (MMA), exhibited in 1835, was unintelligible as compared to Harding's, which was "genuine poetry, both of nature and art."[3] In order to put his exhibition watercolor on a competitive level with Turner's oils, Harding had to use bodycolor. Along with J. F. Lewis and Cattermole, he was cited by contemporaries as one of the first who "by its judicious use [gained] so much light, space, and vigour, both in effect and execution, as entirely to remove the objection of weakness so long waged against water colours."[4]

1. *Literary Gazette*, May 2, 1835, p. 282.
2. Butlin & Joll, *Turner*, nos. 349 and 356.
3. *Fraser's Magazine*, July 1835, v. XII, p. 55.
4. *Art Union*, Oct. 1839, p. 146.

George Cattermole, 1800–1868

Born at Dickleburgh near Diss, Norfolk, Cattermole went to London in 1814 to study architecture under John Britton, with whom he made drawings for *The Cathedral Antiquities of Great Britain*. He exhibited at the RA in 1819 and 1821. The following year he was an exhibitor at the SPW, but soon after the pressure of work under Britton made him drop out. He rejoined in 1829 and was made a member in 1833. Around 1830, under the influence of Bonington's costume pieces, he began to exhibit similar works as well as architectural subjects. He declined a knighthood offered him in 1839 for his watercolor of *The Diet of Spires, 1529*

(VAM), a subject suggested by the Queen. Among his circle of friends were Dickens, Thackeray, Disraeli, Browning, Landseer, and Bulwer-Lytton. In 1852 he retired from the SPW in the hope of being elected ARA, but was unsuccessful. He was awarded a Grande Medaille d'Honneur, first class, for a watercolor shown at the Paris exhibition of 1855.

72. *Salvator Rosa Sketching among the Banditti of the Abruzzi* 1838

Watercolor and bodycolor
548 x 762 21½ x 30
Insc.: Signed with monogram G.C. at artist's foot.
Exh.: SPW, 1838, no. 165, as *Scene from the Life of Salvator Rosa.*
Coll.: Possibly John Knowles, sale Christies May 19, 1877, lot 66, bt. Agnew; William Quilter, sale Christies May 18, 1889, lot 60, bt. Agnew; Agnew, 1898.D.4.1898. Whitworth Art Gallery, Manchester.

Cattermole probably based his exhibition watercolor on the following passage from Lady Morgan's popular biography of Salvator Rosa:

> The event which most singularly marked the fearless enterprises of Salvator in the Abruzzi, was his captivity by the banditti, who alone inhabited them, and his temporary (and it is said voluntary) association with those fearful men. That he did for some time live among the picturesque outlaws, whose portraits he has multiplied without end there is no doubt. . . .[1]

Rosa's artistic influence, which had been strongly felt during the eighteenth century in the works of Wilson, Mortimer, and Morland, had been replaced by the 1830s by an interest in the romantic and bohemian aspects of his career. Cattermole's composition and coloring owed little to Rosa's art: the handsome figure of the artist, the picturesque banditti, and the richly dressed women owe much more to *Lewis's Sketches of Spain and Spanish Character* (1836). Like Lewis, Cattermole relied on bodycolor to give his works solidity. His resignation from the SPW in 1852 was attributed to the fact that "His sensitive organization always made the necessity of considering the conditions of exhibitions, in planning his work, peculiarly irksome to him."[2]

1. Lady Morgan, *The Life and Times of Salvator Rosa*, 1824, I, p. 108.
2. Roget, II, p. 64.

Richard Parkes Bonington, 1802–1828

Born in Nottingham, Bonington moved with his family to Calais in 1817. There he met Louis Francia, who gave him lessons in watercolor. In 1820–22 he was in Paris, working under Baron Gros and exhibiting two works at the Salon. He toured Normandy in 1821 and again, with Prout, the next year and also traveled through Belgium. Lithographs by him appeared in Taylor's *Voyages Pittoresques* in 1824: the next year, he visited England, where he met Delacroix, with whom he shared a studio upon his return to Paris. He exhibited at the BI in 1826 and in the same year visited Italy. He exhibited at the RA in 1827 and was in London briefly that year and in 1828. He died in London.

73. *Figures in an Interior* c. 1826

Watercolor and bodycolor over pencil
165 x 128 6½ x 5¹/₁₆
Insc.: Signed in brush and brown ink, LL: *R P Bonington.*
Exh.: YCBA, *Recent Acquisitions*, 1979.
Coll.: Comte de Bouille; Covent Garden Gallery, 1978. B1978.43.165

In Bonington's costume pieces, surface quality and rich color often took precedence over depth of meaning. This watercolor, which may be a historic scene or a literary illustration, demonstrates Bonington's technical facility and his brilliant palette. Both had great influence on watercolor artists during the 1820s and 1830s. The work can be given a date of c. 1826 by comparing it with the Wallace collection's *Turk Reposing* (signed and dated 1826), which is similar to this watercolor both in the accomplished figure style and in technique.[1] It was at about this date that Bonington began to use bodycolor and gum, which at first was restricted to the shadows and details. Over the next few years, he used such additions more boldly to give greater depth and force to his work in watercolor.

1. Repr. in A. Shirley, *Bonington*, 1940, pl. 97a.

Francis Oliver Finch, 1802–1862

Born in London, Finch was apprenticed to John Varley around 1815. He exhibited at the RA two years later and studied figure painting at Sass's Academy. In 1822 he became an exhibitor at the SPW, after which time he devoted himself to landscape and watercolor.

A member in 1827, Finch continued to exhibit at the SPW until his death, still occasionally sending a picture to the RA. He was an early friend of Samuel Palmer's, and his work demonstrates a close affinity with that of George Barret, Jr.

74. *Religious Ceremony in Ancient Greece* c. 1835

Watercolor, touches of bodycolor, gum, and scraping
468 x 647 18³/₈ x 25½
Coll.: Cyril Fry, 1967. B1975.3.1245

As an apprentice of John Varley, Finch absorbed a number of his ideas and methods. In this instance, Finch accurately repeated Varley's recipe for epic landscape as set out in his *Treatise* of 1816. He included the broken monuments, straight lines, and water recommended by his teacher, but he treated his landscape in a softer, more atmospheric manner than Varley did in his *Suburbs of an Ancient City*. (no. 36). In this example, he reflects the influence of George Barret, whose technique and warm color scheme he imitated closely. The style of Finch's gentle pastorals varied little over the years, and the uninformative nature of his exhibition titles — "composition" and "sunset" were frequently used — makes it difficult to date his watercolors.

Thomas Shotter Boys, 1803–1874

Boys was born in Pentonville and was apprenticed in 1817 to the engraver George Cooke. He moved to Paris around 1823 and, under Bonington's influence, took up watercolor. In 1832 he became an exhibitor at the NSPW and in 1841 a full member. Much of his time was spent working on lithographs for Baron Taylor's *Voyages Pittoresques et Romantiques dans l'Ancienne France* (1835 and subsequently), and in 1835 he published his own *Picturesque Architecture in Paris, Ghent, Antwerp, Rouen, etc.* He returned to London in 1837, publishing his *Original Views of London as it Is* in 1842. The same year he toured Germany and Austria. In 1847 and 1848 he exhibited at the RA.

75. *Prague* c. 1847

Watercolor, touches of bodycolor, and scraping
387 x 286 15¼ x 10⅞
Insc.: Signed in pen and brown ink, LR: *Thoˢ Boys.*
Exh.: London, RA, *The Girtin Collection*, 1962, no. 84.
Lit.: J. Roundell, *Thomas Shotter Boys 1803–1874*, 1974, p. 200.

Coll.: H. Guillemard; H. Wilkinson-Guillemard; T.
 Girtin, 1934; Tom Girtin; Baskett, 1970.
 B1975.3.1099

The view, taken from the Banks of the Moldau, shows
the old town water tower, the bridge tower, and, on
the right, the Church of St. Francis. Boys toured
Austria and Germany in 1842 and exhibited a view of
Prague at the NSPW in 1843 and 1847. Continental
scenes were Boys's bread-and-butter: not only did he
exhibit many European views, but he produced a
series of lithographs which gained him a wider
reputation as a picturesque architectural draughtsman.
Along with Prout, J. D. Harding, and David Roberts,
Boys helped to satisfy the English public's love of
foreign scenery.

His work of the 1840s was drier and heavier than
it had been in the previous decade, when he was still
very much under Bonington's influence. This
watercolor or a later version was exhibited at
Liverpool in 1861 as *Old Towers at Prague—from the
Banks of the Moldau*. Because there were only a few
exhibitions in London, and an ever-increasing number
of competitors for space on the gallery walls, many
artists turned to the provinces, which by the 1830s
were eager to welcome their works at local shows. A
writer in 1839 described what impact these London
artists had: their influence, he wrote, could be "traced
like lawyers taking their western or northern circuit,
through the different provincial exhibitions."[1]

1. *Art Union*, Sept. 1839, p. 129.

Edward Duncan, 1803–1882

Born in London, Duncan was apprenticed to the
engraver Robert Havell, whose nephew William
Havell's watercolors he helped to aquatint. He was
employed by Fores of Piccadilly to engrave sporting
scenes and by William Huggins to reproduce his
shipping subjects. Marrying Huggins's daughter, he
became a sea-painter himself. He joined the NSPW in
1833, but retired in 1847 to became an exhibitor at the
SPW. He was elected a member the following year and
exhibited over 250 watercolors there.

76. The Bass Rock 1855

Watercolor, bodycolor, gum, and scraping over pencil
208 x 504 8¼ x 20
Insc.: Signed and dated in pen and black ink, LR: *E.
 Duncan / 1855*.
Coll.: Andrew Wyld, 1977. B1977.14.142

Like Clarkson Stanfield (1793–1867), Duncan made
his name as an exhibitor of marine and shore scenes.
Earlier marine artists had drawn naval battles and
men-of-war, but Duncan painted the picturesque
coastal views which Turner and Fielding had made
popular in the previous generation. His style owes
much to Stanfield's, whose painstaking, literal
approach he shared, but his work was enlivened by
rich coloring and flickering, scraped-out touches. A
larger version of this subject, dated 1865, is in the
VAM.[1]

1. VAM 139-1889.

William Leighton Leitch, 1804–1883

Leitch was born in Glasgow and apprenticed to a sign
painter there. He became a scene painter at the
Glasgow Theatre Royal in 1824, and continued to
paint scenery after coming to London. He succeeded
George Chambers at the Pavillion Theatre and
worked in conjunction with David Roberts and
Clarkson Stanfield. He traveled to Italy in 1828 and
upon his return contributed to the exhibitions at the
RA and at the NSPW. He became a member of the latter
in 1862 and served as its vice president for many years.
He gave drawing lessons to Queen Victoria and the
Royal Family.

77. Kilchurn Castle, Argyllshire 1865

Watercolor, touches of bodycolor, and scraping over
 pencil, mounted on wood
660 x 1016 26 x 40
Insc.: Signed and dated in brush and brown ink, LR:
 W. L. Leitch 1865.
Exh.: NSPW, 1865, no. 46.
Lit.: Hardie, III, pl. 216.
Coll.: Abbot and Holder, 1967. B1975.3.178

Leitch excelled in rendering misty effects of
atmosphere, as this watercolor demonstrates. Like
Varley and Fielding, from whose works his finished
watercolors were descended, he was an able technician
if not a highly original artist. One practice for which
he was distinguished was his old-fashioned use of a
gray monochrome to establish his shadows, perhaps a
holdover from his early training as a scene painter. A
small view of Kilchurn Castle dated 1871 is in the
VAM.[1] Most of his exhibited works were scenes in
Scotland.

1. VAM P18-1948.

John Frederick Lewis, 1805–1876

The son of an engraver, Lewis was born in London and first exhibited a painting at the BI in 1820. Along with Edwin Landseer, he drew animals at Exeter 'Change, and his early exhibits at the RA and the BI were mostly sporting pictures. Around 1824–26 he worked at Windsor for George IV. In 1827 he made a tour of the Swiss and Italian Tyrol and was an exhibitor at the SPW that year. Upon his election in 1830, he devoted his energies to watercolor full-time, exhibiting at the SPW until 1841. A trip to Spain in 1832–33 led to the publication of two volumes of lithographs: *Lewis's Sketches and Drawings of the Alhambra* (1835) and *Lewis's Sketches of Spain and Spanish Character* (1836). In 1837 he visited Rome and Asia Minor and settled in Cairo in 1841, where he began to collect the material for his later exhibition watercolors. In 1850 he sent a watercolor, *The Hhareem* (VAM), to the SPW, where it received much critical acclaim. He returned to London the next year and was elected president of the SPW in 1855. In 1858 he resigned in order to try for academic honors. He was elected ARA in 1859 and RA in 1865. His later oils were simply versions of his meticulous watercolors.

78. *Figures in a Vineyard* c. 1829

Watercolor, bodycolor, scraping, gum
420 x 521 16½ x 20½
Lit.: Lewis, 1978, no. 313.
Coll.: P. Polak, 1967. B1975.4.2005

Lewis's election as an exhibitor at the SPW in 1827 had a decisive influence on his career. Until that time he had devoted himself to oils, first exhibiting a painting at the BI in 1820 and continuing to show animal and sporting subjects thereafter at the RA as well. His early assurance with watercolor can be seen in his animal studies of around 1825, for example, the *Study of a Lioness* (YCBA).[1] Upon his election to the SPW Lewis put all his energy into producing watercolors, exhibiting almost solely in this medium until his resignation from the SPW in 1858. His ambition to shine at the Society's shows led him to travel to the Rhineland and the Italian Alps in 1827 in search of new subjects and material. Almost a dozen exhibition watercolors resulted, including the present work, which was probably exhibited in 1829 either as *Peasants in the Italian Tyrol at their Devotions* (no. 314), or as *A Vineyard in the Val d'Aosta* (no. 385).

In terms of technique, this watercolor can be compared to the *Gamekeeper and Boy Ferreting out Rabbits* (YCBA), exhibited in 1828.[2] Both show Lewis's characteristic parallel wet brushstrokes in the foliage, and his early light and transparent handling.

The vineyard scene, however, is somewhat darker and more elaborate. Lewis's developing technical mastery is visible in his use of dry brushwork and touches of bodycolor for highlights. Stylistically it is comparable to the Devon scenes which Lewis exhibited the following year, for example, *An Old Mill* (Blackburn Corp. Art Gallery).[3] The current mode of the continental picturesque led Lewis away from his early love of sporting scenes, but he continued to include animals in many of his compositions, and was second only to his friend Landseer in his ability to give them expression. If Bonington's death in 1828 and the ensuing vogue for his work encouraged Lewis to try painting picturesque costumes and genre pictures, his trip to Spain in 1832–33 confirmed him in this kind of subject. In all, he exhibited five vineyard scenes between 1828 and 1835, three Italian and two Spanish ones. After several years spent in producing two books of lithographs after his Spanish sketches, Lewis left England in 1837, once again in search of fresh material for exhibition and publication.

1. Repr. Hardie, III, pl. 69.
2. Repr. Lewis, 1971, pl. 4.
3. Repr. ibid., pl. 5.

79. *Highland Hospitality* 1832

Watercolor, bodycolor, gum, scraping
546 x 750 21½ x 29½
Engr.: By W. Gillier
Exh.: SPW, 1832, no. 192; Arts Council, *British Life*, 1953, no. 107; Fine Art Society, 1973, no. 80, repr.; Guildford House Gallery, *J. F. Lewis*, 1977, no. 18.
Lit.: Lewis, 1978, no. 313.
W. Gilbey, *Animal Painters in England*, 1900, II, p. 171; OWSC, 3, 1927, p. 32; Hardie, III, p. 50; *Connoisseur*, 183, Aug. 1973, pp. 266–67, repr. on cover. Lewis, *Lewis*, 1978, p. 64, no. 116, fig. 15.
Coll.: G. A. Fuller; Thomas Pegram, sale, Sotheby's Nov. 24, 1948, lot 22, bt. Fine Art Society; Noel Stevenson, sale, Sotheby's Apr. 19, 1961, bt. Frost and Reed Ltd.; Christies, March 19, 1973, lot 13, bt. Fine Art Society; from whom purchased in 1978. B1978.43.167

Exhibited in 1832, *Highland Hospitality* was the result of a tour made two years before, in the same year that Lewis was made a member of the SPW. Since Sandby's day, artists had found Scotland a fertile source of subject matter, but Lewis's watercolor was unlike any Highland subject previously shown at the Society's gallery. It was neither an illustration to Scott nor a Scottish pastoral of the sort produced by Cristall during the 1820s and 1830s. The precedent for the

work was not to be found in the work of any SPW member, but rather in the oils of three painters — Landseer, Wilkie, and Bonington. Landseer's *Highland Interior* (Countess of Swindon), exhibited at the RA in 1831, probably inspired Lewis to try such a subject, but it was from paintings like Wilkie's *Blind Fiddler* (Tate) and Bonington's *Henri IV and the Spanish Ambassador* (Wallace) that Lewis derived his interest in capturing the psychological attitudes and relationships between his figures.[1] In no previous work had he attempted such complex interactions, but he succeeded in capturing them not only through the expressions of his figures, but in his compositional devices as well. The scene is divided in half by the cauldron: on one side, the handsome young men are ranged with their guns and dogs; on the other, the pretty daughter is barricaded in the corner by her suspicious family. The host's wary gesture of hospitality is negated by his wife's hostile attitude, which is pictorially balanced by the pose of the visitor lighting his pipe. Two of Lewis's friends served as models for the young men: George Cattermole and William Evans of Eton. An oil version of the subject was formerly in the Hutchinson collection, where it was incorrectly attributed to Landseer.[2]

1. *Highland Interior* is repr. in Sheffield, Mappin Art Gallery, *Landseer and his World*, 1972, fig. 6.
2. London, Hutchinson House, *National Gallery of British Sports and Pastimes*, n.d., no. 324.

80. *A Frank Encampment in the Desert of Mt. Sinai, 1842 — the convent of St. Catherine in the distance. The picture comprises portraits of an English Nobleman and his suite, Mahmoud, the Dragoman, etc., etc., etc., Hussein, Scheikh of Gebel Tor, etc., etc.* 1856

Watercolor and bodycolor
648 × 1343 25½ × 52⅞
Insc.: Signed and dated in pen and brown ink, LR: *J.F. Lewis / 1856.*
Exh.: SPW, 1856, no. 134; Manchester, *Art Treasures Exhibition*, 1857, no. 638 (?); Leeds, *Exhibition of Works of Art*, 1868, no. 2167; Liverpool, Walker Art Gallery, *Grand Loan Exhibition of Pictures*, 1886, no. 982; Manchester, *Royal Jubilee Exhibition*, 1887; Southport, *Centenary Exhibition*, 1892; Scarborough Art Gallery, *Paintings from the Collection of R. T. Laughton, Esq., C.B.E.*, 1970, no. 50; Laing Art Gallery, Newscastle upon Tyne, *John Frederick Lewis*, RA 1805–1876, 1971, no. 74.
Lit.: J. Ruskin, *Academy Notes*, 1856, in *Works*, XIV, pp. 73–78, and OWSC, 3, 1926, pp. 1–5; *Art Journal*, 1858, p. 43; Roget, II, pp. 145–46, 148; R. Davies, "John Frederick Lewis, RA. Some

Contemporary Notices with Comments by the Editor," OWSC, 3, 1926, pp. 35–36, 39–40; H. Stokes, "John Frederick Lewis, RA, 1805–1876," *Walker's Quarterly*, no. 28, 1929, pp. 31–33, 42–43; B. Ford, "J. F. Lewis and Richard Ford in Seville, 1832–33," *Burlington Magazine*, 80, 1942, p. 128; Hardie, III, p. 54; Wilton, *British Watercolours*, pp. 190–91; R. Searight, "An Anonymous Traveller Rediscovered," *Country Life*, 163, May 4, 1978, p. 1259; Lewis, *Lewis*, no. 564.
Coll.: H. Wallis (?); G. R. Burnett, sold 1860; G. W. Moss, sale, Christies, April 28, 1900, lot 102, bt. Agnew; C. D. Rudd, sale, Christies, May 2, 1919, lot 38; Mrs. Fiona Campbell-Blair, sale, Sothebys, April 4, 1968, lot 76; R. T. Laughton, Esq.; Sotheby's Apr. 14, 1976, lot 68; Fine Art Society, 1977. B1977.14.143

In 1842, Lewis was commissioned to paint a picture of the traveling party of Frederick Stewart, Viscount Castlereagh, who wrote to the artist on May 10 of that year, "— you will exercise your discretion as to place, persons, and details. The price 200 G.s."[1] Castlereagh set out for Palestine two days later and camped near the convent of St. Catherine on May 23. His suite included Sheik Hussein of Gebel Tor, the central standing figure, as guide, an Arab named Mahmoud as factotum, plus a hired artist, a doctor, and several friends. Lewis did not accompany them, but he had already made a trip to Mt. Sinai in March–April of the same year, and he visited it again in 1843. Several sketches later used for the *Frank Encampment* survive from these two tours.[2] After a mysterious hiatus of fourteen years, the *Frank Encampment* appeared at the SPW's 1856 exhibition. Rodney Searight, who identified the main figure as Castlereagh, suggests that there was a falling out between artist and patron which was resolved after Lewis's return to England.[3] A replica in oil, possibly bought by Castlereagh, was exhibited at the RA in 1863 (no. 158).

When the watercolor was shown at the SPW, it was singled out for generous praise by Ruskin. He interpreted it as "a map of antiquity and modernism in the East," a study in contrasts between the ancient human temperament represented by the Arabs and the modern disposition embodied by the Englishman.[4] But what concerned him chiefly was the amount of labor in it: "If the reader will take a magnifying glass to it, and examine it touch by touch, he will find that, literally, any four square inches of it contain as much as an ordinary watercolour drawing; . . . Let him examine, for instance, the eyes of the camels, and he will find that there is as much painting beneath their drooping fringes as would, with most painters, be thought enough for the whole head."[5] Like Hunt and the Pre-Raphaelites, Lewis was a master of minute

detail and finish, and his conscientious workmanship allowed him to re-create a tremendous range of textures and surfaces. The picture represents no significant personal or historical event: it is simply a breathtaking moment of intense light and color, a celebration of the visual riches of the Eastern world.

At Ruskin's urging, and upon his own realization that he could not sell his watercolors for as much as oils, Lewis resumed painting in 1855. Since he used the two media in an almost identical fashion, the change was easy to make. But it was a step backward: in none of his later work did he achieve the technical and compositional originality of his great exhibition watercolors.

1. Letter from Castlereagh to Lewis, May 10, 1842, quoted in Searight, "An Anonymous Traveller Rediscovered," *Country Life*, 163, May 4, 1978, p. 1259.
2. See, for example, *The Desert of Mt. Sinai*, Leeds City Art Gallery, and YCBA's study of *Sheik Hussein and his Son*, B1975.4.1937, repr. in YCBA, *Portrait Drawings*, 1979, no. 119. There is a pencil study for the ornamentation of the tent canopy in the VAM (E1025-1918).
3. R. Searight, op. cit.
4. J. Ruskin, *Academy Notes*, in *Works*, XIV, p. 75.
5. Ibid., p. 74.

Samuel Palmer, 1805–1881

A native of London, Palmer studied drawing under William Wate. At the age of fourteen he exhibited at the RA, and in 1822 he met his future father-in-law, John Linnell. Linnell introduced him to Blake, whose works influenced the direction of Palmer's art. At Shoreham from 1826, he was the leader of a group of young artists, followers of Blake, who called themselves "The Ancients." Among the group were F. O. Finch, George Richmond, Edward Calvert, and Linnell. In 1836 Palmer was again in London and married Hannah Linnell the following year. They traveled to Italy, remaining there until 1839. From 1843 he exhibited at the SPW, becoming a member in 1854. He moved to Redhill in 1862, where he began to etch and to make drawings for the shorter poems of Milton.

81. Pistyll Mawddach, North Wales c. 1835–36

Watercolor and bodycolor over pencil on buff wove
438 x 533 17¼ x 21
Insc.: Signed in pen and brown ink, LL: *Pistil Mawddach North Wales / Samuel Palmer / 4 Grove St. Lisson Grove Marylebone.*
Exh.: YCBA, *English Landscape*, 1977, no. 222.
Lit.: G. Grigson, *Palmer: The Visionary Years*, 1947, p. 132.
Coll.: Sir John Ramsden; Mrs. R. J. Tapp; Agnew, 1965. B1977.14.4644

After touring Wales in 1835 and again in 1836, Palmer exhibited a picture of Pistyll Mawddach at the RA and at the BI in 1836. It is unclear which work, or works were shown. An oil in the Tate, which is a version of this watercolor, was probably one of the exhibition pieces.[1] Another vertical watercolor of the fall was on the London art market in 1967.[2] Although the YCBA's watercolor was probably not exhibited, Palmer certainly considered it a completed work. He often produced such highly wrought studies, in which he focused all the color and sharp detail on the center of the drawing, gradually getting looser and less clear around the edges. In effect, Palmer was trying to capture the actual way in which the eye takes in a scene. His approach stemmed from the interests of the Varley circle, and in particular, those of Cornelius Varley, whose experiments with optics resulted in the invention of his Patent Graphic Telescope.

1. Tate inv. no. T1069.
2. Sotheby's, July 12, 1967, lot 228; bt. Agnew.

82. The Lonely Tower 1868

Watercolor, bodycolor, and gum on London board, mounted on wood panel
511 x 708 20⅛ x 27⅞
Insc.: Label on verso, in artist's hand: *No. 1 / The Lonely Tower. "Or let my lamp, at midnight hour, / Be in some high lonely tower, / Where I may oft outwatch the Bear, / With thrice great Hermes." / Samuel Palmer.*
Exh.: SPW, 1868, no. 16; London, *International Exhibition*, 1871, no. 1; London, Fine Art Society, 1881, no.74; London, RA, *Exhibition of Old Masters*, 1893, no 121; Glasgow, *International Exhibition*, 1901, no. 91; VAM, *Samuel Palmer — A Vision Recaptured*, 1979, XXIIe.
Lit.: A. H. Palmer, *The Shorter Poems of John Milton with Twelve Illustrations by Samuel Palmer*, 1889, pp. XIV–XVIII, pl. following p. 30; Palmer, *Life*, pp. 148–55; M. Hardie, "Samuel Palmer," OWSC, 4, 1926–27, pp. 38–39; Palmer, *Letters*, v. 2, pp. 695–96, 704, 767–68, 840; R. Lister, "Samuel Palmer's Milton Watercolours," *Connoisseur*, v. 194, Jan. 1977, pp. 16–19.
Coll.: Leonard Rowe Valpy; A. W. Dunn; sale, Christies, June 18, 1892, lot 51; Robert Dunthorne; J. Douglas Fletcher; sale, Christies, June 8, 1976, lot 189. B1977.14.147

In 1864 Palmer wrote, "I never artistically know 'such sacred and heartfelt delight' as when endeavouring in all humility to realize after a sort the imagery of Milton."[1] Although he occasionally painted subjects from Milton, and once left London to work on designs

for *L'Allegro* and *Il Penseroso*, it was not until he was commissioned by L. R. Valpy in 1865 that Palmer was able to work on a coherent set of Miltonic illustrations. He produced eight watercolors, all approximately 28 x 20, most of which were exhibited at the SPW beginning in 1868. At the time of the commission, Palmer also planned to produce etchings of the designs for an edition of the shorter poems of Milton, but only *The Bellman* and *The Lonely Tower* were executed by him. There is a preparatory drawing in wash and chalk for the YCBA's watercolor in the Cincinnati Art Museum.[2]

Palmer's love for his subject made him especially slow and cautious in working on the watercolors. He wrote to explain this to Valpy, who was impatient over the long delays: "I have *lavished time without limit or measure*, even after I myself considered the works complete."[3] Not only were they technically complex: the works were charged with associations, for Palmer believed that the simple vision of God's creation was nothing without the higher meanings of religion and poetry. "Though sight is the most refined of the senses," he wrote, "yet sight of colour and shade is a sensual pleasure, unless the visible suggest the historic or poetic."[4] In *The Lonely Tower*, he created a landscape meant to evoke a sensation he described as "poetic loneliness — not the loneliness of the desert, but of a secluded spot in a genial pastoral country, enriched also by antique relics, such as those so-called Druidic stones."[5] *The Lonely Tower* marks not only a high point in his own career: it is also one of the final great expressions of the pastoral tradition so long carried on by British watercolor artists.

1. Palmer, *Letters*, v. 2, p. 691.
2. Repr. in *Samuel Palmer — A Vision Recaptured*. Exhibition catalogue, VAM 1979, Raymond Lister, no. XXII(d).
3. Palmer, *Life*, p. 15.
4. Ibid., pp. 148–49.
5. Palmer, *Letters*, v. 2, p. 695.

Joseph Nash, 1808–1878

Born at Great Marlow, Nash became a pupil of Augustus Pugin in 1829, traveling with him to Paris to assist in making drawings for *Paris and its Environs*. He became an exhibitor at the SPW in 1834, becoming a full member in 1842. His watercolors were of ancient architecture, usually enlivened with figures, and an occasional literary illustration. He studied lithography and in 1838 published *Architecture of the Middle Ages*, followed by *The Mansions of England in the Olden Time* (1839–49), an instantly popular work. He also contributed a number of illustrations to annuals like *The Keepsake*.

83. *The Long Gallery, Haddon Hall, Derbyshire*
1839

Watercolor, bodycolor, pen and brown ink
547 x 755 21½ x 29¾
Insc.: Signed and dated in pen and brown ink, LR: *Joseph Nash 1839.*
Engr.: Nash's *Mansions of England in the Olden Time*, 1839–49, v. I, pl. 23.
Exh.: SPW, 1839, no. 170.
Lit.: Hardie, III, pl. 118.
Coll.: Abbott and Holder, 1966. B1975.3.1242

"This king of antique mansions," wrote the critic for *The Athenaeum* in 1838, "has been constantly in request of late."[1] Haddon Hall was the subject of a number of exhibition pieces during the 1820s and 1830s, including watercolors by David Cox, Turner of Oxford, Cattermole, and Nash. The popularity of this type of picture, the costume piece in a historic setting, culminated in Nash's *The Mansions of England in the Olden Time* (1839–49), which included fifty-three color lithographs of Tudor and Jacobean houses. The key to Nash's success and the clue to his approach is found in his title word "Olden." His intention was not really antiquarian: he appealed instead to the current taste for romantic recreations of daily life in the past, which had been sparked by the novels of Scott and by Bonington's little history scenes.

However romantic in inspiration Nash's work might have been, it still was completely accurate in the details of architecture and costume. Like Cattermole, Nash was trained in the antiquarian architectural tradition, but although contemporaries saw Nash and Cattermole as being in direct competition, they in fact differed profoundly in approach. With Cattermole, the figures were all-important, while the setting was generally dashed off with a few suggestive strokes. For Nash, on the other hand, the setting was the motivating interest, and his figures always played a secondary role. *Haddon Hall* demonstrates this very well: in it, the figures are used like props, placed at careful intervals in order to accent the main features of the long gallery.

1. *Athenaeum*, April 1838, p. 330.

William Callow, 1812–1908

Born at Greenwich, Callow was apprenticed to the engraver Theodore Fielding (elder brother of Copley Fielding) in 1825. In 1829 he moved to Paris, where he worked with Newton Fielding (younger brother) and later with Thomas Boys, whom he met in 1831. About this time he began to devote himself to watercolor,

exhibiting at French salons and in 1838 becoming an exhibitor at the SPW. He was a successful teacher of watercolor in France and, beginning in 1835, went on annual walking tours of different parts of Europe. In 1840 he met Turner in Italy. He became a member of the SPW in 1848, having moved to London seven years previously. He finally settled in Great Missenden, Buckinghamshire, in 1855 and made his last visit abroad in 1892.

84. *Le Pont Neuf, Paris* *c.* 1834

Watercolor, bodycolor, scraping, pen and gray and brown ink
330 x 492 13 x 19⅜
Insc.: Signed brush and gray ink, LR: *W. Callow*; on verso in pencil: *Paris from the Pont Lou . . .*
Exh.: Agnew, 1971, no. 152; Victoria, 1971, no. 2, pl. 1; PML-RA, 1972, no. 148.
Lit.: J. Reynolds, *William Callow*, 1980, p. 206.
Coll.: Agnew, 1971. B1975.4.1471

In spite of his reticence about Bonington, Callow was certainly influenced by his works, especially during the 1830s, when he was in close contact with T. S. Boys, a friend and follower of Bonington's. Callow met Boys in 1831 and was soon making a series of drawings for him of the bridges of Paris. One of these may have been used as the basis for this watercolor, which dates from around the year they shared a studio in 1833. There is a larger watercolor by Boys, a more distant view of the Pont Neuf, dated 1833, in the VAM.[1] During that year, Callow visited England and, while in London, met Bonington's engraver, George Cooke, who presented him with some proof sheets from Turner's *Picturesque Views of the South Coast* (1826). These had an immediate impact on Callow's style, as can be seen in the sky of this work, which is similar to that of the engraving by Cooke after Turner's *Margate*.[2] However, it is Bonington's manner which Callow reflects in his color scheme and use of pen to strengthen outlines.

In 1834 Callow met J. F. Lewis, who after seeing such watercolors as this, encouraged him to join the SPW. With further urging from his friend Charles Bentley, Callow sent sample drawings to the SPW committee in 1838, who promptly made him an exhibitor.

1. VAM 25-1922.
2. W. G. Rawlinson, *The Engraved Work of J. M. W. Turner*, RA, 1908, 1, p. 60.

85. *Wallenstadt from Wesen, Switzerland* 1838

Watercolor over pencil on pale blue wove
248 x 363 9¾ x 14⁵/₁₆
Insc.: In pencil, LL: *Wallenstadt / from Wesen —*; in pencil, BC: *Lac de Wallenstadt de Wesen* (erased), over this in brush and red ink, *W·· Callow*; verso in pencil: *Lake Wallenstadt / from Wesen.*
Exh.: London, National Book League's Gallery, March 1978, no. 56.
Coll.: Michael Spratt, London. Mr. and Mrs. Paul Mellon

Like a number of his contemporaries, Callow found that the use of colored paper was an easy expedient for giving tone and depth to an otherwise slight pencil or wash sketch. From such a beginning, he could work up a finished watercolor back in his studio (see no. 86). In the present case, Callow turned a relatively calm study into a more dramatic scene with effects of wind, shadow, and cloud which reflect the influence of Turner's Swiss watercolors.

86. *Wallenstadt from Wesen* 1842

Watercolor and bodycolor over pencil
445 x 546 17½ x 25½
Insc.: Signed in brush and brown ink, LL: *W. Callow.*
Exh.: SPW, 1842, no. 238; Royal Liverpool Academy, 1842, no. 509; YCBA, *English Landscape*, 1977, no. 226.
Lit.: Hardie, III, pl. 53; J. Reynolds, *William Callow*, 1980, p. 207.
Coll.: P. Polak, 1967. B1975.3.189

Formerly published as *The Ferry Glenelg, c.* 1849, this watercolor was retitled and dated when an inscribed study for it was found in 1978 (see no. 85).[1] In the same year that he was elected an exhibitor at the SPW, Callow toured Switzerland and Germany for the first time and mentioned in his *Autobiography* a visit "by coach to Wesen on the lake of Wallenstadt."[2] The trip resulted in several large exhibition watercolors, including the *Oberwesel on the Rhine and the Castle at Schonburg* (Whitworth Art Gallery) and the present work. It was presumably not sold when exhibited at the SPW in 1842, for Callow reexhibited it the same year at Liverpool.

1. YCBA, *English Landscape*, no. 226.
2. Callow, *Autobiography*, p. 69.

Edward Lear, 1812–1888

Of Danish parentage, Lear was born at Highgate. He worked at the zoological gardens in 1831 and published an ornithological work, *The Family of the Psittacidae*, the following year. Continuing his bird studies, he worked for Lord Derby at Knowsley and traveled in England and Ireland in 1835–36. Between 1837 and 1841 he wintered in Rome, publishing a book of views in 1841. He gave drawing lessons to Queen Victoria in 1846. His first visit to Greece and Egypt was made in 1848–49. He also traveled in Albania and the Mideast, publishing *The Journals of a Landscape Painter in Greece and Albania* in 1851 and *Southern Calabria* in 1852. In Egypt again in 1857–58, he also spent several winters in Malta, Nice, and Cannes, finally settling at San Remo. He exhibited at the RA, the BI, the SBA, and at the Grosvenor Gallery.

87. *Abou Simbel* 1867

Watercolor over pencil, gone over with pen and
 brown ink
349 x 511 13 ¾ x 20⅝
Insc.: In pen and brown ink over pencil erasure, LL:
 Aboo Simbel / 11–11:30 AM. / 8 Febr. 1867; LR:
 (374): color notes all over drawing. Verso, in
 pencil, center: *21. Longurse / alone.*
Exh.: Agnew, 1971, no. 65; Victoria, 1971, no. 24,
 pl. 5.
Coll.: Agnew, March 1971. B1975.4.1559

On his second journey to Egypt, Lear recorded his visit to Abou Simbel: "In turning the corner forth suddenly came the Rameses Heads!! . . . As a whole the scene is overpowering from its beauty — color — solitude — history — art — poetry — every sort of association."[1] Lear made two drawings of the scene, the present watercolor and a smaller, closer view made in the afternoon of the same day.[2] His analytic approach to landscape, the formal discipline of line used to explore rocky structure and forms, harks back to the eighteenth-century topographic tradition, and in particular to the work of Francis Towne. A parallel between the two can be made in their shared appreciation of finished sketches, which they both believed to be intellectually provocative insights into an artist's creative process. The Varleys and Palmer occasionally produced such works, continuing the tradition, but Lear was the only nineteenth-century artist who made it his central working method. His annotations of time, color, and texture, which he was careful to include in his finished watercolors, give this drawing great immediacy, a sense of the exact time and place which inspired him.

1. Lear's diary, quoted in Worcester Art Museum, *Edward Lear,
 Painter, Poet, and Draughtsman*, 1968, p. 28.
2. Harvard College Library.

Sir Frederick William Burton, 1816–1900

Son of an Irish landscape painter, Burton was born in County Clare. He was a pupil of the Brocas brothers of Dublin in 1828, was made an associate of the Royal Hibernian Academy in 1837 and a member in 1839. He first exhibited at the RA in 1842 and at the SPW in 1854, and he became a member of the latter institution the following year. Between 1842 and 1859 he spent much time on the Continent, living for several years near Munich. In 1870 he resigned from the SPW, a gesture of support for Edward Burne-Jones, who left the Society when the committee requested him to alter one of his exhibits. Burton was reinstated as an honorary member in 1886. From 1874 to 1894 he was Director of the National Gallery, and was responsible for the purchase of Leonardo's *Virgin of the Rocks*, Raphael's *Ansidei Madonna*, and Van Dyck's *Charles I on Horseback*. With Sir Charles Eastlake, he arranged a rotating public exhibition of the watercolors and drawings in the Turner Bequest.

88. *Dreams* c. 1861

Watercolor, bodycolor, and gum over pencil, laid
 down on card
204 x 316 8 x 12
Insc.: Monogrammed in brush and green ink, UR:
 FWB.
Coll.: Edwin Wilkins Field; Mrs. Field, 1890; Walter
 Field; sale, Sotheby's, Belgravia, Oct. 6, 1980, lot
 60; bt. Jeremy Maas. B1980.37

On June 10, 1861, the SPW committee decided to present their legal advisor, Edwin Wilkins Field, with a folio of drawings executed by the members.[1] Field had been instrumental that year in revising the Society's laws and, as an amateur artist himself, was a friend of a number of the SPW members. J. D. Harding, Carl Haag, and William Evans were chosen to collect and arrange the drawings for the portfolio. Although they were not exhibition watercolors, the works can be classed in a similar category: highly finished "presentation drawings," meant to represent the best, most characteristic work of each artist. This watercolor was Burton's contribution to the Field portfolio, and while not as large or ambitious as most of his exhibition pieces, it has all the strength and simple charm of his finest work. In his use of loose stipple technique,

Burton continued in the tradition of Hunt and Lewis, but the rich colors were entirely his own.

1. Roget, II, p. 106.

Sir John Gilbert, 1817–1897

Gilbert was born at Blackheath and began his career as an estate agent. He was exhibiting at the BI and the SBA by 1836, but the majority of his work was in book and magazine illustration, including 30,000 drawings for the *Illustrated London News* between 1842 and his death. He illustrated in part or whole about 150 books. Around 1851 he devoted an increasing amount of time to watercolor, becoming an exhibitor at the SPW in 1852 and a member in 1854. Succeeding Frederick Tayler in 1871, he became president of the SPW and was knighted the following year. Although he rarely painted in oil, he was made ARA in 1872 and RA in 1876. His exhibition subjects were often from Shakespeare, Cervantes, and Le Sage.

89. *Malvolio Washes off Gross Acquaintance* 1863

Watercolor and bodycolor over pencil
489 x 755 19¼ x 29¾
Insc.: Signed and dated in brush and brown ink, LL: *John Gilbert / 1863.*
Exh.: SPW, 1863, no. 29; London, *Special Exhibition of Works by Sir John Gilbert*, RA, 1898, no. 76; YCBA, *Shakespeare and British Art*, 1981, no. 50.
Coll.: Miss Rawson; Lincoln Kirstein; American Shakespeare Theatre Coll. B1976.1.52

Twelfth Night, Act III, scene IV.
Malvolio, Maria, Sir Toby and Fabian
Malvolio: Go off; I discard you; let me enjoy my private; go off.

Malvolio, tricked into thinking that Olivia loves him, appears cross-gartered and dismisses the three who have played the joke on him. When exhibited, this watercolor was considered "a much less fortunate presentation of Shakespearean humour" than Gilbert usually produced, because Malvolio was too "coarse and commonplace."[1] Gilbert's scenes lacked the sparkling brushwork and deep color of Cattermole's illustrations, from which is work was descended. His technique, especially the dry hatching which he used to render every texture from marble to grass, was adapted from his prolific practice as a magazine illustrator.

1. *Athenaeum*, May 1863, repr. in OWSC, 10, 1933–34, p. 35.

Myles Birket Foster, 1825–1899

Foster's family moved from North Shields to London in 1830, where he was apprenticed to Bewick's pupil, Peter Landells. He cut blocks for the *Illustrated London News* and *Punch*. By 1846 he was self-employed, and in 1852–53 he traveled on the Continent, touring around the Rhine. In 1859 he began to concentrate on watercolor, becoming an exhibitor at the SPW in 1860 and a member in 1862. Further trips abroad were made in 1861, 1866, and 1868, the last with Fred Walker and W. Q. Orchardson. In 1863 he built a house at Witley in Surrey and continued from there to send a steady stream of watercolors to the SPW, where they were much in demand. He received £5000 from Charles Seeley for a set of fifty drawings of Venice.

90. *The Hayrick* c. 1862

Watercolor, bodycolor, scraping, laid down on wood
472 x 670 30⅜ x 26⅜
Insc.: Monogrammed, LR: $\frac{F}{B}$
Engr.: *Birket Foster's Pictures of English Landscape*, 1863, no. 10.
Exh.: Victoria, 1971, no. 6, repr. pl. 2.
Coll.: G. W. Blundell, Liverpool; Christies, March 9, 1951; L. Mortimer; P. Polak, March 1966. B1977.14.6169

The history of the present watercolor illustrates Foster's rapid rise in public estimation after his election to the SPW. Until 1859 Foster worked almost entirely on book illustration. That year the Dalziel brothers commissioned him to make fifty drawings of scenes from English landscape, each of which was to be accompanied with a verse by Tom Taylor. Foster received £350 for his contributions to the book, which by 1863 had been reduced to thirty designs.[1] In the interim Foster found that his exhibition watercolors were far more lucrative than his previous work, which he dropped entirely after this period. When the Dalziel brothers offered him £3000 to make watercolor versions of their illustrations, of any size he chose, he refused.[2] It was a measure of his enormous success that he could afford to pass up such an offer. However, he did make at least one finished version of a subject from the Dalziels' book, *Building the Hayrick*.

The scale of the drawing reflects his rising reputation, and is an unusually large example of Foster's work. He often worked on commission for collectors, and dealers frequently bought works straight from his studio to avoid the crowds competing for his exhibition works on the first day of the SPW's show. This would explain why this watercolor was not exhibited. In technique, *The Hayrick* was based

upon the precedent set by Hunt. Foster adopted the use of chinese white as a base upon which further drawing could be carried out, a practice he was already familiar with from his early training as a wood engraver. But his debt to Hunt was not only one of technique: the subjects he chose, the rustic pastorals, pretty milkmaids and children, are also descended from Hunt's genre subjects of the 1830s and 40s.

1. F. Reid, *Illustrators of the Eighteen Sixties*, London, 1928, p. 24.
2. *The Brothers Dalziel: A Record of their Work, 1840–1890*, foreword by G. Reynolds, London, 1978, pp. 141–42.

Alfred William Hunt, 1830–1896

The son of a landscape painter, Hunt was born in Liverpool, where at the age of twelve, he exhibited. He entered Corpus Christi College, Oxford, in 1848, won the Newdigate prize for English poetry in 1851, and obtained a fellowship in 1853. He devoted himself to painting and watercolor, becoming an associate of the Liverpool Academy in 1854 and a member two years later. He showed at the RA between 1854 and 1857, where his works were praised by Ruskin. In 1862 he moved to London and exhibited at the SPW: two years later he was elected a member.

91. *"Blue Lights," Tynemouth Pier — Lighting the Lamps at Sundown* 1868

Watercolor, some bodycolor, gum, and scraping
362 x 527 14¼ x 20¾
Insc.: Signed and dated in brush and brown ink, LL: *AW. HUNT, 1868.*
Exh.: SPW, 1866, no. 281; London, Fine Art Society, *Loan Exhibition of Pictures and Drawings of Alfred William Hunt*, 1884, no. 44; London, Guildhall, *Loan Exhibition of Water-Colour Drawings*, 1896, no. 85; Liverpool, Walker Art Gallery, *Memorial Exhibition of Pictures by Alfred William Hunt*, 1897; London, BFAC, *Drawings in Water-Colour by Alfred William Hunt*, 1897, no. 94; Dublin, *Irish International Exhibition*, 1907, no. 444; London, RA, *Exhibition of Works by the Old Masters*, 1906, no. 199.
Lit.: V. Hunt, "Alfred William Hunt, R.W.S.,".OWSC, 11, 1924–25, pl. XII.
Coll.: Humphrey Roberts; Christies, May 23, 1908, lot 258; bt. Gooden & Fox; William Newall; Christies, June 30, 1922, lot 28; bt. Victor Rienaecker; N. D. Newall, Esq., sale Christies, Dec. 13, 1979, lot 161. B1980.3

Hunt sketched this scene a couple of days after a wreck had washed against the pier and damaged the pilings and the tramway upon it. He contributed a small wash drawing of the subject for the portfolio of drawings presented to the SPW's legal advisor in 1863 (see no. 88).[1] He also made an elaborate exhibition work of Tynemouth pier, which was shown in 1866 at the SPW. It is unclear whether this watercolor is the same one: it may be a later version of the untraced exhibition watercolor. If it is the 1866 work, the later date may have been added by Hunt after reworking, or more simply, appended when the watercolor was sold.

Hunt captured a stormy and atmospheric effect through vigorous manipulation of both paper and pigments, which he scrubbed and scraped to eliminate outline and detail. In this, he ultimately owed a debt to Turner's watercolors of *c.* 1830–45, but the immediate inspiration for this watercolor must have been Whistler's work, such as his *Battersea Bridge* (Addison Art Gallery, Andover), exhibited at the RA in 1865.[2] Whistler's concentration on assymmetrical compositions, strong diagonals, and his deliberate lack of clear detail had a profound effect on Hunt. However, unlike Whistler, Hunt was afraid that his watercolor of Tynemouth Pier would not be "intelligible enough and effective, and so escape the objection — a serious one to bring against a picture — that it does not tell its tale easily to the eye."[3]

1. Christies, Nov. 18, 1980, lot 76, repr.
2. Repr. D. Sutton, *James McNeill Whistler: Paintings, Etchings, Pastels, and Watercolours*, 1966, p. 186.
3. Letter from Hunt to Humphrey Roberts, quoted in Christies Cat., Dec. 13, 1979, p. 123, no. 161.

The Plates

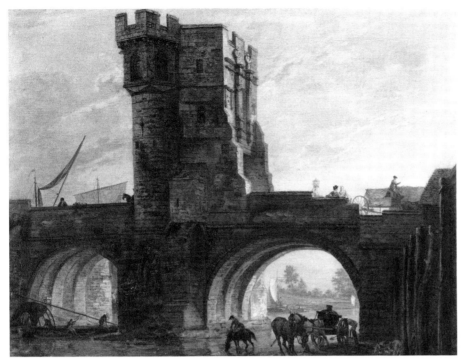

1. Paul Sandby *Old Shrewsbury Bridge*

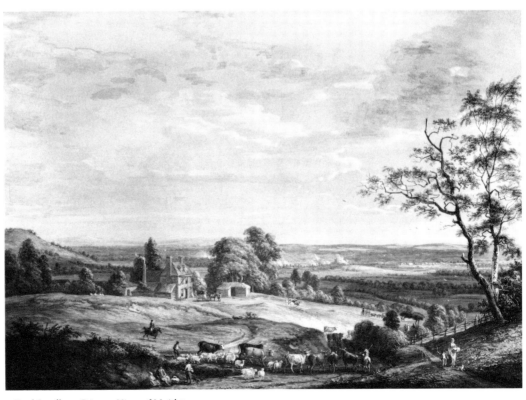

2. Paul Sandby *Distant View of Maidstone*

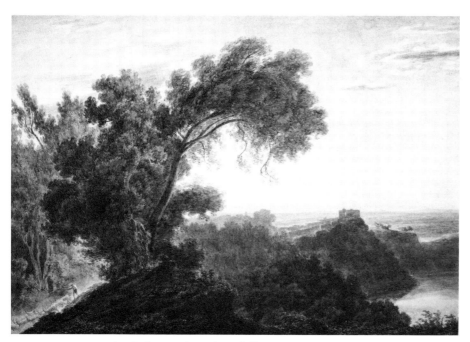

7. John R. Cozens *Lake of Albano and Castel Gandolfo*

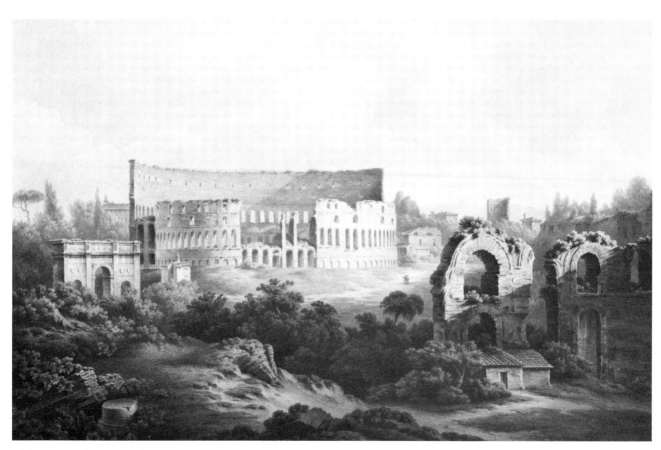

5. John "Warwick" Smith *The Coliseum, Rome*

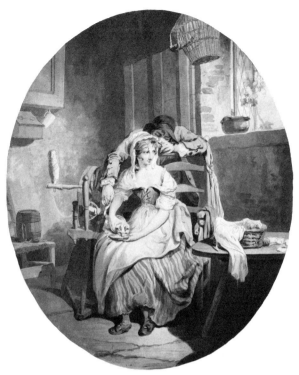

3. Francis Wheatley *Rustic Courtship*

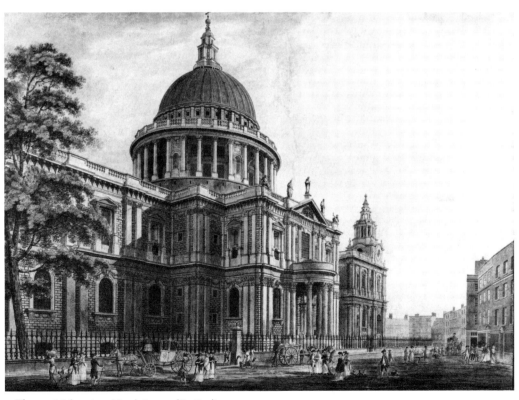

4. Thomas Malton Jr. *North Front of St. Paul's*

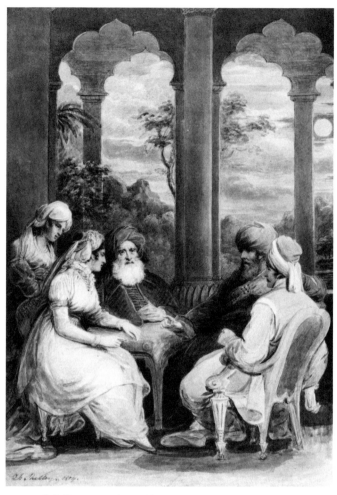

6. Samuel Shelley *Rasselas and his Sister*

9. Francis Nicholson *Bonnington Linn*

8. Francis Nicholson *London Bridge and the Monument*

10. Thomas Stothard *The Tenth Day of the Decameron*

14. Richard Westall *Rosebud*

12. Adam Buck *Portrait of a Family*

13. Edward Dayes *Queen Square*

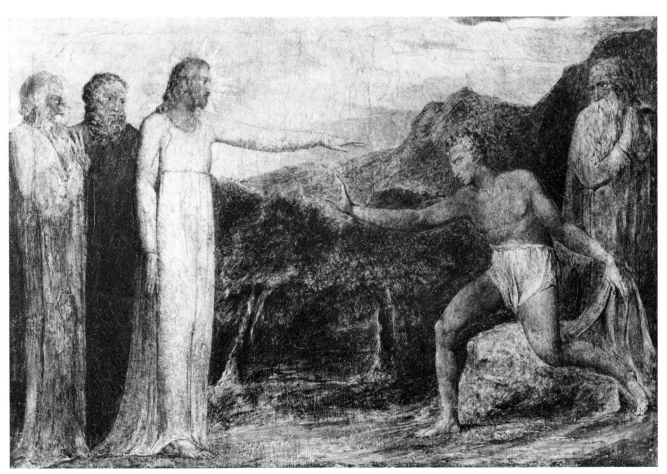

11. William Blake *Christ Healing the Blind Man*

15. George Barret Jr. *View of London from Highgate*

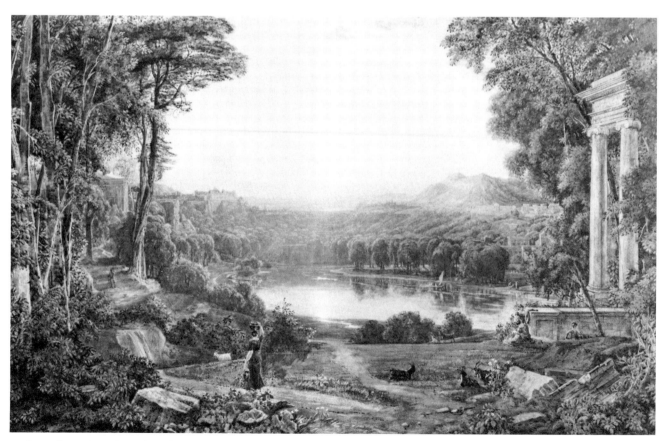

16. George Barret Jr. *Classical Landscape*

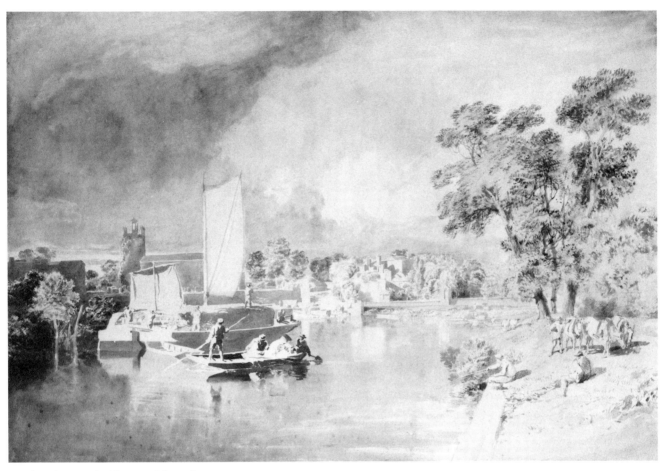

17. John Glover *The Thames at Isleworth*

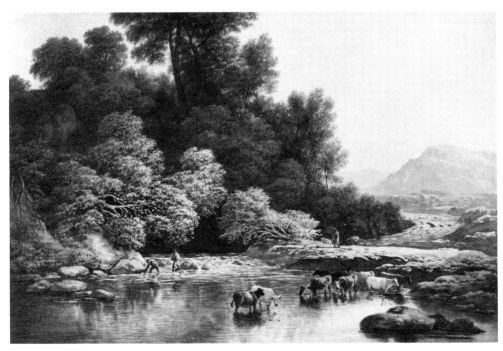

18. John Glover *Hilly Landscape with River and Cattle*

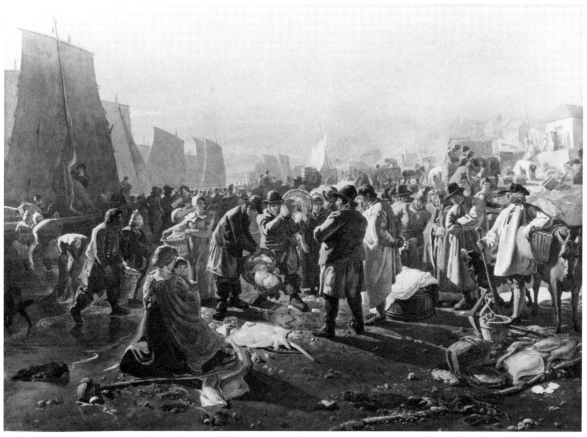

19. Joshua Cristall *The fish-market, Hastings*

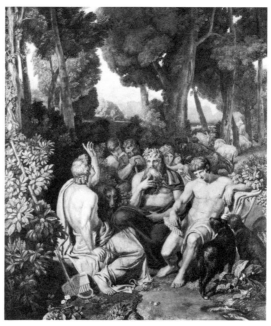

20. Joshua Cristall *Arcadian Shepherds*

21. Joshua Cristall *Young Woodcutter*

23. Robert Hills *Landscape and Cattle*

26. Thomas Girtin *The Ouse Bridge, York*

24. Robert Hills *A Village Snow Scene*

28. Thomas Heaphy *Inattention*

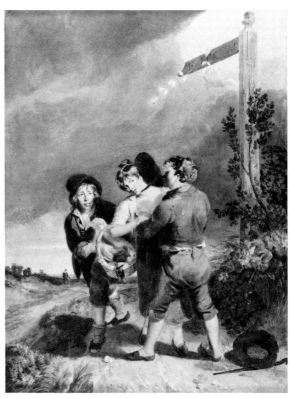

27. Thomas Heaphy *Robbing a Market Girl*

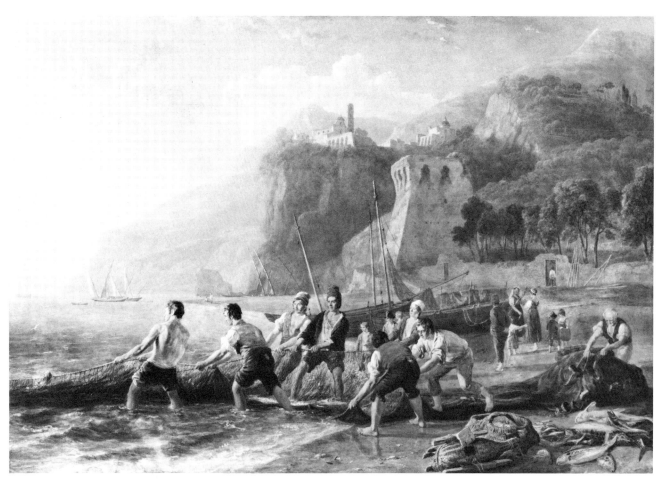

29. Ramsay R. Reinagle *Fishermen Hauling their Net Ashore*

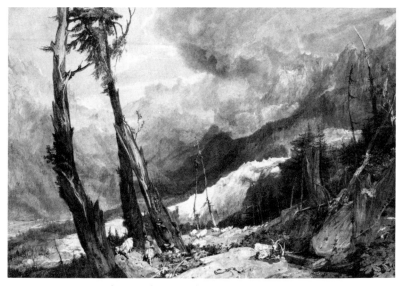

30. J. M. W. Turner *Glacier and Source of the Arveyron*

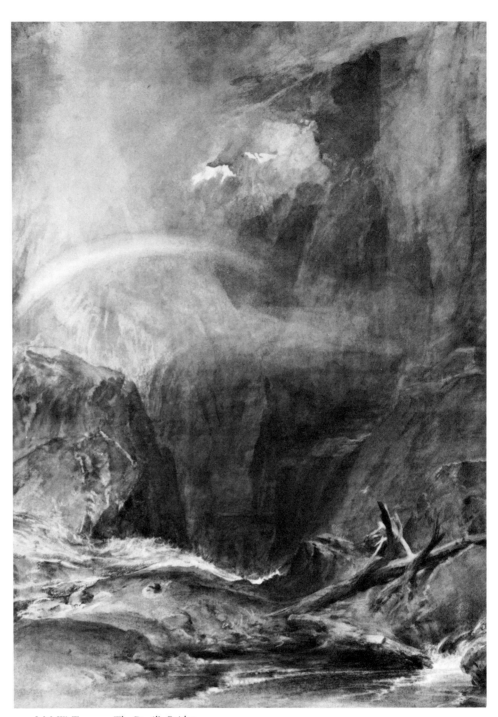

30a. J. M. W. Turner *The Devil's Bridge*

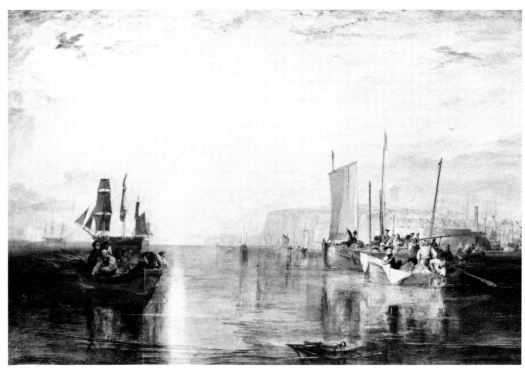

32. J. M. W. Turner *Whiting Fishing off Margate*

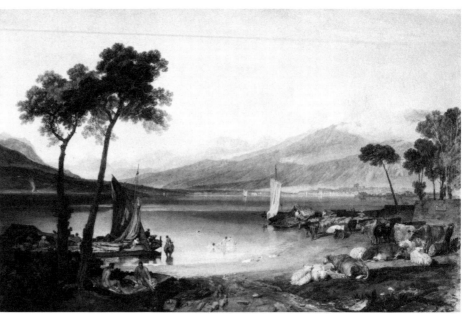

31. J. M. W. Turner *Lake of Geneva*

34. John Varley *Harlech Castle and Teguyn Ferry*

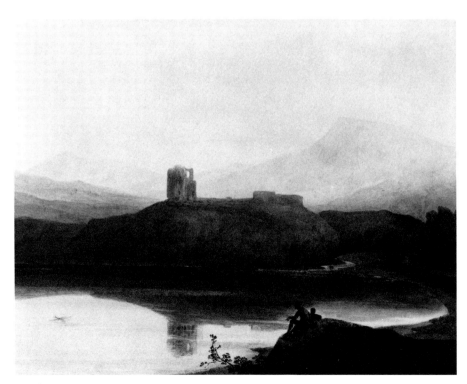

35. John Varley *Dolbadern Castle*

38. John Varley *The Thames near the Penitentiary*

37. John Varley *Vauxhall Bridge*

36. John Varley *Suburbs of an Ancient City*

39. Andrew Wilson *Tivoli*

41. John S. Cotman *Bridge in a Continental Town*

43. William Havell *Landscape with Figures*

44. William Havell *Carew Castle*

25. Paul S. Munn *Pale Melancholy*

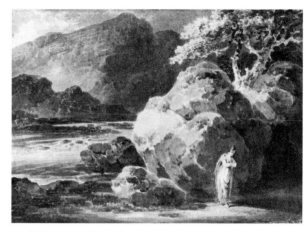

42. William Havell *Pale Melancholy*

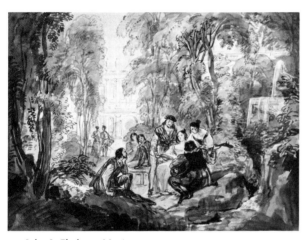

33. John J. Chalon *Music*

22. Joshua Cristall *Gil Blas*

40. Alfred E. Chalon *Gil Blas*

45. Thomas Uwins *Gil Blas*

48. David Cox *Antwerp - Morning*

47. David Cox *Millbank*

53. Peter De Wint *Harvesters in a Landscape*

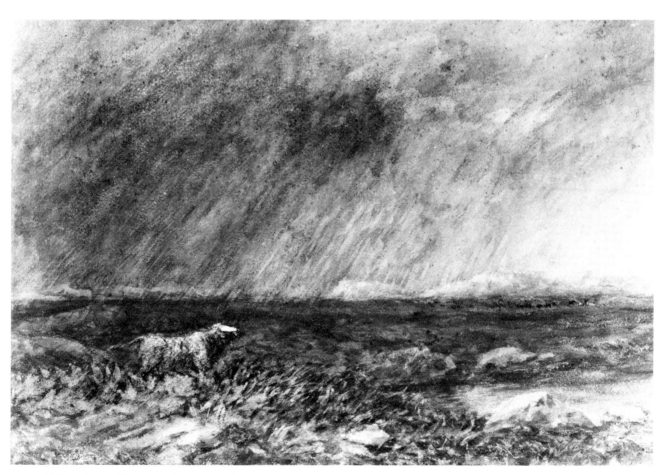

49. David Cox *On the Moors near Bettws-y-Coed*

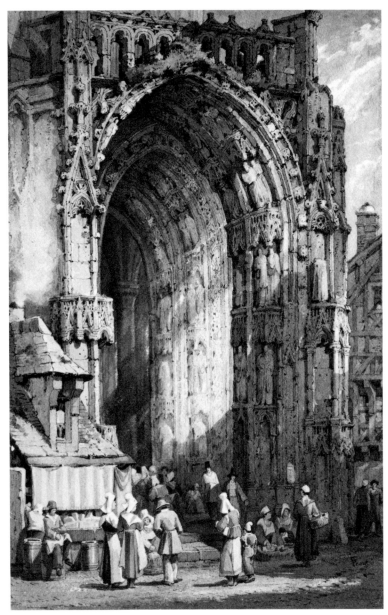

50. Samuel Prout *The Porch, Rheims Cathedral*

46. Thomas Uwins *Festa di San Antonio*

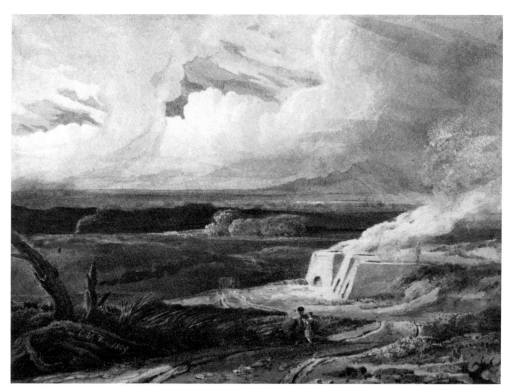

56. A. V. Copley Fielding *Landscape with Limekiln*

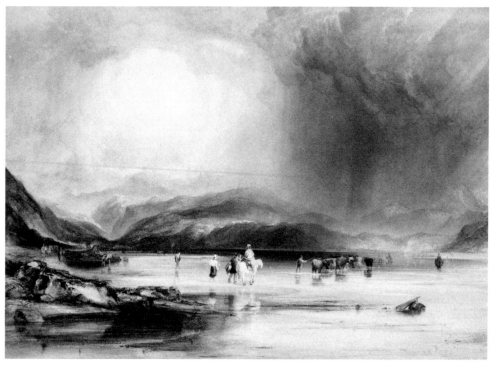

57. A. V. Copley Fielding *View of Snowdon*

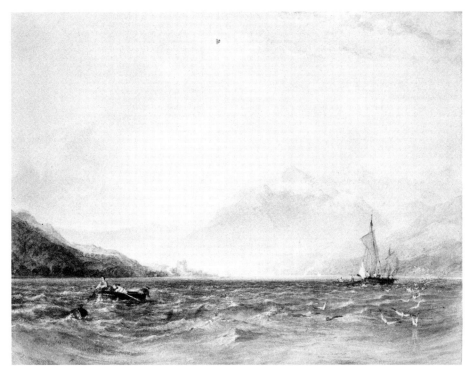

59. A. V. Copley Fielding *Loch Fyne*

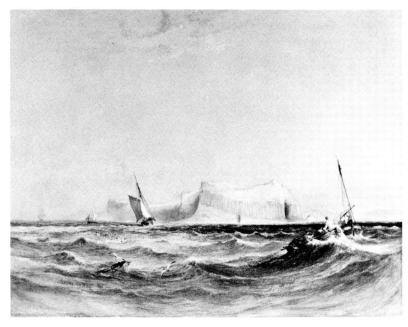

58. A. V. Copley Fielding *Shipping off Staffa*

54. Peter De Wint *Study for 'Elijah'*

55. Peter De Wint *Study for 'Elijah'*

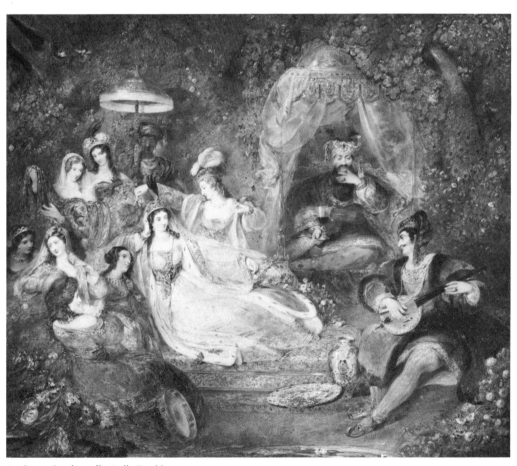

60. James Stephanoff *Lalla Rookh*

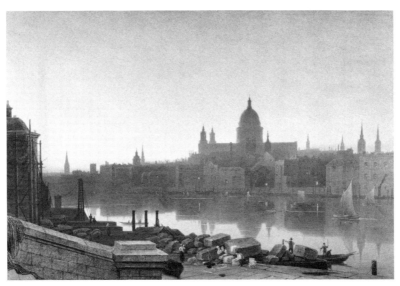

63. George F. Robson *St. Paul's from Southwark*

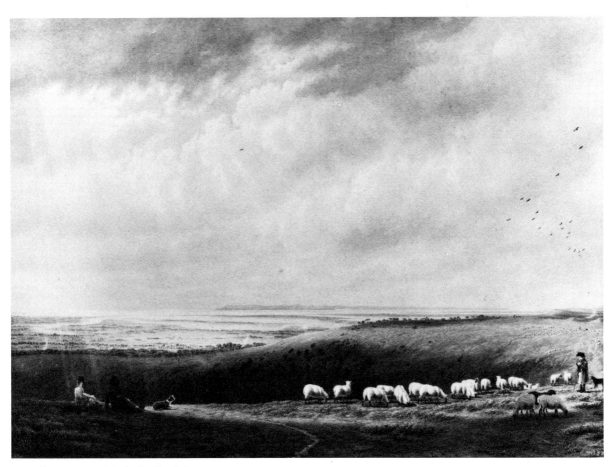

64. William Turner of Oxford *Kingly Bottom*

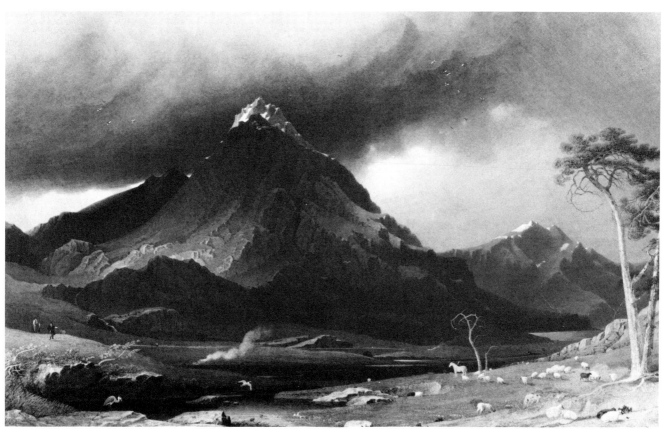

61. George F. Robson *Highland Landscape*

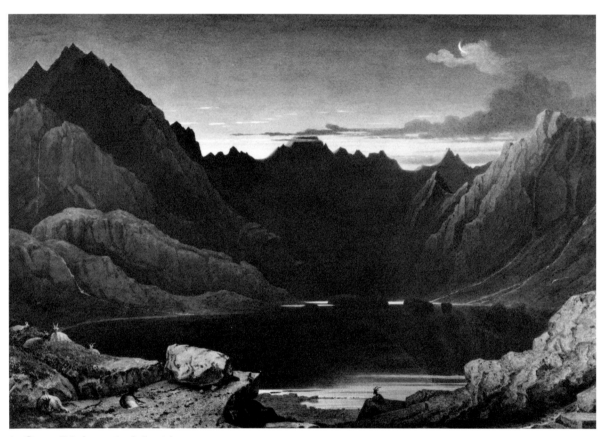

62. George F. Robson *Loch Coruisk*

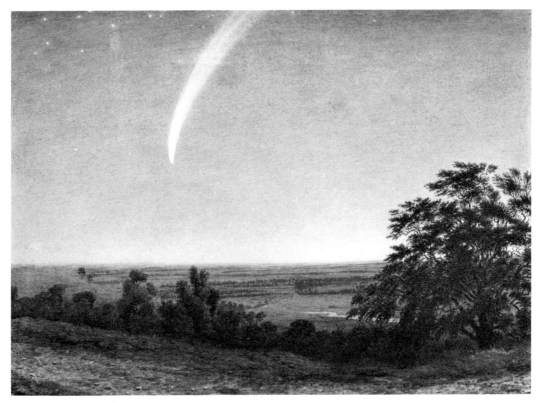

65. William Turner of Oxford *Donati's Comet*

67. William H. Hunt *Plums and Mulberries*

66. William H. Hunt *The Outhouse*

70. James D. Harding *French Fisherboy*

68. John Linnell *Mrs. William Wilberforce and Child*

69. Samuel Jackson *Romantic Landscape*

73. Richard P. Bonington *Figures in an Interior*

72. George Cattermole *Salvator Rosa among the Banditti*

71. James D. Harding *The Grand Canal, Venice*

74. Francis O. Finch *Religious Ceremony in Ancient Greece*

75. Thomas S. Boys *Prague*

77. William L. Leitch *Kilchurn Castle*

76. Edward Duncan *The Bass Rock*

78. John F. Lewis *Figures in a Vineyard*

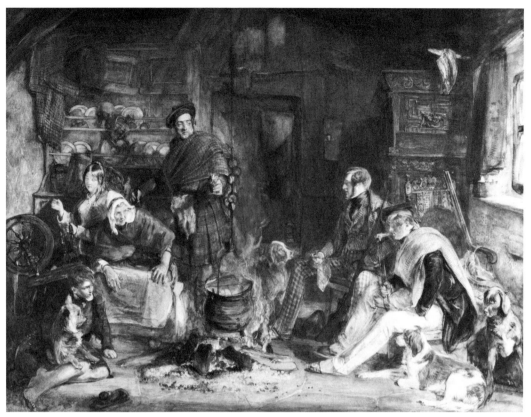

79. John F. Lewis *Highland Hospitality*

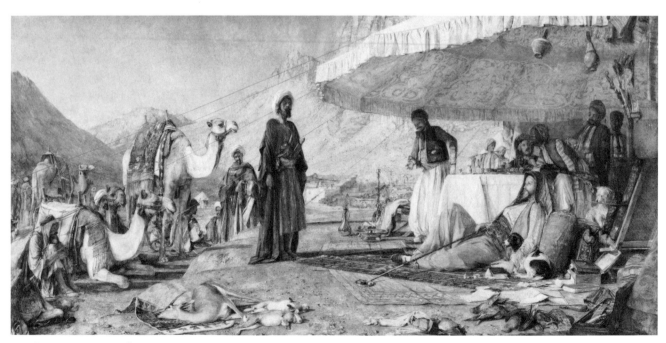

80. John F. Lewis *A Frank Encampment in the Desert*

81. Samuel Palmer *Pistyll Mawddach*

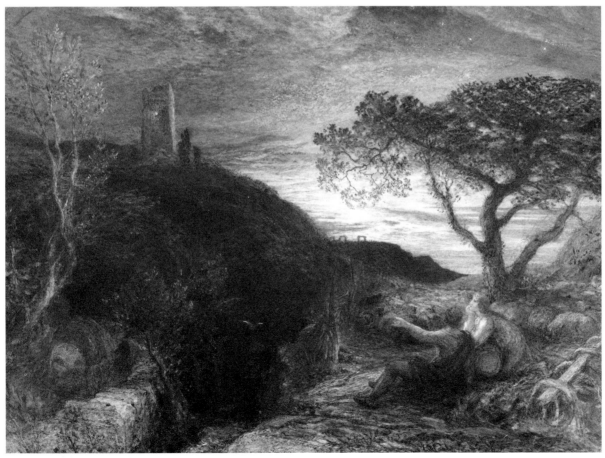

82. Samuel Palmer *The Lonely Tower*

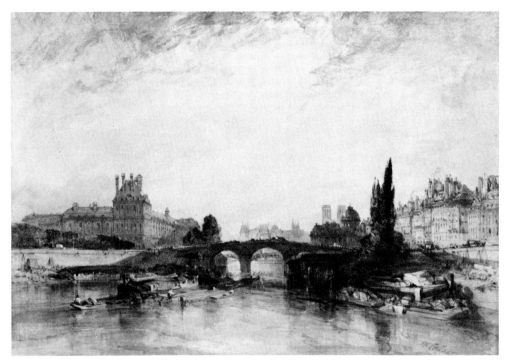

84. William Callow *The Pont Neuf, Paris*

87. Edward Lear *Abou Simbel*

85. William Callow *Wallenstadt from Wesen*

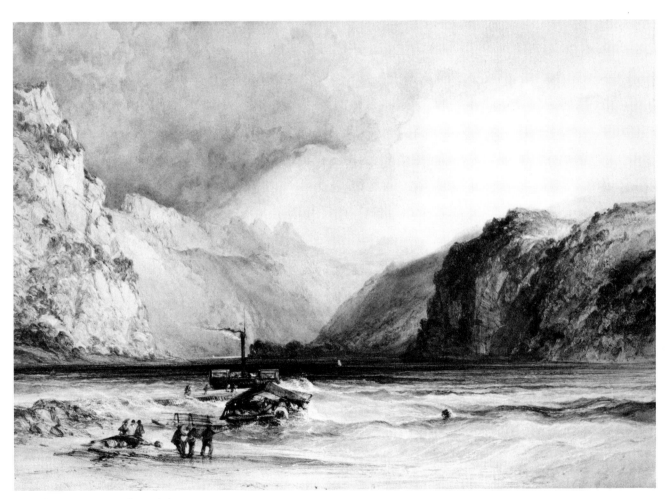

86. William Callow *Wallenstadt from Wesen*

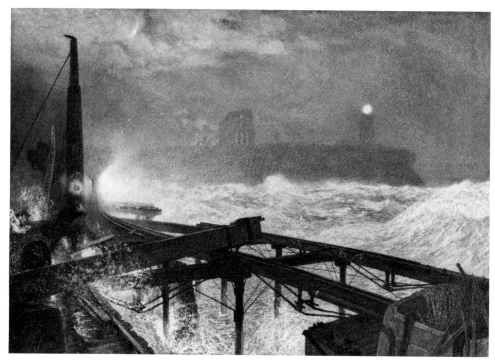

91. Alfred W. Hunt *The Blue Light, Tynemouth Pier*

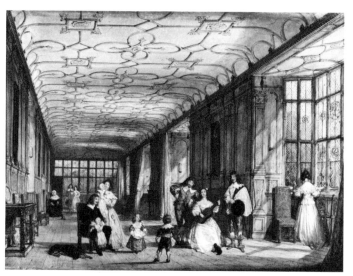

83. Joseph Nash *Haddon Hall*

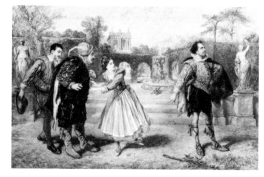

89. Sir John Gilbert *Malvolio*

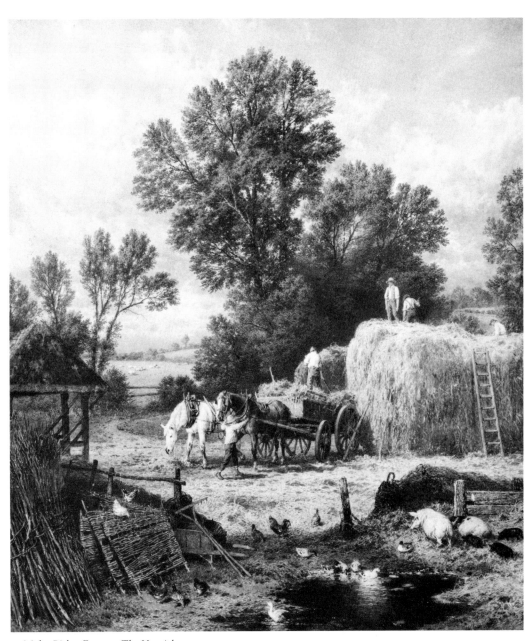

90. Myles Birket Foster *The Hayrick*

88. Sir Frederick W. Burton *Dreams*